1554

MATISSE
The Graphic Work

Margrit Hahnloser

MATISSE
The Graphic Work

MALLARD
PRESS

MALLARD PRESS
An imprint of BDD Promotional Book Company, Inc.
666 Fifth Avenue
New York, N.Y. 10103

Mallard Press and its accompanying design and logo
are trademarks of BDD Promotional Book Company, Inc.

Originally published in German under the title
Matisse — Meister der Graphik. Translated by Simon Nye.
English translation copyright © 1988 by Office du Livre S.A.

© 1987 by SPADEM, Paris, and PROLITTERIS, Zurich.
Excerpts from Matisse's letters from *Matisse of Art* by Jack D. Flam,
published by Phaidon, Oxford are reprinted by permission of Phaidon
Press Limited.

World English language rights reserved
by W.S. Konecky Associates, Inc.

ISBN: 0-7924-5739-0

Printed in Hong Kong

INTRODUCTION

Matisse's graphic work has a marginal existence in the context of his work as a whole, since this great twentieth-century master was above all a painter. His main creative impulses are derived from his deeply rooted painter's temperament and his exceptional sensitivity to color. As one of the fauves he became the trailblazer of a new generation of painters. His graphic work, however, is relatively little known. European and, to some extent, American museums contain only occasional examples or limited series, rather than representative collections. There are exceptions: the collection in the Bibliothèque Nationale in Paris and the early bequests of the great collector Jacques Doucet in Paris (the Bibliothèque Littéraire and the Bibliothèque d'Art et d'Archéologie at the University of Paris). Today, thanks to the "dépôt légal" (legal trust) required by the French state and gifts by Matisse's family (the Donation Jean Matisse and the archives of the Musée Nationale in Nice), there are indispensable and precious documentary sources. The scarcity of examples in other countries is surprising, for in the 1920s Matisse had been one of the most sought-after artists of his time, with international exhibitions from Copenhagen to New York and the attention, furthermore, of a host of great collectors. In their minds, however, Matisse was not a graphic artist and certainly not a renewer of technical printing processes or a magician with mysterious mixing techniques like Picasso, his contemporary. Matisse was happy with old-established, classical methods of block printing and started after 1900 to work with etching, drypoint, and litho chalk. He gave up painstaking woodcuts after a few attempts and did not extend his repertoire until the 1930s and 1940s with aquatint techniques and linocuts. It should be added that, with few exceptions, he excluded color completely from this work. His enthusiasts saw the prints, presumably, merely as a supplement, an additional attraction; they recognized the artist's signature particularly in the richly worked half-tones of the lithographs of the 1920s with their sensuous odalisques and the brilliantly decorated interiors.

The 1983 catalogue of graphic works compiled by Marguerite Duthuit and Claude Duthuit, the artist's daughter and grandson, the impressive exhibitions of Matisse prints organized in 1970 and 1981 by the Bibliothèque Nationale in Paris, and the major show of prints brought together at the Musée d'Art et d'Histoire, Fribourg, Switzerland, in 1982 made it possible to see the close connections with Matisse's other work. They include and document creative moments in which the artist took steps that influenced his work as a whole and produced solutions to artistic problems in painting and sculpture. No other artist in this century has been the recipient since 1980 of such a flood of thorough, scientific investigations and appraisals, valuable individual studies, and major exhibitions, giving rise to new chronologies and artistic connections (we should mention here the new generation of researchers on Matisse: Pierre Schneider, Dominique Fourcade, Isabelle Monod-Fontaine, John Elderfield, Jack Flam, Jack Cowart, Sir Lawrence Gowing, John Hallmark Neff, and others). Over thirty years after the artist's death and a hundred years after his birth, those with an interest in art, who have been stimulated by the numerous Matisse-inspired paintings of a younger generation of artists, search today to probe deeper into this brilliant, tirelessly creative mind. His graphic work has also become a rich source in this context and calls for reevaluation, since there is still no purely scholarly assessment of this aspect of his work.

We are attempting here, assisted by a selection of one hundred prints, to give an overview of Matisse's graphic work, including biographical data and correspondence, in the context of his oeuvre as a whole while at the same time looking into some queries specific to his work in this medium.

Matisse's graphic work gives us a glimpse into the artist's studio, bringing us into direct contact with the actual artistic process. We are guided on the one hand by the works — and by the artist's numerous statements on his work — but we must also draw on individual accounts from models and contemporaries. Lydia Delektorskaya, the artist's model in the late 1920s, made a significant contribution in this context with her recently published collection of valuable documentary materials.

Matisse's graphic works were not primarily preliminary drawings for his paintings, but rather he employed graphic media to learn about objects themselves. His works are studies of objects in the broadest sense, and his objects were almost exclusively models. Matisse's graphic work as a whole — and it numbers over eight hundred works — is a life-long dialogue between artist and model. "What interests me most is neither still life nor landscapes, but the human figure," explained the artist in 1908 in one of his first public statements on his art (F. 38). "The model, for others, is a piece of information. In my case it is something which arrests me. It is the source of my energy,"[1] the thirty-nine year old Matisse professed. His art always began with the human model, with external stimuli, and in the process of making the pictorial transposition, he would constantly refer to the physical presence of the model. Drawing

models was an innermost need and became a creative obsession. Matisse worked on the concept of man in his totality, an uninterrupted image, and the artistic representation of this image demanded a thorough commitment that absorbed his emotional strength. His artistry moved between a visual seizing of the subject matter and the free, inventive reproduction and interpretation of this same subject matter, which intensified in the later work into little more than distinctive markings. This produced an unlimited field of creative opportunities for pictures and represented a constant adventure. Matisse's graphic work, in fact, bears witness to this life-long questioning of the model, from self-portrait to academy studies, portraits of friends and relations, and to the numerous variations of model drawings.

In the repetition over the years of the same work situation and the same artistic methods, the prints reveal the artist's great creative imagination, his working methods, his mental commitment, and emotional input in pursuit of his objective, and they also disclose moments of doubt and struggle over these pictures.

In painting, the canvases are reworked: the different versions are laid one over the other, and thus the variations become concealed. Only in occasional cases, when there is photographic evidence, is it possible to trace stages in the work. In the drawings several versions sometimes remain, particularly in *Thèmes et variations*, but the artist destroyed many intermediate stages as he worked, so that there are often large gaps in the documentation of the processes of creation. With few exceptions the different proofs of his graphic work were not preserved, making it virtually impossible to reconstruct the variations produced in a print by the successive printing steps and individual pulls.

Test proofs are rare and are not printing stages in the usual sense – they should be looked on instead as pulls that the artist would examine to decide on changes. Trial proofs document attempts on various qualities of paper, which were extremely important to Matisse because tone, conveyed by the paper, determined the character of the work.

It is the rapid succession of motifs that proves to be of particular value and assistance to an understanding of the compositions. There are series of this kind in the 1906 nude lithographs, during the First World War in the various versions of a portrait (Fanny Galanis, Loulou, or Emma Laforge, for example), then in the 1920s in the sets of nudes in an armchair or of the head with goldfish bowl, and finally in the many portraits in the late work. The graphic work is

thus able to illuminate precious stages and aspects of a work, which demonstrate the artist's real concerns in a striking manner.

Matisse set himself purely graphic objectives in the line drawings, which were often virtuoso. He concentrated exclusively on the power and meaning of line as a medium of limiting form, volume, and space, as a means of decomposing and storing light, and as an indicator of movement. Line became for the artist a highly complex and summarizing method of presentation. When looked at, his works reveal little of this complexity. In what seem to be simple outlines, Matisse traced the essential features of his models and objects, condensed and abstracted forms, suppressed or minimized details, invented others, and, by such means, conjured up his own visual world. Line punctuated his symphonies of color, while the colors in turn gave the line dynamic force and luminosity. For Matisse color and line were independent elements that had to be synthesized. His paper cutouts – compositions designed from cutout shapes of hand-colored paper – stemmed from these conflicts and gave the artist the strength in old age of an innovator and originator in art. "An artist is an explorer. He should begin by searching for himself, seeing himself act. Then show no restraint. Above all do not be easily satisfied," the aged master warned.[2]

Reproducing the figure as such was not a problem for Matisse, unlike the integration of the figure in a specific picture space. "Above all I had to give the impression of vastness in a limited space ... I use a fragment and I lead the spectator by the rhythm, I lead him to follow the movement from the fragment he sees so that he has a feeling of the totality" (F.139). We can feel this picture space extending optically beyond the edge of the print in the smallest etchings, such as his last great work, the wall decorations for the Chapel of the Rosary at Vence. Infinite spaciousness and airy vastness are characteristic of all his works.

Matisse's writings are an indispensable aid to understanding his artistic development but they should be read as the product of a constantly changing creative mind that was attempting to give form to his experiences. That this was often a difficult undertaking was confirmed by his occasional resignation when giving advice to other artists: "he who wants to dedicate himself to painting should start by cutting out his tongue" (F.111). In other words, the work should speak and be judged for itself alone.

Matisse's graphic work, as already mentioned, dealt almost exclusively with the model, a human being. The choice of person for this function – which is known by accounts, photographs, and so-

cial relationships between artist and model – provides a look at the artist's daily life, shows him coming to terms with art, with himself, and his environment, revealing also the artist's need to be stimulated emotionally by his subject matter if it is not to become ossified in a formula. It was perhaps the parade of models that enabled the artist to arrive at the image of an eternally young woman that became a forerunner of today's mannequin.

His work required him continually to objectify the model but it required intuition to no less an extent, an emotional basis, if the pictures were not to lose their life-like quality. Matisse realized that love of the subject matter was the driving force: "My only religion is that of the love of the work to be created, love of creation and of great sincerity" (F.144). He also found this force in the works of the great masters of the past, Rembrandt, Michelangelo, Courbet, or Cézanne. The sensuous radiation of an object, a body, the asymmetry of a face, the harmony of a movement – these were crucial and kept Matisse's creative senses alive.

His models were not made in accordance with the classical idea of beauty, although Matisse proceeded from such archetypes and frequently referred to them. He distorted figures to enhance the expressive power of a picture, making them serve the synthesis of the composition. It becomes a thrilling experience to watch how close he came in his line drawings to producing caricatural features without falling into caricature. Lining up these virtuoso sketches, particularly the variations of faces, produces a film-clip effect as well as increases the dynamic impact of a portrait. The models' poses also contain an inner dynamic, although they may appear to the observer to be resting and static, making him stop and ponder. The fascination that he feels as he looks is attributable not least to the sublimated, sensuous forces that are inherent to the motifs and the composition of the picture. It is for the observer to pick up this "vibrant space," as Matisse called it. "Giving life to a line, an outline, bringing a form into existence; you don't work out how to do that in conventional academies, but outside, in nature, by observing in depth the things that surround it."[3]

This emotionally rooted, sensuous relationship of artist to subject matter led him to pronounce the following words at the end of his life: "I have gained a deep knowledge of my subject. After prolonged work in charcoal, made up of studies which more or less interrelate, flashes of insight arise, which while appearing more or less rough, are the expression of the intimate exchange between the artist and his model. Drawings containing all the subtle observations made during the work arise from a fermentation within, like bubbles in a pond"(F.152).

1 HENRI MATISSE ENGRAVING

(Henri Matisse gravant)

"We didn't have enough to buy a beer." (Henri Matisse, F. 56)

Matisse was certainly a prolific draftsman, but it was not until after 1900, during a period of extreme financial hardship, that he became interested in graphic work. The self-portrait reproduced opposite was the first in the series of engravings in the catalogue raisonné established by his daughter Marguerite Duthuit and grandson Claude. By representing himself in the process of engraving, the artist, who made use of the traditional techniques of etching and drypoint in his earliest attempts, appears to have wanted to imprint his creative will on an uncertain future. Unusual for his work as a whole, four stages of this composition have been retained and show how the artist first drew outlines and then applied dense hatching, before returning light and brightness to the picture by reducing the heavily shaded areas. The example shown here is the final version.

In the self-portrait Matisse is seen looking up questioningly from his work as if someone had interrupted him with his engraving tool in his hand. We are confronted with a young man with prematurely thinning hair and a bearded face showing its first lines. The head and powerful shoulders are worked in fine cross-hatching. An intense, almost magical gaze emerges from behind dark eyebrows and spectacles. The hand and the material he is working on are by contrast sketchily, although precisely, indicated, standing out from the heavily engraved body as bright areas, as if the light is focused on the artist's actual instruments – his engraving tool and his hands. One is reminded of Rembrandt's etched self-portrait of 1648, in which the artist also is depicted looking up from his work table, but better fed, more critical, and self-assured, a mature man fully confident of his objectives. Matisse referred constantly to the great masters, especially when he was familiarizing himself with a new technique. At the time of this self-portrait he had received no public recognition and his art provided no source of income, but his will seemed unshakable. In the engraving energy and determination radiate from the area around the artist's hands, ready to challenge the resistance of his materials.

At the turn of the century Matisse was working with zeal, despite his severe privations that eventually brought on physical exhaustion. Ill health forced him, finally, in 1902 and 1903 to spend some time recuperating in Switzerland, in Villars-sur-Ollon, and at his parents' home in Bohain. "I am immobilized in the country on a strict restorative diet, and hardly working at all," he wrote to his friend and colleague Henri Manguin in 1903, "all because I didn't know how to stop when I should have."[4] Jean Puy, a fellow painter, remembered: "Matisse was working enormously hard at that time: at the Academy in the morning, copies at the Louvre in the afternoon, not to mention sketching sessions from five to seven, as well as sculpture in an evening class."[5]

Matisse continued to work in spite of this period of convalescence, and when artistic problems seemed to be inhibiting the progress of a piece of work, he would try to solve them by using other techniques, thus giving himself breathing space and new encouragement.

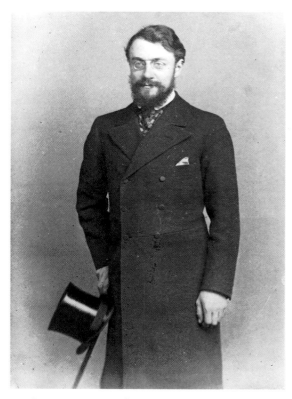

Matisse. c.1900. Photograph. Henri Matisse Archives. Claude Duthuit Collection

1
1900–3. Drypoint, pl.52 D. Fourth stage. 15 × 19.9 cm. 3 test proofs; edition of 30, signed and numbered, on Van Gelder wove paper. Duthuit no.1. Bibliothèque Nationale, Paris

26/30
Henri. Matisse

2 WEEPING WOMAN

(La Pleureuse)

Drawing the nude formed part of the artist's basic training and was the first hurdle that had to be taken in academies and studios. The following two engravings are typical examples of Matisse's work with models in academy classes. Matisse arrived in Paris from Cateau-Cambrésis in 1891–92 in order to study at the Ecole des Beaux-Arts. It was in the studio of Gustave Moreau, however, that the self-willed artist found an instructor from whom he took advice on figure drawing. Moreau must have possessed a strange attraction for young hotheads such as Marquet, Matisse, and Rouault, not particularly because of his work but because of his tolerant and open-minded approach. He knew how to let young artists discover themselves, encouraging them to judge their ideas and creativity in terms of the great masters and to train their own visual powers on everyday subjects.

This important guidance gave Matisse the courage of independent thought and inspired his insatiably inquiring mind. He first liberated his creative genius from the direct influence of others through landscape painting when he spent some time in Brittany in 1896 and especially during stays in the south of France, Toulouse, and Corsica in 1898–99. His sensitivity to color gave him pre-fauvist impulses, which expressed themselves in impetuous patches of color. When he returned to Paris in 1899 he looked again into the possibility of working from models, as though the liberated landscape painting and fiery red interiors had completely eclipsed figure pleuring. It is possible that he himself was shocked by his bold creations, which took him to the outer limits of figurative work and suggested abstraction, the principles of which he had not yet mastered and which his friend Henri Jacques Edouard Evenpoel had described as "exasperated painting by someone who is grinding his teeth."[6]

His teacher Gustave Moreau died in 1899. What Matisse needed now was a quiet working environment, which he found at the Académie Carrière. Jean Puy, his colleague, remembers: "Matisse took great care to balance his figure. He wanted its weight to count exactly where it was needed for the natural movement of the body. So he made abundant use of the plumb rule, and checked his work by taking numerous measurements of the head, height, width, comparing the directions of the lines with each other, some converging, others diverging, all the scientific means which, although they do not amount to genius, allow a painter to achieve a fine plastic power and a strength that satisfies the spectator."[7]

2
1900–3. Drypoint, pl.56bis. 14.9 × 9.8 cm. 10 test proofs; edition of 30, signed and numbered, on Van Gelder wove paper. Duthuit no.7. Private Collection

3 TWO NUDES, TWO CHILDREN'S HEADS

(Deux Nus, deux têtes d'enfants)

At the beginning of the 1900s, Matisse worked like a young student, going back to drawing his models with extreme care and attention to detail. Whenever the artist applied himself to a technique he was unfamiliar with or to a new material, his first attempts were conventional, almost academic in character.

The small nudes shown opposite, which were etched directly on the plate, demonstrate on close examination not only an already practiced hand but also new relationships between outline, volume, and area, which Matisse seemed to be searching for. He probably worked quickly so that he did not lose a momentary overall impression, and he achieved astonishing precision and firmness. The models are said to have changed their pose up to four times in an hour at the academy. Matisse fixed the position of the figure with outlines, using short brisk strokes, independent of any effect of light, thereby increasing its three-dimensionality. Shading surrounds the model and conveys space. These sketches suggest the work in sculpture that was going on at the same time in Antoine Bourdelle's studio. Matisse's contact with sculpture gave him new perceptions of space and volume, and he also examined Cézanne's *Bathers* in detail. He discovered the artist at Ambroise Vollard's, the most enterprising art dealer of the period, in his small shop in Rue Laffitte and spent his last money on, amongst others, a small picture showing three bathers *(The Bathers, 1881–84)*. It became a most important guide: "In the thirty-seven years I have owned this canvas, I have come to know it quite well, I hope, though not entirely; it has sustained me morally in the critical moments of my venture as an artist; I have drawn from it my faith and my perseverance" (F.75), the artist wrote in 1936 to Raymond Escholier, who was then a young curator. In the same year Matisse donated this picture to the French state and it is presently at the Musée du Petit-Palais, Paris.

The model, in this engraving, is standing firmly on the ground, while the two heads of the artist's children, Marguerite and Jean, are just rapid sketches. An early stage of this work without the heads (Duthuit no.5) indicates that they were added later, probably about 1906. Jean was six years old at the time; Marguerite was twelve. A sketch from Collioure,[8] which shows the heads of all the Matisse family, supports this idea.

This small print is an important indicator for the general nature of Matisse's work and introduces major themes: figure and portrait.

3
1900–3. Drypoint, pl.55 B. 15 × 10 cm. 10 test proofs, many on laid paper; edition of 30, signed and numbered, on Van Gelder wove paper. Duthuit no.6. Private Collection

Etat
Henri Matisse

4 TWO WOMEN DRESSED FOR TOWN

(Deux Femmes en costume de ville)

Gustave Moreau advised his students: "Don't be content with going to the museum, go out into the streets"(F.54), and Matisse once commented, "In effect it's there that I learned to draw. I went to the Petit Casino with Marquet....We were trying to draw the silhouettes of passersby, to discipline our line. We were forcing ourselves to discover quickly what was characteristic in a gesture, in an attitude. Didn't Delacroix say 'One should be able to draw a man falling from the sixth floor?'"(F.52).

Many of these "instant" sketches by Albert Marquet remain, but very few by Matisse still exist. "Last year, in a moment of tidiness, I tore up more than two hundred of these attempts, which struck me as useless."[9]

Such rapidly produced pictures occupied the somewhat older nabis (Bonnard, Vuillard, Vallotton), who dominated the artistic avant-garde around the turn of the century, capturing refreshing street scenes on their sketch pads. Whereas for the nabis the movement of a dress or the often ludicrous gestures of figures as they hurried by would become the main theme, Matisse concentrated chiefly on the quality of the material of the dress and accessories, which recalls Renoir more than Bonnard. Matisse's wife Amélie opened a millinery business during this period, on Rue Chateaudun, in order to earn some money for herself, and she may, as a result, have influenced her husband's attentiveness to fashion.

These instant drawings were an indispensable aid to the artist, exercising his powers of observation, and in their quick execution, teaching him to grasp the essential stages of his models' movements. The need here was to capture an initial, basically realistic pictorial impression. Years later, Pierre Courthion described the technique behind this effect: "Matisse erases, starts again, often leaving the outline of the previous drawing showing through. He sometimes rubs with the end of his finger in order to shade the volume softly, then coming back over it with the contrast of his thickly emphasized line."[10]

The trend toward modeling is evident in partly overlayed series of strokes and in the redrawing of certain outlines. Matisse was striving early on for a stable portrayal of the human form: "I might be satisfied with a work done at one sitting, but I would soon tire of it; therefore, I prefer to rework it so that later I may recognize it as representative of my state of mind"(F.36).

4
1900. Drypoint, pl.56 B. 14.9 × 10 cm. 9 test proofs; edition of 25, signed and numbered, on Van Gelder wove paper. Duthuit no.9. Bibliothèque Nationale, Paris. Test proof

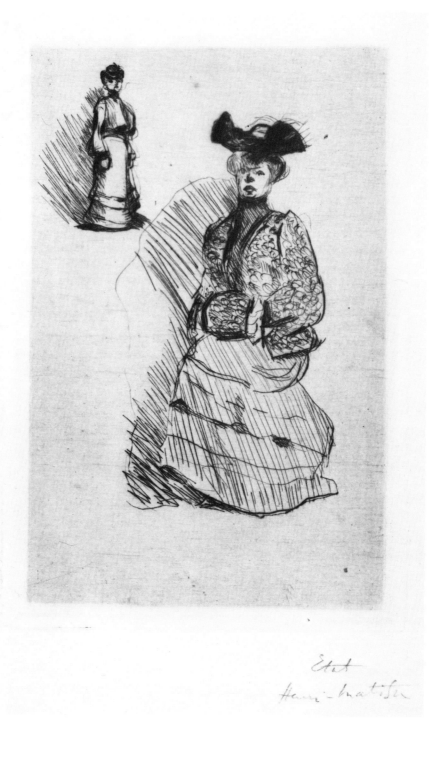

Etat
Henri-Matisse

5 COLLIOURE HARBOR

(Port de Collioure)

If one did not know the artist of this spontaneous sketch of Collioure harbor, one might be tempted to ascribe it to Albert Marquet, Matisse's friend and contemporary. Marquet was a master of this type of rapid drawing and sketched numerous harbor locations. Paul Signac, a passionate sailor, settled in Saint-Tropez at the turn of the century and made young painters aware of the delights of the Mediterranean region, blessed as it is with fair weather. However, in 1905 he admitted that the elements could be precarious even in the Midi and wrote to Matisse: "Our poor painters Marquet, Manguin, and van Rysselberghe are complaining about the unsettled weather. I really cannot see the connection between art and the barometer. On that logic, a country which has constant rain and wind would not have any artists! It seems to me pointless, even dangerous, to fight against nature in that manner. The most rapid type of notation is still the best. It furnishes you with the most varied information, and at the same time, it leaves you freer to create afterward."[11] In his search for more stable working conditions, Matisse stayed in the sunny south every year, at Saint-Tropez in 1904 and from 1905 at Collioure, making his home later in Nice. He appeared to find new vitality in Collioure after the long period of hardship in Paris. The place released the artist's exceptional color sense, as Ajaccio and Toulouse had two years before. Patches of color that had hitherto appeared in isolated sections of pictures like beacons now broke out into an all-enveloping field of mostly prismatic tones. Painting experience gained through neoimpressionism and knowledge of theories of color as well as the fact that Signac was a close neighbor led to highly original compositions in pure spectral colors, which brought Matisse and his colleagues the name fauves following the Paris Salon d'Automne in 1905.

It is not surprising that Matisse, involved in new problems of light and color, rediscovered the landscape and increasingly sketched in the open air and while out walking. He produced spontaneous records of the coastal region with atmospheric moods. He also began to paint in watercolors, as this medium brings out the intensity of light most directly. Cézanne may again have exerted an influence in this domain, yet watercolors remained a rarity in Matisse's work. They ought probably to be seen more as a supplementary form of expression in the struggle for light and color. A watercolor of Collioure harbor exists (now in the Cone Collection at the Baltimore Museum of Art), which comes close to the mood of this sketch, and which the Cone sisters bought from the artist in February 1906. The sketch is thought to have originated in 1907, however, in a very small edition of individual trial prints and may have been used as a test to assess the dark tones with lithographic ink. Matisse appeared here to be reminded of Collioure and in particular of the light that shimmers towards us, conveyed by the very sparing, broken lines and the separated strokes and dots, which seem to vibrate. Signac always stressed that "It is the aim of the neoimpressionist method to capture the maximum color and light."[12] Matisse took this function beyond painting and applied it to drawing, later arriving at solutions that enabled him to create his own pictorial values independent of painting.

5
1907. Lithograph, pl.13. 11.1 × 19.5 cm. A few proofs on white vellum were used as greeting cards. Duthuit no.406. Museum of Modern Art, New York. Given in memory of Leo and Nina Stein. Proof with inscription "hommage à Mademoiselle Stein, Henri Matisse" on beige transfer paper

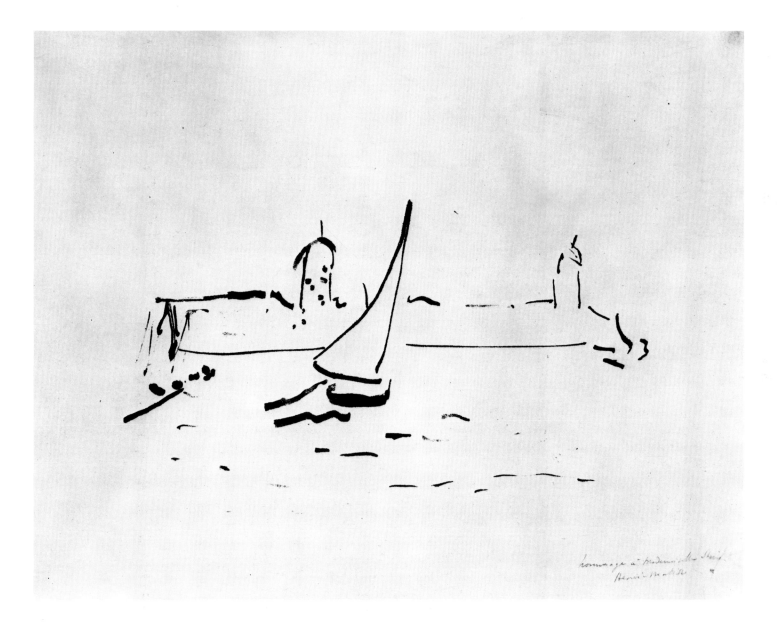

6 LARGE WOODCUT

(Le Grand Bois)

"Forty watercolors, some hundred drawings, and fifteen canvases," Matisse commented in a letter to his friend and teacher Paul Signac on September 14, 1905.[13] This was the output from his summer in Collioure. The number of drawings is surprising and suggests that during his most intensive involvement with expressive, autonomous color values Matisse was also struggling to capture the lines of an object, converting new experience with paint into drawing. He discovered in so doing "the eternal conflict between drawing and color." André Derain, his friend and comrade during these summer months, even talked of a crisis: "This color has put me on the wrong track [*m'a foutu dedans*]. I've lost my old qualities."[14] Never before, perhaps, had Matisse referred so explicitly and confidently to a conflicting relationship between color and drawing: "one, drawing, depends on linear or sculptural plasticity, and the other, painting, depends on colored plasticity."[15] This experience led him anew, in the winter of 1905–6 to study the human figure, a decision which was also spurred on, in part, by the bitter rebuke received at the Salon d'Automne in Paris in 1905.

Matisse produced ink drawings, sometimes with a reed pen, of unusual strength and energy, which were converted into woodcuts. Three wood engravings (Duthuit nos. 317–19) occupy a special place in terms of their expressive power and illustrate the artist's search for new principles of order. During Matisse's summer sojourn in Collioure not only had color become detached from subject matter conquering the entire planar surfaces, but line also had developed an autonomy, permitting it to render space and volume.

It is possible that Matisse had seen Gauguin's woodcuts and referred to van Gogh's drawings. These older artists had been the subjects of commemorative exhibitions after the turn of the century and were frequently discussed. Matisse is said to have even helped with the hanging itself for the van Gogh retrospective in the Salon des Indépendants in 1905 and owned drawings by the artist. Works by Gauguin were also known to him. He had discovered them in Ambroise Vollard's small shop on Rue Laffitte and bought a small picture, *Young Man with Flower*. Furthermore, Matisse was also familiar with Gauguin's pictures and documents in the possession of Georges Daniel de Monfried, who had settled in the south of France. As Gauguin's friend and agent, de Monfried owned Gauguin's latest works from Tahiti, and Maillol – who lived in nearby Banyuls – as well as Derain and Matisse used to call on him. It is clear that Gauguin's works from Tahiti gave Matisse the impetus for his great composition *Joie de vivre* (1906–7, now in the Barnes Foundation, Merion, Pennsylvania). His woodcuts were conceived in the same spirit.

The two-dimensional portrayal of the model opposite, in a deck chair, shows how between 1905 and 1906 Matisse discovered a completely new type of picture that put the entire composition on the same plane, in which he conveyed model and background dynamically and expressively with equivalent lines, unafraid to create distortions. Matisse had liberated himself from academic constraints and was now standing on the threshold of an independent form of artistic creativity whose impulses stemmed from the immediate present as never before, pressing forward toward monumental forms. He declared in 1908 in his *Notes of a Painter* that "There are two ways of expressing things; one is to show them crudely, the other is to evoke them through art. By removing oneself from the literal *representation* of movement one attains greater beauty and grandeur" (F. 37).

6
1906. Woodcut. 47.5 × 38.1 cm. 1 trial proof; edition of 50, signed and numbered with monogram in the wood, on Van Gelder wove paper. Duthuit no. 317. Private Collection

7 SMALL LIGHT WOODCUT
(Petit Bois clair)

Matisse's woodcuts are evidence of the ongoing conflict in his work between color and line, between a pictorial approach and sculptural body outlines. Matisse tried all methods in order to extract from an instant impression a lasting ideal image: "a truer, more essential character, which the artist will seize so that he may give to reality a more lasting interpretation" (F. 37). The artist seemed further to underline this search for permanence in graphic representation with laborious incisions in wood, an act of will that revealed plainly his determination. In the woodcut opposite form and pose of the model are rendered in thick outlines, the angular turns and variable density of which convey the resistance of the material worked. The figure is set against a decorative pattern of dots that are spread over the whole surface of the picture, evoking the painterly effects reminiscent of fauvist compositions. The contrast of the unpatterned surface of the body with the patterned background gives the model a bright substantiality which Matisse achieved in earlier versions by shading. The monumentality of the works is due also to the proximity of the model to the artist.

Matisse was clearly aware how important these prints were to understanding and interpreting his new artistic conceptions. They are found in the context of the composition *Joie de vivre* which was also produced during the winter of 1905–6 and which he exhibited in the Salon des Indépendants in Paris in March. The woodcuts were displayed at that time in a show at the Galerie Druet from March, 19 to April, 7. It was the first comprehensive show since Ambroise Vollard exhibited a few works to the French public in his little gallery on Rue Laffitte in 1904. The artist came up against criticism and rejection, as he had with his fauve pictures in the fall of 1905.

He fared no better with *Joie de vivre,* and Signac, who had until then been full of praise for his pupil, was bitterly disappointed: "Matisse, whose attempts I have liked up to now, seems to me to have gone to the dogs. Upon a canvas of two-and-a-half meters, he has surrounded some strange characters with a line as thick as your thumb. Then he has covered the whole thing with flat, well-defined tints that – however pure – seem disgusting..."[16]

It seemed impossible, however, that even a progressive public could digest the figures, contained in simple, summary outlines, and landscapes that consisted only of areas of color. Even so, the work was bought by the pioneering American collector of avant-garde art, Leo Stein, whose purchases in art unsettled the Parisian public. His apartment on Rue de Fleurus – he lived at the time with his sister Gertrude Stein – became the meeting place of an intellec-

tual elite with avant-garde interests. For Matisse this acquisition by a known collector meant recognition, support, and his first payment – exactly what an artist needs if he is not to lose courage and belief in himself.

7
1906. Woodcut. 34.2 × 26.6 cm. 2 trial proofs; edition of 50, signed and numbered with monogram in the wood, on Van Gelder wove paper. Duthuit no.318. Bibliothèque Nationale, Paris

48/50
Henri Matisse

8 NUDE CROUCHING, PROFILE WITH BLACK HAIR

(Nu accroupi, profil à la chevelure noire)

"The simplest means are those which best enable an artist to express himself. If he fears the banal he cannot avoid it by appearing strange, or going in for bizarre drawing and eccentric color. His means of expression must derive almost of necessity from his temperament. He must have the humility of mind to believe that he has painted only what he has seen" (F.39). These are the words of Matisse in his *Notes of a Painter* in 1908. At this time he began to teach not only a large number of young, international artists (first in the Couvent des Oiseaux on Rue de Sèvres and then in rooms in the Hôtel Biron), but he also felt the need, after all the public hostility, to share his reflections and experiences of art with a wider audience. This led to *Notes of a Painter,* a series of valuable ideas that show how greatly Matisse was struggling for a new language of form. Georges Desvallières commented on the artist's contribution: "You have to admit after reading and examining the drawings, whatever reservations one might have about this artist, that he has helped through his investigations developments in our means of plastic expression... In a word, the architecture that Matisse has constructed with these disproportionate fragments is a solid architecture in which all the proportions are true, even though the figure it represents does not give the impression of nature as we normally see it."[17]

In the spring of 1906 Matisse, in parallel with his work in wood-cut, turned to lithography for the first time. Already a popular artistic medium, lithography had reached new heights with Toulouse-Lautrec and the Nabis. In a series of twelve prints of equal size, the artist depicted various poses and expressions of the same Italian model, Rosa Arpino, in simple outlines. He had the drawings printed on beautiful, cream-colored Japan paper at the Imprimerie Auguste Clot, which was much-used by artists at the time. An artist had never before dared to produce such sketch-like studies. They show the "banality" and "naivety" mentioned before, and the model's ever-changing pose is given as the artist sees it. If we translate the French *Nu accroupi* in the title by "crouching," the actual position of the model in our illustration is not clear, for she appears to be in a sitting position, rather than a crouching one, on the edge of an unseen support. In other words Matisse leaves out parts of the picture that are necessary for understanding. He concentrates completely on the rhythm of the model's form in spontaneous poses. This provides the viewer an unusual insight into Matisse's creative process, which he related in *Notes of a Painter:* "I want to reach that state of condensation of sensations which makes a paint-

ing" (F.36). However, he needed studies done "at one sitting" in order to achieve this "condensation of sensations." He even had these sketches printed. The lithographic printing process clearly helped him to achieve an abstraction and distance from his own creations, establishing a kind of yardstick for comparison. This process also made him better able to assess the autonomous pictorial power of simple line drawings, which showed the female body free of embellishment.

8
1906. Lithograph, pl.3. 39.5 × 21.5 cm. Edition of 25, signed and numbered with monogram on the plate, on Japan paper. Duthuit no.395. Private Collection

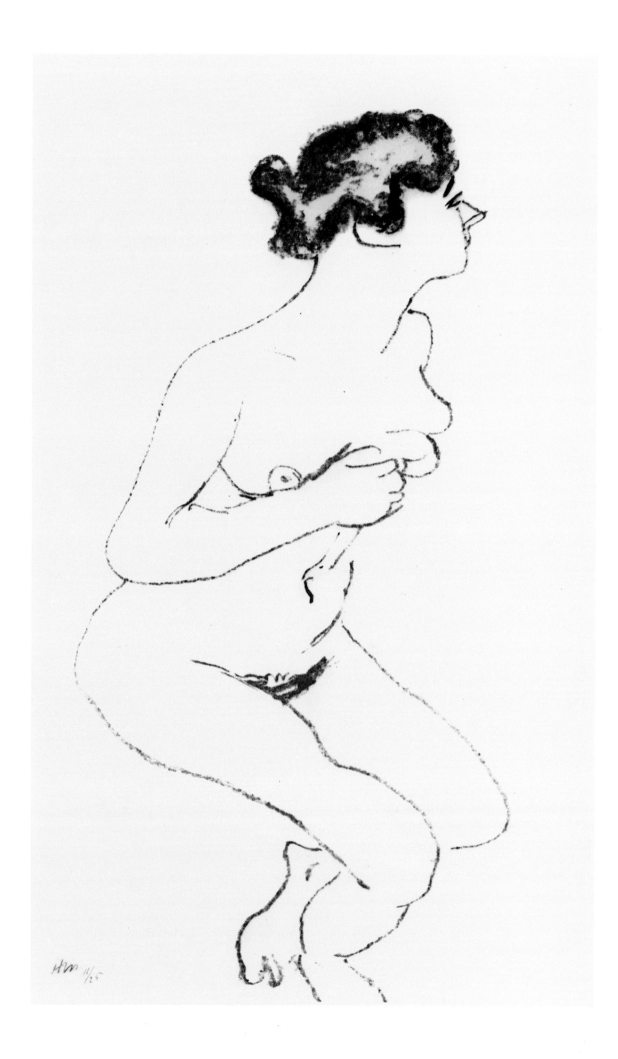

9 FIGURE FROM THE BACK WITH BLACK NECKLACE

(Figure de dos au collier noir)

It is not surprising that the lithographs produced in 1906 scandalized the public when they were shown five years before the Armory Show, the trailblazing avant-garde exhibition at the photographer Alfred Stieglitz's small gallery at 291 Fifth Avenue in New York, *An Exhibition of Drawings, Lithographs, Watercolours and Etchings by M. Henry Matisse* at the Little Galleries of the Photo-Secession, April 6–25, 1908. It was the first Matisse exhibition in America and, as Alfred Barr commented, "in fact the first one-man show outside of Paris."[18]

Edward Steichen, a photographer and a guest at the Steins' in Paris, initiated the exhibition. He wrote to Stieglitz: "I have another cracker-jack exhibition for you that is going to be as fine in its way as the Rodins are. Drawings by Henry Matisse the most modern of the moderns ... they are to the figure what the Cézannes are to the landscape. Simply great. Some are more finished than Rodin's, more of a study of form than movement – abstract to the limit."[19]

The criticism was devastating. It referred to "female figures that are of an ugliness that is most appalling and haunting and that seems to condemn this man's brain to the limbo of artistic degeneration" and to "gothic fancy for the ugly and distorted ... caricatures without significance." But there was also the following comment: "The French painter is clever, diabolically clever. Lured by the neoimpressionists, by Gauguin's South Sea sketches, he has outdone them all by his extravagances."[20] No one was able to find any genius in these apparently formless studies of models, despite the fact that Matisse had been introduced to the American public as an avant-garde leader and that isolated voices of recognition were becoming heard.

Edward Steichen made clear that Matisse's prints were not studies in movement and did not, like Rodin's, capture extreme, delicately balanced elements of movement. They remained all the more difficult to understand in that they were neither studies of a milieu, as in the work of Toulouse-Lautrec, nor caricatures in the style of Daumier. Matisse wanted to avoid all literary, illustrative content: "A work of art must carry within itself its complete significance and impose that upon the beholder even before he recognizes the subject matter" (F. 38).

9
1906. Lithograph, pl.8. 41 × 27.5 cm. Edition of 25, signed and numbered with monogram on the plate, on Japan paper. Duthuit no.397. Baltimore Museum of Art. Cone Collection

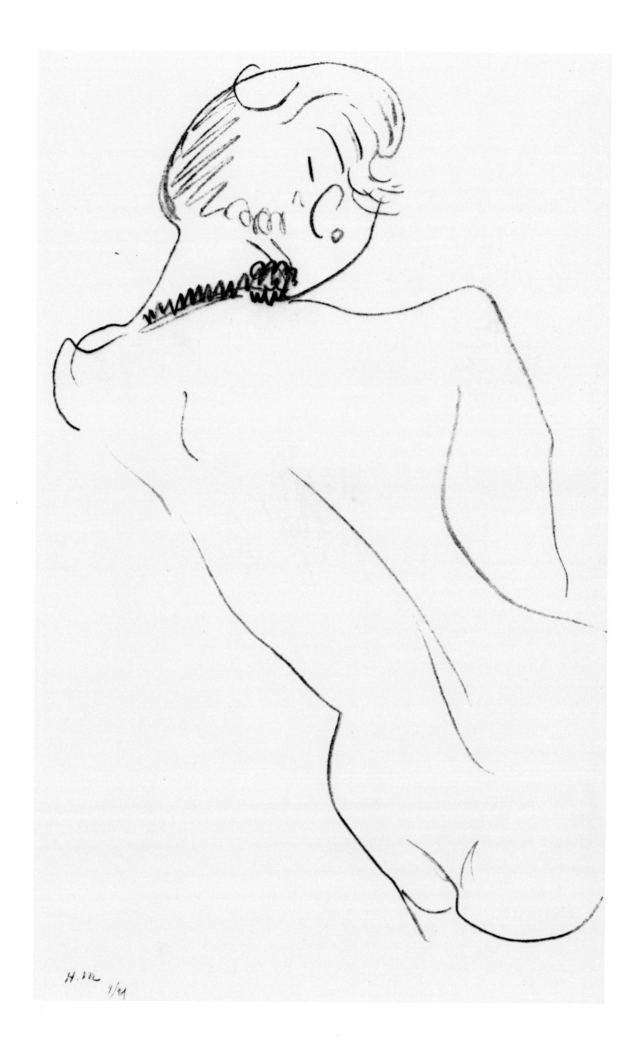

10 UPSIDE-DOWN HEAD

(Tête renversée)

Matisse's predilection for drawing the human figure stemmed from his profound awe before the mystery of human life. He was concerned not with producing a replica of a face but with depicting its human quality: "I do not insist upon all the details of the face, on setting them down one-by-one with anatomical exactitude. If I have an Italian model who at first appearance suggests nothing but a purely animal existence, I nevertheless discover the essential qualities, I penetrate amid the lines of the face those which suggest the deep gravity which persists in every human being" (F.38).

Thanks to his improved circumstances, Matisse worked regularly with professional models after 1905–6. It was an Italian model, Rosa Arpino, who prompted him to produce the series of massive lithographs of which there remain three close-up views of her head – one with her eyes closed, the example here with laughing, open eyes, and finally a head and shoulders with a thoughtful expression (Duthuit nos. 390, 397, 400). As never before, the artist found in the formal vocabulary of the female body expressive and sensually brutal features, which he reduced to a few dynamic lines; he thus brought to the highly suggestive nakedness of the model, which filled the page, a raw vividness. The secret of his art resides in this condensation, in the absolute honesty of his pictorial interpretations. Matisse was well served in the process by the habit he had acquired of making fleeting sketches of people on Paris's streets and squares at the beginning of the century, which had developed his ability to note down freely, yet precisely, the poses and forms he observed.

In the lithograph illustrated, Matisse was exploring his way around the facial features for the first time, not as a portrait, however, but as a part of the human figure, in harmony, in terms of form and expression, with the physical structure of the model. In order to do this, the artist resorted to artifice: he turned around the normal position of the head, which distanced him from the subject matter, facilitating his search for the essential features of the face.

Close-up studies of heads were familiar from the time of the nabis (Bonnard, Vuillard, and Vallotton), and no longer represented anything shocking to the informed eye. Yet this monumental view of a thrown-back head with a laughing, challenging look trained on the observer, was unusual. In the swinging lines of the hair, eyebrows, nose-mouth-chin, shoulders, and breasts, Matisse found a recurring rhythmic curve motif, which covered the whole surface of the paper decoratively.

10
1906. Lithograph, pl.5. 28 × 27.5 cm. Edition of 25, signed and numbered with monogram on the plate, on Japan paper. Duthuit no.397. Baltimore Museum of Art. Cone Collection

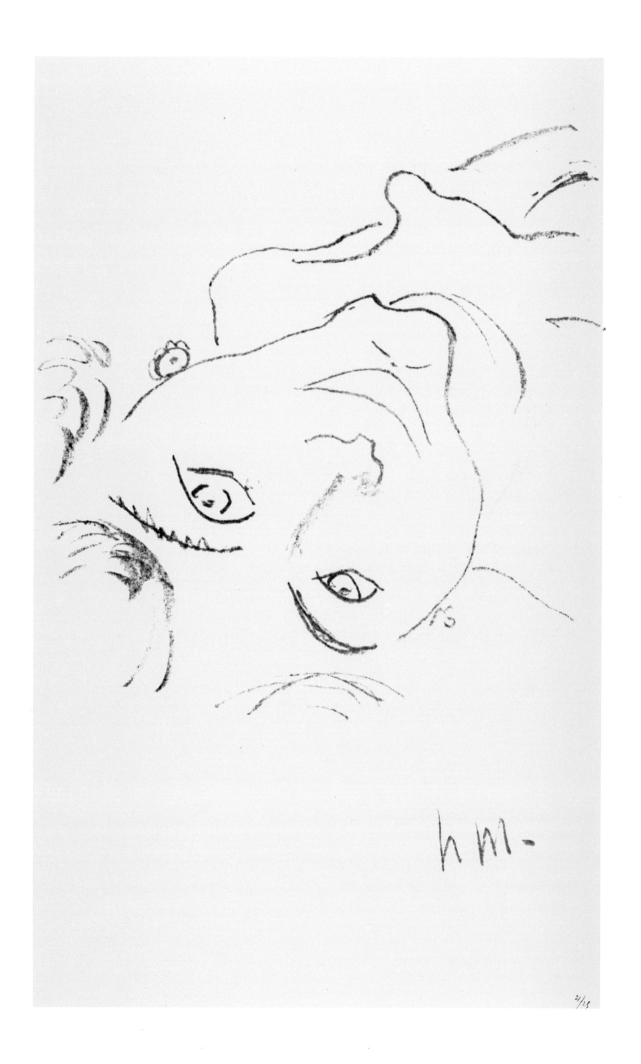

11 LARGE NUDE

(Le Grand Nu)

Unlike the previous series of lithographs, the unusual work shown opposite was printed on transparent China paper and has the character of a pencil drawing. It was generally assumed in studies that it originated somewhat later than the series, in close association with the first cubist works of Picasso and Braque. The catalogue of Matisse's work, however, sets its date at the same year, 1906, pointing out that it was drawn directly onto the litho stone. The original edition number cannot be ascertained with certainty but could be either Pl. 10 or Pl. 29 (i.e. it could have been either from 1906 or 1913).

This print, which is atypical in every way, gives rise to problems. The artist has shaped blocks of volume in graduated gray tones, hardened the outlines, and created space with areas of hatching along the line of the body. The extremities and the personal features of the face, apart from the thin line of the mouth, are not indicated – similar to his *Bathers with Tortoise* (1908; City Art Museum, St Louis). The line of the shoulder and neck runs straight, without indentation; the place where the arm begins is flat, the elbows at right angles; the two globular breasts are set high up, and the supple buttocks and thighs are formed from gently flowing lines. These characteristics can also be seen in the *Bathers with Tortoise* and in the works from 1907–8.

The model's pose recalls Degas' sculpture *Woman in Tub* (1886) and shows the parts of the body in a surprisingly abstract form which suggests later works on the theme of the "Faun and Nymph." Matisse approached this theme for the first time in the ceramic triptych that he produced in 1907–8 for his great German collector Carl Ernst Osthaus in Hagen. Like many artists, Matisse worked in André Méthey's ceramic studio during this period. The art dealer Ambroise Vollard encouraged young artists to become involved not only in book illustrations and printing but also with sculpture and ceramics. Matisse thus discovered that a change of artistic medium could prove extremely beneficial, since temporary blocks in the often laborious process of creating a work of art could thereby be freed and new insights gained.

In a recent study John Hallmark Neff suggested that this lithograph was first mentioned in the catalogue of the Galerie Bernheim-Jeune in Paris: "the always problematic *Large Nude* lithograph is listed not from 1906, but from the year preceding the catalogue, 1913."[21] He puts the print in the stylistic context of the large picture *Young Girls by the River,* now at the Art Institute of Chicago and the last work commissioned by the Russian collector

Sergei Shchukin before the First World War but which never reached its destination. It is difficult to judge whether the unusual *Large Nude* was reworked. It remains proof, however, of the artist's impressive aptitude for abstraction, which would continue to assert itself in the works from 1906–7 on.

11
1906. Lithograph, pl.10 or 29. 28.5 × 25.3 cm. 1 trial proof; edition of 50, signed and numbered, on China paper. Duthuit no.403. Private Collection

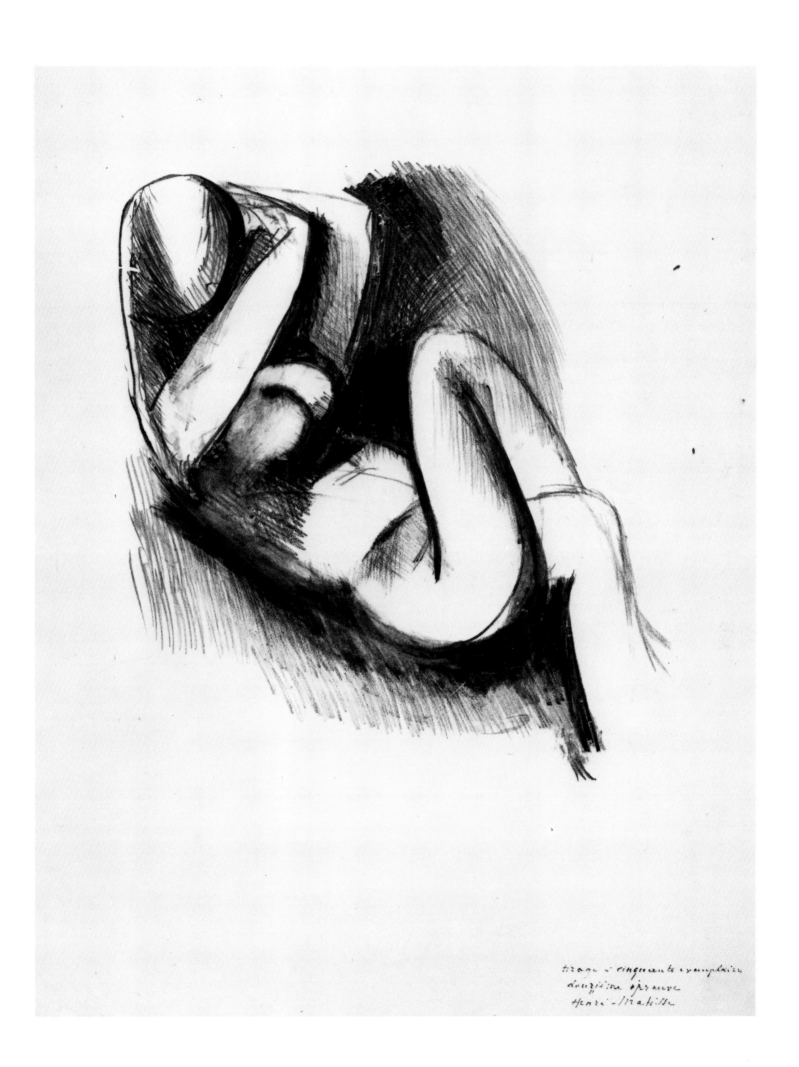

tirage à cinquante exemplaires
douzième épreuve
Henri-Matisse

12 FACE WITH BANGS

(Visage à la frange)

In 1913 Matisse caused another stir with a series of eight bold line lithographs. Like the 1906 lithographs, these works all have the female figure as their subject matter, are in portrait format, and were printed on Japan paper.

The artist's life – he was now forty-four years old – had changed. A large section of the public, admittedly, still attacked his work, but Matisse's many *succès de scandale* at international exhibitions and early one-man shows abroad – in Berlin in 1908–9 and New York in 1908, 1910, and 1912 – attracted international buyers. These collectors were chiefly Americans, such as the Steins, and Etta and Claribel Cone, from Baltimore, but also included European industrialists such as the Russians Sergei Shchukin and Ivan Morosov, as well as Carl Ernst Osthaus from Germany, and Christian Tetzen-Lund from Denmark, who began to buy the latest in modern art in Paris in previously unheard of quantities. Matisse, having received his first large commissions, bought a house outside Paris in 1909 in Issy-les-Moulineaux to which he added his studio. "The studio, a good-sized square structure, was painted white, within and without, and had immense windows (both in the roof and at the side), thus giving a sense of out-of-doors and great heat. A large simple workroom it was, its walls and easels covered with his large, brilliant, and extraordinary canvases" (F.50), was the description given by the American Clara MacChesney in 1912 after interviewing the artist. Here Matisse was able to execute his large-sized commissions and paint the larger-than-life figures *(Dance* and *Music)* for Shchukin's rococo palace. His vast studio also allowed him to observe variations in colors as the light changed.

This expansive, large-scale art is echoed in the lithographs of 1913. These consist mainly of extreme close-ups of a face or torso and have monumental expressive power, which apparently were rapidly produced and without visible revision. Matisse worked from the model, in this case Germaine Raynal, wife of the art critic Maurice Raynal, a friend of Juan Gris who was particularly well-known in cubist circles. Matisse sketched the shape of the head and the facial features with astonishing virtuosity, the sweeping lines of the neck and shoulders giving the head a peculiar tilt and turn, continuing the rhythmic form of the hair and chin. Highly economical lines and groups of strokes create a serene likeness reminiscent of ancient portraits. "In the antique, all the parts have been equally considered. The result is unity, and repose of the spirit" (F.42), the artist declared to his pupils. Sarah Stein, who was among the early collectors of Matisse, was also part of the circle of students at the short-lived Académie Matisse, and she noted down the artist's advice and criticism in 1908. These notes provide valuable insights into aesthetic and methodological questions connected with Matisse's craft as well as details of his personal experiences with his art. Many of the concepts that are found in these notes – such as those concerning the role of line, its richness and diversity – run like leitmotifs through the artist's entire graphic work. "One must always search for the desire of the line, where it wishes to enter or where to die away. Also always be sure of its source; this must be done from the model. To feel a central line in the direction of the general movement of the body and build about that is a great aid" (F.43). This dynamic interpretation of line is clear in *Face with Bangs,* and we can see why Matisse gave his pupils these comparisons: "In the antique, the head is a ball upon which the features are delineated. These eyebrows are like the wings of a butterfly preparing for flight" (F.42).

Germaine Raynal. Photograph. Kahnweiler-Leiris Archives

12
1913. Lithograph, pl.20. 46.5 × 29.5 cm. 5 test proofs; edition of 50, signed and numbered with monogram on the plate, on Japan paper. Duthuit no.413. Private Collection

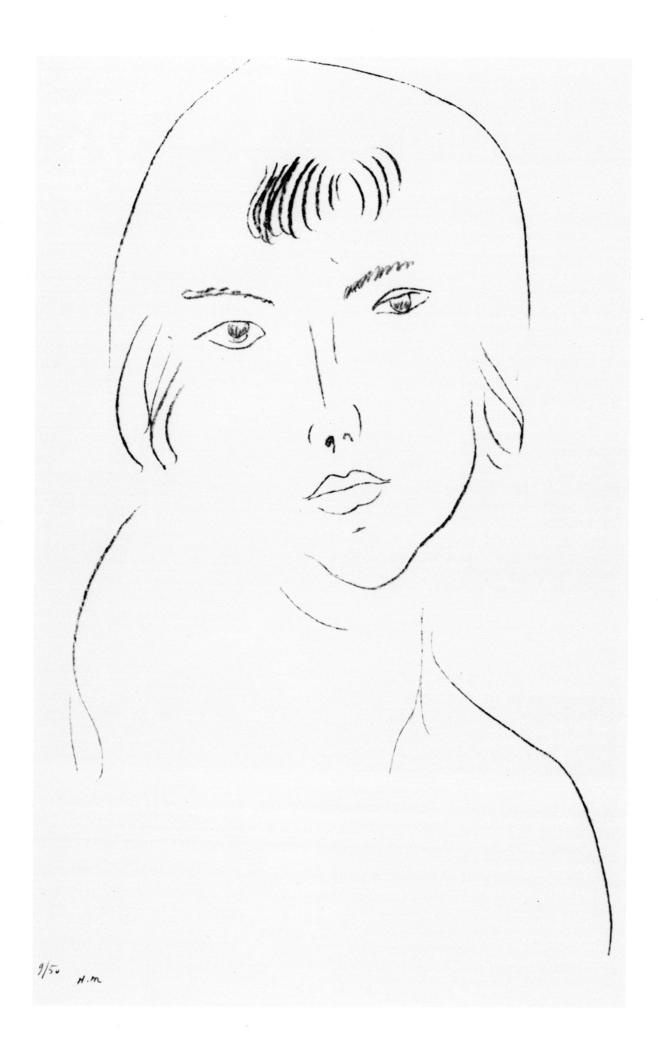

9/50 H.M

13 THREE-QUARTER VIEW OF NUDE WITH PART OF HEAD MISSING

(Nu de trois quarts, une partie de la tête coupée)

"This pelvis fits into the thighs and suggests an amphora. Fit your parts into one another and build up your figure as a carpenter does a house. Everything must be constructed – built up of parts that make a unit: a tree like a human body, a human body like a cathedral. To one's work one must bring knowledge, much contemplation of the model or other subject, and the imagination to enrich what one sees. Close your eyes and hold the vision, and then do the work with your own sensibility" (F. 42–43).

This advice from the master to his pupils, seemingly simple, was difficult to follow as it was related too closely to Matisse's own creative strengths. "Proportions according to correct measurement are after all but very little unless confirmed by sentiment, and expressive of the particular physical character of the model," Matisse warned, also saying "I do not say that you should not exaggerate, but I do say that your exaggeration should be in accordance with the character of the model" (F. 43). All these statements were based on the artist's experience and reveal the subtle and often intuitive work with a model. Although Matisse gave lessons and was therefore forced to formulate creative problems, he quickly realized that he was not able to pass on his ideal principles of art. In an interview in 1909 he had talked about the "state of condensation that makes the painting" (F. 36), but how was it possible for an artist to teach the condensation of sensations when he himself had to struggle for it daily and to draw it constantly from his model? Matisse gave up teaching completely after 1911, partly in order to catch up with his accumulating commissions and partly to concentrate his energy on the art that he wrestled tirelessly from his hands and senses. He must have possessed an inexhaustible energy for work, and it is not surprising that after breaking into landscape painting in the winter months of 1911–12 and 1912–13 in Tangiers, he devoted himself again to the study of the human form, "the source of my energy."[22] Oddly enough, few figure drawings were produced between 1909 and 1913. Painting and sculpture clearly claimed his full creative intensity. During his second period in Tangiers in the winter of 1912–13 Matisse searched desperately for the same model who had worked for him the year before in order to spare himself a new, laborious process of familiarization. His painter friend Charles Camoin relates: "At Tangiers I worked at the same time as he from several prostitutes,"[23] but these drawings have not survived. On September 15, Matisse wrote to Camoin: "At the moment I am tired and ought to drive all worries from my mind. Yet I've worked at little this summer." He then went on to list his large relief *Back II, Bathers,* and *Portrait of My Wife,* which is presently in Leningrad. The lithograph drawings from the same period appear, however, to testify to new, concentrated, but also relaxed impulses. Matisse discovered an unusually easy, flowing, and monumental form of line drawing that would have been inconceivable to the same extent without his large-format paintings, his outlined sketches, and the expansion of his repertoire of forms. "I will condense the meaning of this body by seeking its essential lines" (F. 36). Matisse succeeded masterfully.

13
1913. Lithograph, pl.15. 50.1 × 30.3 cm. 2 test proofs; 3 trial proofs; edition of 50, signed and numbered with monogram on the plate, on Japan paper. Duthuit no.409. Private Collection

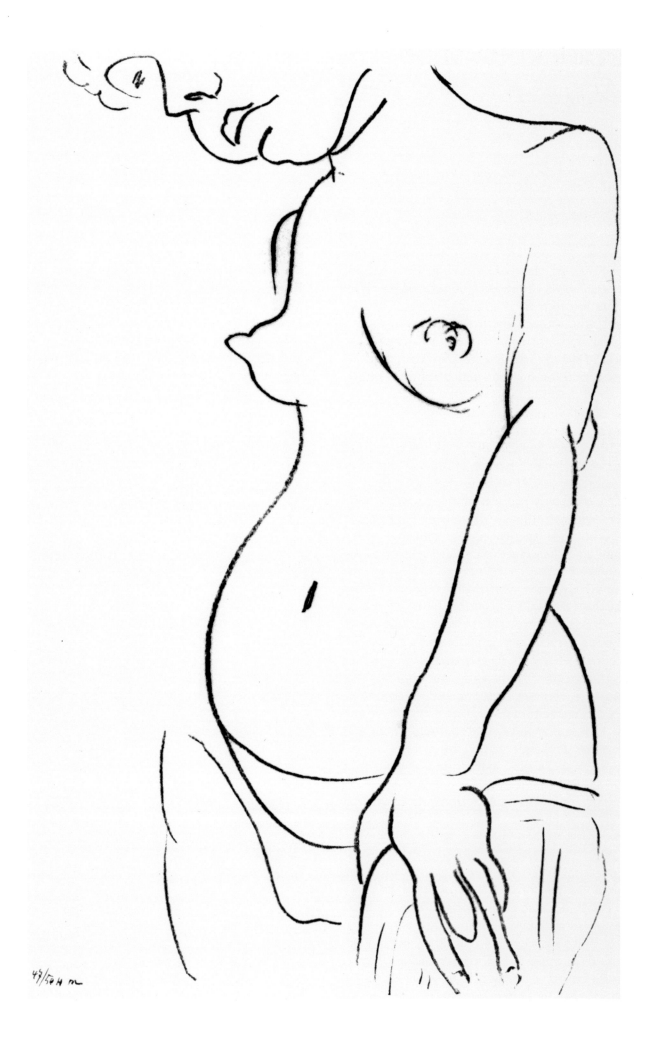

47/50 H m

14 NUDE IN ROCKING CHAIR

(Nu au rocking chair)

The round lines of the rocking chair harmonizing with the forward-leaning position and curves of the model doubtless provided Matisse with the inspiration for this lithograph. The model was again Germaine Raynal, who was also the artist's model in a series of etchings and in a striking oil painting done in shades of gray, *Gray Nude with Bracelet* (1913), which gave the artist renewed impetus through a variety of techniques to attempt the great theme of the seated nude.

The identity of the model was not known, understandably, for a long time. It is known today, however, that Maurice Raynal, her husband, was plagued by severe financial difficulties during these years: "At the age of twenty Raynal, having in one year spent an inheritance that was considerable for that time, had seen his means of subsistence cut off by his family and was plunged into extreme poverty," Alice Halicka, the wife of Louis Marcoussis, relates in her memoires.[24] Matisse, who had experienced the same difficulties himself, helped out and paid the beautiful model well, as was his custom.

Figure drawings in outline are the basis of all the versions of the same subject and illustrate Matisse's virtuosity. It is rare in the artist's work to find a model smiling. He strove constantly for a more convincing rendering of the subject, to "obtain greater stability" or to seize the essential character of the human face, as he wrote in his *Notes of a Painter* in 1908. "Expression, for me, does not reside in passions glowing in a human face or manifested by violent movement. The entire arrangement of my picture is expressive: the place occupied by the figures, the empty spaces around them, the proportions, everything has its share" (F. 36).

In this illustration the model's facial expression is spontaneous and caught at a given moment, indicating that in Matisse's work drawing can contain different creative stages from those involved in painting and that it is closer to the immediate, visually experienced moment. Works such as these are better described as studies of models — not in the sense of preliminary drawings for major compositions but in Matisse's sense of getting to know the subject matter. He seeks out the form of the model on the paper with his eyes and his pen, but at the same time his practiced hand adapts and interprets this form according to his inspiration or his concept of the picture. This produces an autonomous work of art. While the other prints from this series of lithographs deal exclusively with nudes and fragments of nudes, here information on the surrounding space is also given, in the details of the lines of the floor and the latticework pattern of the back of the chair. The portrayal thus gains greater vividness, partly from the formal interplay of nude and chair and partly from the motif of the chair back, which gives the impression not only of space but also of dynamic movement: in effect, the tension between the inclined back of the chair and the forward-leaning figure in front creates a rocking motion that animates the entire composition.

14
1913. Lithograph, , pl.17. 48.1 × 27.2 cm. 5 test proofs; edition of 50, signed and numbered with monogram on the plate, on Japan paper, Duthuit no.410. Bibliothèque Nationale, Paris

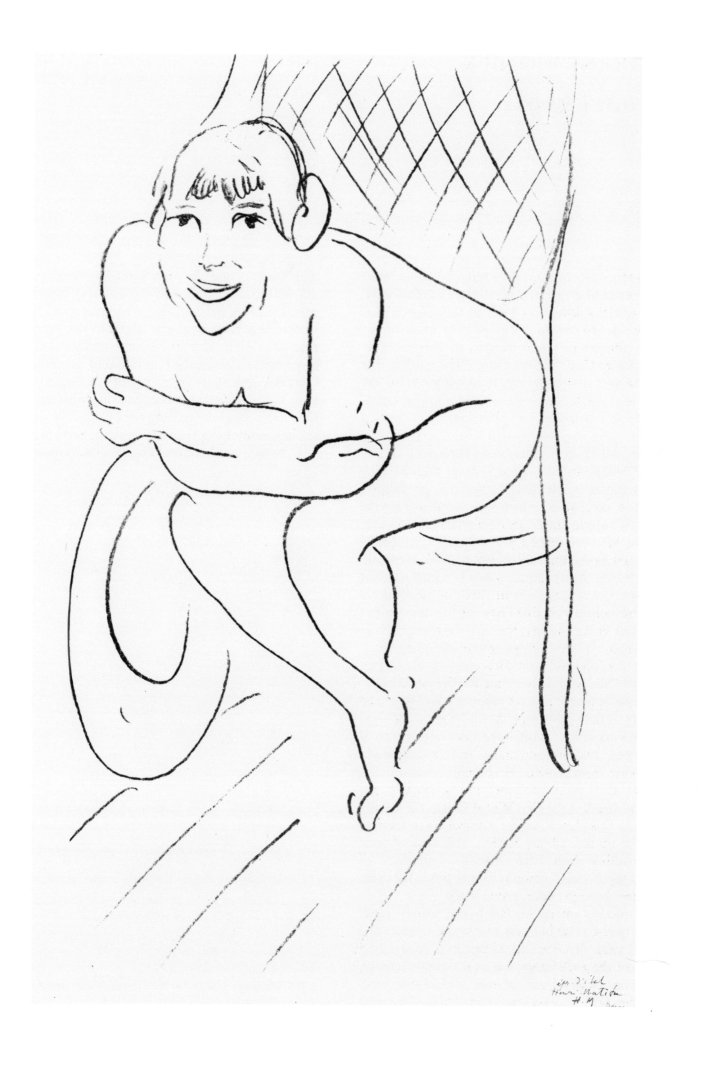

15 LARGE IRENE VIGNIER

(Grande Irène Vignier)

Matisse spent the winter of 1912–13 in the south (Collioure, Marseilles, Tangiers) in order to escape the gray mist that enshrouds Paris, making these months damp and cold. In the fall of 1913, however, the artist decided to remain in the city. The harvest from his work during the summer had been meager. In November he wrote to his friend Charles Camoin from Paris: "The truth is that painting is something very disappointing. It so happens that my picture (the portrait of my wife) has some success among progressive people. But it doesn't satisfy me; it is the start of a laborious effort."[25]

He was clearly faced with a creative problem. He seemed on one hand to be exhausted by the enormous effort that the great Russian commissions and his vocation cost him, but increasingly frenetic cultural activity during these years, which was stimulated by the new theories based on cubism, must also have had a paralyzing effect. In the autumn Matisse rented a studio at 19 Quai Saint-Michel in Paris, the same house that he had left in 1909. He wrote to Camoin again: "It will probably surprise you when I tell you that I've made plans to spend a few months in Paris, by subletting a studio in Montparnasse, considering that I have to do some concentrated work for the time being and that the trip, the change of climate, and the excitement of new things, where the picturesque strikes one first before anything else, would lead me to diversify, [so] that the excitement of Paris would satisfy me for the moment."[26]

By this move Matisse appeared to have taken stock of where he actually was in his artistic development. His retirement to the tranquility of a new studio marked, as is often the case in situations of self-discovery, a renewed concentration on the surrounding world and a return to drawing from models. He bought a small hand-operated printing press and immersed himself in working with the etching needle. The outbreak of the First World War in the following year did not disturb this plan as, unlike many of his colleagues, Matisse was not called up for military service. This time of great political tension, together with what Matisse complained of frequently as "the sad sky of Paris," could at least be put in the background to some degree through concentrated work.

Matisse found his models among his family and friends. Little Irène Vignier, about twelve years old, was a welcome subject. The artist's son, Pierre Matisse, describes her as being of outstanding beauty. Charles Vignier, the girl's father, was an antique dealer with a particular interest in Oriental art. Matisse etched the well-balanced features of the child's face on several small plates, one with dark shading, one like a mask in a few lines, always serious, imposing, and absorbed. The etching probably came after the Ingres-like pencil drawing that is today in the Baltimore Museum of Art. The picture illustrated here, the largest of the series, is a small masterpiece of subtlety. Dot-like leaves reminiscent of snowflakes in Japanese prints heighten the impression of lightness, reminding us that Charles Vignier was a great Japanese art expert and had a collection that Matisse must have been familiar with. In creating this work, the artist moved the etching needle carefully over the plate in short strokes, something that can easily be seen in the slightly halting lines, bringing out the budding facial features of the adolescent girl.

15
1914. Etching, pl.2. 17.9 × 12.9 cm. 1 test proof; edition of 15, signed and numbered, on laid paper. Duthuit no.19. Private Collection

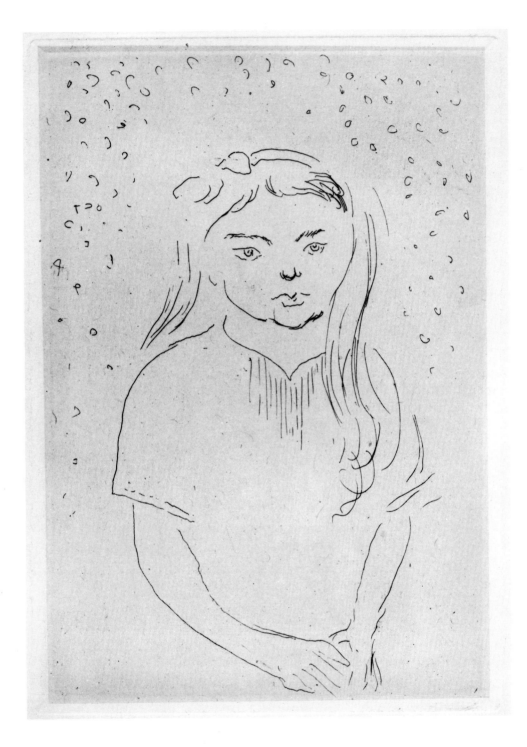

16 DOUBLE PORTRAIT OF JOSETTE GRIS

(Double portrait de Josette Gris)

In September 1914 the Matisse family traveled to the south of France, reaching Collioure on September 10. There they met Juan and Josette Gris. A rewarding friendship grew up between the two families based on a rich exchange of ideas drawn from artistic experiences which led to reformulating cubist theories of art. Gris wrote to the art dealer Daniel Henry Kahnweiler: "I see Matisse a lot.... We talk about painting voraciously while Marquet listens while dragging his feet..."[24]

Juan Gris lived in circumstances of great deprivation, was already ill, and was forced by the war to do without material support from Kahnweiler. Matisse helped him with a monthly salary, aided by Gertrude Stein, and he also engaged Josette for portrait sittings, which helped the couple overcome the worst of their problems. Matisse always paid his models well and he took the opportunity to draw the wives – for example Mme. Derain, Mme. Galanis, and Emma Laforge – of artist friends who were on military service. He produced seven small etchings of Josette Gris. In spite of her summer attire in these prints, the etchings were probably made in Paris, after she returned in October. Matisse liked to have his models pose in clothes that harmonized with his aesthetic ideas. Josette's sailor collar was well suited to her fine, narrow face and her pinned-up hair with its impish bangs. She was young and slim and had striking eyes that reflected the seriousness of the situation and her daily worries. Juan Gris confessed: "I sometimes wonder if the need to eat will not force me to become involved in a war to which neither my nationality, my character, nor my ideas call me. For all of us who have a path sketched out in life it means changing everything temporarily and becoming I don't know what. Because I know, my dear friend, that in this nightmare that we are all going through no previous commitment can count and that we have to manage. How I do not know."[28] The war was wearing down morale, yet everyone tried to help each other. Dark, earthy colors and shades of black found their way onto Matisse's palette, and his paintings became highly abstract (for example, *The Yellow Curtain,* 1914–15; *The Painter and His Model,* 1917), spurred on by the influence of Juan Gris and his cubist circles. The etchings, however, were barely affected by this trend and remained rooted in the direct relationship with the model, particularly with the portrait.

Josette Gris in the studio of her husband Juan Gris at Bateau-Lavoir. 1914. Kahnweiler-Leiris Archives

16
1915. Etching, pl.32. 13.1 × 18.1 cm. 2 trial proofs; edition of 15, signed and numbered, on laid paper. Duthuit no.64. Private Collection

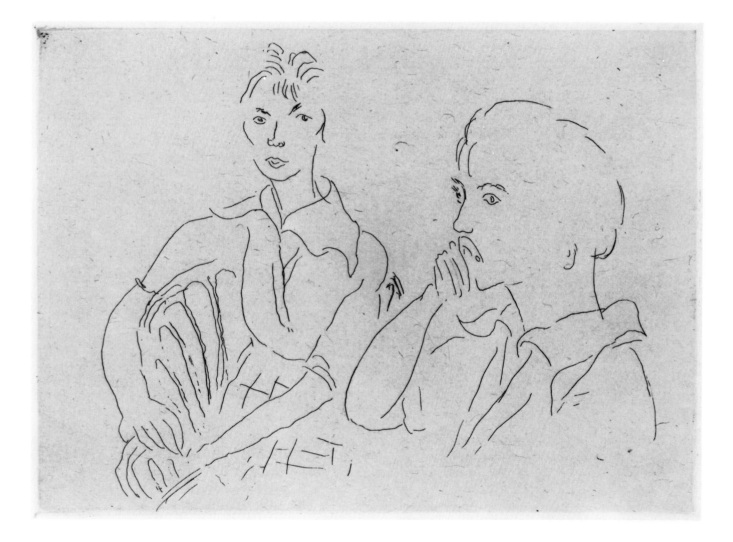

Matisse said of Albert Marquet: "When I see Hokusai I think of our Marquet – and vice versa – I do not mean imitation of Hokusai but similarity."[29] Later he told André Rouveyre: "painters moved from one picture to the next almost each hour, according to how changes to the light affected the objects through the movement of the sun (Manet, Marquet). You didn't look around the Louvre in order to mess up, in other words to be led astray. But you looked at the Japanese because they showed color. So you developed by narrowing your mind rather than by doing the opposite."[30]

The Japanese art of printing was without doubt one of the central sources of inspiration for the young nabis and the fauves. Matisse is said to have bought a few inexpensive prints, but he did not start a collection of these works as Monet or even many of the nabis did. "I only know and profited from the Japanese through reproductions, cheap prints bought from the print dealers on Rue de Seine. Bonnard told me the same thing, and he added that when he saw the originals he was somewhat disappointed. This can be explained by the patina and a little by the discoloration of the old prints."[31]

The influence of Japanese prints on artists at the turn of the century is an accepted fact, and the strong impression these prints exerted on Matisse is evidenced in the illustrated etching. One source of his renewed exposure to Japanese art was doubtless the exhibition of exquisite prints in the Musée des Arts Décoratifs in Paris. Matisse's friend Charles Vignier, the antique dealer and Orientalist, collaborated on the catalogue.[32] In January 1912 a selection of exceptional Utamaro prints was on show, an exhibition of masterpieces of portraiture. These prints obviously had some influence on Matisse, and may even have helped to reawaken his interest in portraiture. Our example reveals stylistic characteristics: the extreme close-up of the head, which may be partially missing, the three-quarter view, the oval line of the head, strands of hair in parallel lines, slanting eyes, the two-dimensional style of the portrait. Utamaro had put himself in individual scenes with courtesans. His figures do not look at the observer, however, and they are shown as self-absorbed or flirting erotically. The mouth here is un-Japanese and unusually wide. Matisse was reworking a European portrait with Japanese stylistic features but added an immediate, sensuous presence – conveyed expecially in the look that is trained on the observer – which makes an individual out of the Japanese portrait type.

17
1914. Etching, pl.14. 17.8 × 12.9 cm. 1 trial proof; edition of 15, signed and numbered, on laid paper. Duthuit no.29. Bibliothèque Nationale, Paris

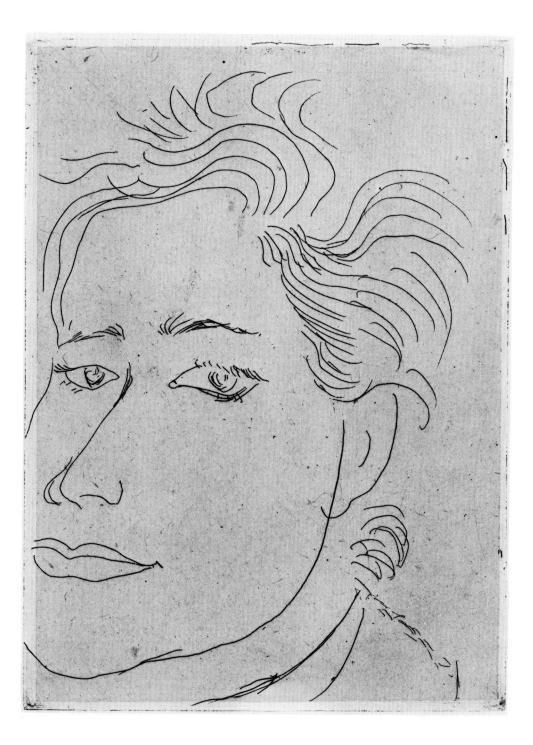

18 THE PERSIAN

(La Persane, Madame Matisse)

STANDING FIGURE WITH HEAD BOWED

(Figure debout, tête baissée, Madame Matisse)

The format and content of these engravings show how enduring the influence of Japanese prints was on Matisse. Instead of a beautiful courtesan Amélie Matisse is portrayed in her house coat, typical of the European woman's life. The tall, slim figure in the loosely falling Persian coat – cut off toward the bottom, her hair up and her head lowered like a Japanese woman in one print, and in the other, a frontal view against a decorative ground of large flowers and leaves. The monumentality of the little pictures is attained by the simplest means – extremities such as the feet are left out, making the figure appear even larger. While in one version the portrait of Amélie remains clearly recognizable, in the other it is incorporated into the formal interplay of the background of leaves and treated as a decorative element.

Amélie Matisse was described by painter friends as an exceptionally lovable and selfless woman. Jean Puy called her "simple and friendly,"[33] and Charles Camoin recalled: "His [Matisse's] marriage was extremely happy for him, with Amélie Matisse, exceptionally devoted, working to enable him only to concern himself with his painting. Charming, courageous, and full of faith in her husband's talent."[34] After their marriage in 1898, Amélie acted frequently and patiently as Matisse's model until the end of the First World War. One of the first full portraits produced in 1901 depicts her as a Japanese in a kimono with a flower in her hair, a sign at this early stage of the influence on the artist of Oriental subjects and articles of clothing. The full-faced pose illustrated is reminiscent of this picture, but Amélie stops appearing in Matisse's work from the beginning of the 1920s, when professional models took over.

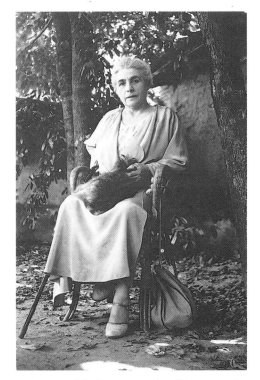

Madame Matisse. 1934. Photograph. Henri Matisse Archives. Claude Duthuit Collection

18 I
1914. Drypoint, pl.12. 16 × 5.9 cm. 2 trial proofs; edition of 15, signed and numbered, on laid paper. Duthuit no.27. Bibliothèque Nationale, Paris

18 II
1914. Etching, pl.13. 16 × 6 cm. 1 trial proof on Rives paper; edition of 15, signed and numbered, on laid paper. Duthuit no.28. Metropolitan Museum of Art, New York. Harris Brisbane Dick Fund, 1929

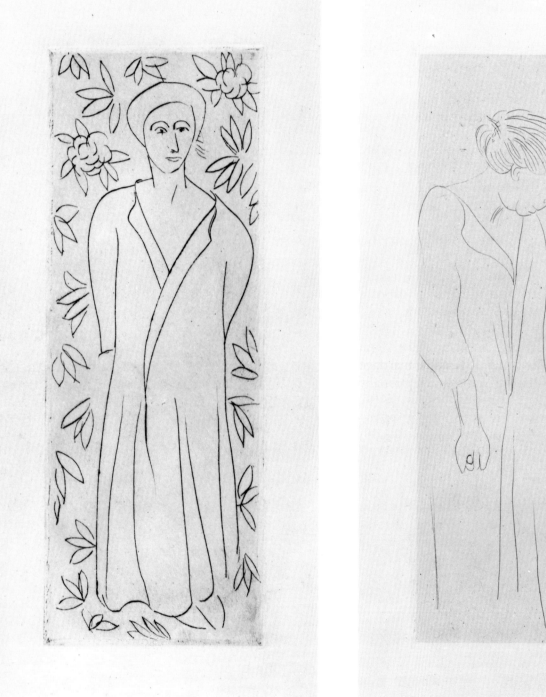

I

II

19 MARGOT IN KIMONO

(*Margot en kimono*)

"Up to the end of the First World War, Matisse often used his family as models... For Matisse the family was a source of free, continually available models... The whole family revolved around the labors of the father," commented Pierre Schneider in his comprehensive monograph on Matisse.[35] Marguerite, the eldest child in the Matisse family, filled the role of model for the artist more frequently than the other children. Margot, as she was affectionately called, appears here as a young woman of twenty-one. The Japanese influence is unmistakable here. The kimono with the large, cheerful fish pattern probably provided the idea for the picture. The arms hidden behind the back increase the vividness of the patterned garment and obscure the contours of the body. The lines of the hair with the few strands falling over the forehead are reminiscent of Oriental examples, as is the model's position turned away from the observer.

Margot generally wore a velvet neckband which Matisse converted into a strong feature in the paintings for he invariably made it black in the compositions. Pierre Schneider gives a clue as to the origin in this neckband: "Marguerite on the other hand, whose health was fragile after having had a tracheotomy to save her life when she contracted diphtheria at the age of four, was, in her own words 'the artist's child who hung around the studio.'"[36] Here the neckband recedes as an element of substance and ties in subtly with the pattern on the kimono. In this little sketch, which was worked directly onto the plate, Matisse gives the portrait a new interpretation. The portrait itself is suppressed in favor of decorative elements, yet at the same time integrated into the composition as a whole, so that Margot's familiar facial features and her personality can still be discerned and they determine the general character of the work. The degree of familiarity with the model allowed the artist to portray a delicate play of decorative abstraction and individual features. The result is an unpretentious picture of the artist's daughter which captures, on the one hand, a moment in the girl's life and, on the other, a period in Matisse's artistic development. In fact, this example demonstrates that for this artist the more intimately he knows his model, the greater is his freedom of interpretation.

19
1915. Etching, pl.43. 19.5 × 10.8 cm. Edition of 10, signed and numbered with monogram on the plate, on off-white wove paper. Duthuit no.68. Private Collection

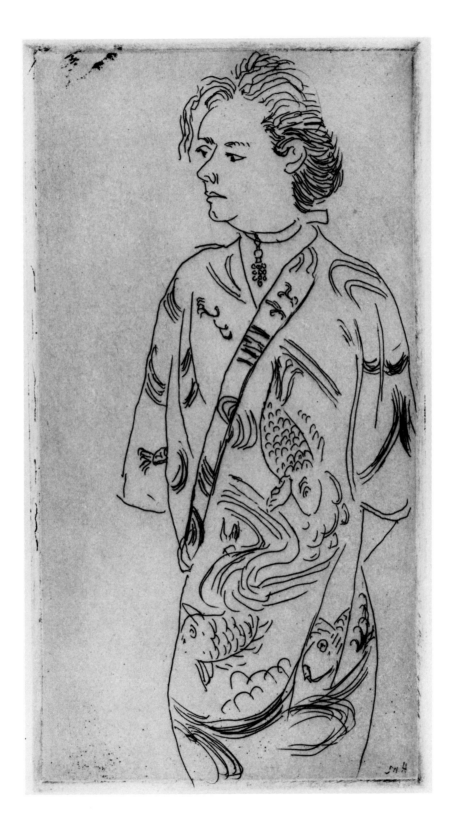

20 FANNY (MADAME DEMETRIUS GALANIS)

FANNY – THREE-QUARTER VIEW

(Fanny de trois quarts)

Fanny was the wife of Demetrius Galanis, an artist colleague of Matisse. A native of Greece, Galanis received French citizenship for service rendered to the country during the war. He was known for his lively, humorous drawings in magazines such as *Le Rire* and *Assiette au Beurre* and for his woodcuts and illustrations. As a painter-engraver he may have given Matisse advice on printing, but it was mainly their great interest in music that kept them together. Matisse's circle of acquaintances had always been surprisingly cosmopolitan, a factor which helped in choosing models.

Matisse produced excellent, spontaneous etchings of Fanny's head, all in the narrow, vertical format of the Japanese portrait style. They reveal a masterly gift for observation and great economy in the interpretation of the face, which appears extremely close as a result of the cropped lines of the hair. Viewed in sequence these prints simulate a cinematic movement. The portraits were sketched directly into the etching plate. Walter Pach, an American painter and friend, substantiated Matisse's rapid working method with the following story: In 1914 Pach had been sitting in his friend's studio for some time, chatting easily with him. As he was about to leave, Matisse asked to be allowed to spend five minutes doing an etching of him; there was a clock on the table. The artist engraved the portrait directly into the copper plate. Matisse was pleased to be able to work under such conditions, for at a further, longer sitting the result was less successful. "We looked at the five-minute etching....it had just the life that the more heavily worked things had lost."[37]

Matisse found that the small etched portraits presented an unsuspected creative range that tested his powers of perception and drawing and sharpened his ability to concentrate. He constantly sought affirmation of his artistic competence by testing it in the graphic medium.

20 I
1914. Etching, pl.18. 16 × 6.1 cm. Edition of 15, signed and numbered, on laid paper. Duthuit no.36. Metropolitan Museum of Art, New York. Harris Brisbane Dick Fund, 1929

20 II
1914. Etching, pl.20. 15.9 × 6.1 cm. 1 trial proof; edition of 15, signed and numbered, on laid paper. Duthuit no.38. Metropolitan Museum of Art, New York. Harris Brisbane Dick Fund, 1929

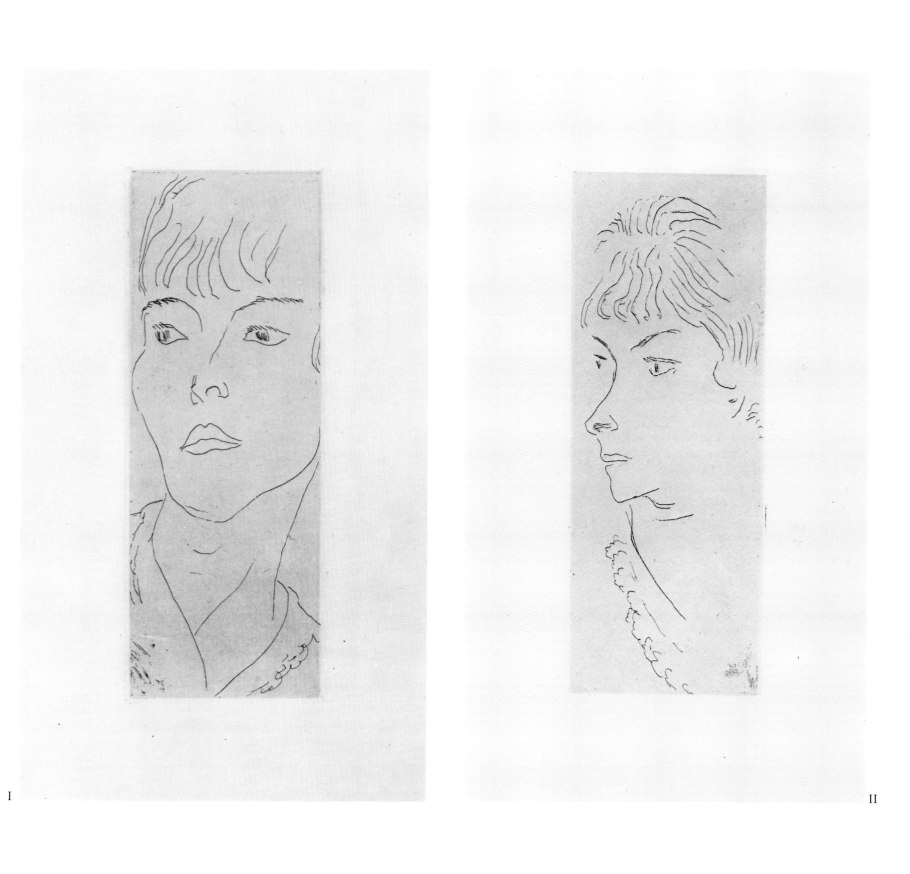

I

II

21 FRONTAL PORTRAIT

(Portrait de face)

As soon as a drawing was made into the etching plate, Matisse had the opportunity to print it straight away on his hand press. The importance of this procedure in his artistic process cannot be underestimated, for Matisse was able to assess his work in an instant. The counterproof, which he had so readily available, offered aspects that had not been evident at first. In other words it quickly gave the artist a distance between the work obtained, constantly calling on his power of judgment. The portraits, which were reduced to a few lines, responded to the smallest nuances in the strokes. We know that in his painting Matisse often only arrived at the final version after long reworking. This instantly created work, however, could not have been produced with a lot of revising – not without being ruined. It is difficult to know to what extent and how often Matisse revised his work. He often left imperfections if the composition as a whole was right or the print revealed pleasant surprises. Unlike in painting, he did not go over something that had already been started but instead began again as if it were a drawing pad. He easily eliminated works that did not satisfy him and kept only those that were significant to his artistic development, even if they did not necessarily represent perfect achievements.

Monotype broadened Matisse's experience of printing in two essential ways: the black and white elements were transposed and there was only one impression that looked like an original. The mask-life face in the monotype opposite stands out from the dark background; only the hair and the parts of the eyes recall certain structures from painting but they are lightly sketched, as in the etchings. In the original pull, however, slightly revised areas are clearly visible, particularly at the hairline and the chin, revealing the great sensitivity of these lines. Matisse produced four small monotypes of these features.

The association with a mask is heightened by the luminosity of the white strokes on the black ground, which has a magic radiance. Matisse, like all his contemporaries, was interested in African and Oceanian art. The white Fang mask from Gabon that Derain bought from his friend Vlaminck fascinated Matisse. "Derain took this mask away to his studio on Rue Tourlaque where Picasso and Matisse were meeting and were perturbed by the piece," Vlaminck remembered.[38] Just how intensely Matisse involved himself with the structural forms of African art between 1910 and 1920 is reflected in his sculptures *Back III* and *Jeannette V* as well as in an important portrait of his wife from 1913, now in Leningrad.

21
1914–15. Monotype. 8.3 × 5.9 cm. On laid paper, signed "monotype Henri Matisse" in pencil, lower right. Duthuit no.332. Private Collection, New York

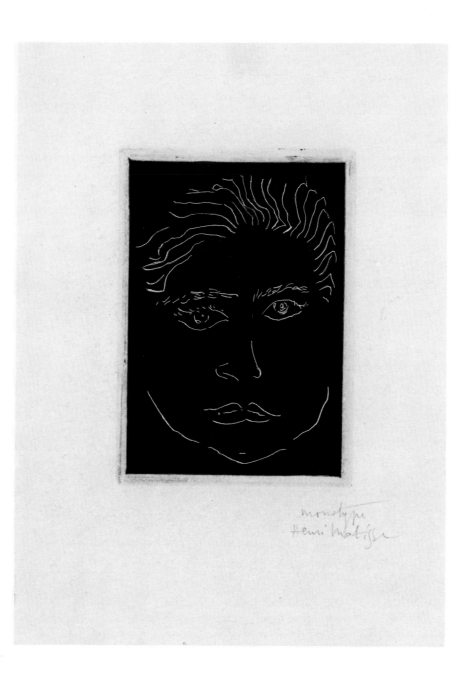

monotype
Henri Matisse

22 SEATED NUDE WITH BRACELET II

(Nu assis au bracelet II)

The seated torso gleams like a streak of light from the black background and heightens the sensuous and animal presence of the nude. The nipples, hair, and garters begin to vibrate, and the occasionally halting movement of the lines produces vibrations as well. Matisse, who was himself probably surprised at the monumental, sensuous effect of this monotype, prepared four versions with slight shifts of the torso section. The model was Loulou, friend of the film producer Gaston Monod. Matisse also did an etching of her in the same chair (Duthuit no. 52) and several versions in a flowery hat.

Western artists were fairly familiar with sensuous and erotic pictures from Japanese prints, and some were inspired to produce their own, sometimes pornographic, interpretations, such as *The Academy of Ladies* (1912–13) by Albert Marquet (which appeared in a private edition in New York). Matisse refrained from such excessive overtness and even criticized it in other artists: "Van Dongen had added to his notoriety with a little scandal in which he was helped by the prudishness of Desvallières...A woman opens her coat to show her pussy. I consider this picture a sign of mental depravity. But haven't we seen others like it? [Le Châle espagnole, 1913]"[39]

But Matisse also learned from the Japanese to reassess black in printing: "The Orientals made use of black as a colour, notably the Japanese in their prints" (F. 106). He found European examples in such painters as Manet and Odilon Redon, artists whom he greatly admired. Photographic negatives were also an important source of inspiration – for painters the reversing of the light and dark values was a stimulating experience. As Matisse asserted, it also signified the demystification of an object, which now had to be read anew: "We are encumbered by the sensibilities of the artists who have preceded us. Photography can rid us of previous imaginations" (F. 66).

22
1914. Monotype. 17.9 × 12.2 cm. On laid paper, signed "monotype Henri Matisse" in pencil, lower right. Duthuit no.359. Bibliothèque Nationale, Paris. Donation Jean Matisse

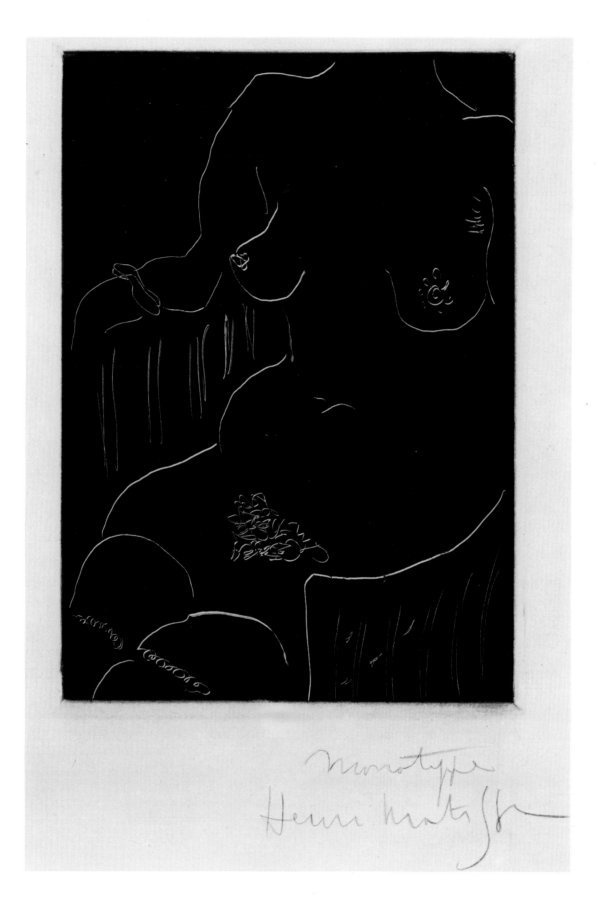

Monotype

Henri Matisse

23 STILL LIFE WITH GOLDFISH V

(Nature morte aux poissons rouges V)

While the etchings from the war years are devoted almost exclusively to portraits and nudes, the monotypes increasingly reveal parallels with painting and were presumably produced as playful permutations on the same theme. Matisse often talked of the regenerating effect of changing media, in which he included modeling with clay. "When I tire of some medium, then I turn to the other – and I often make, *pour me nourrir*, a copy of an anatomical figure in clay," he answered in an interview in 1912 (F.52). His daughter Marguerite recognized a parallel function in the graphic works: "Usually executed at the end of arduous sessions of painting, the prints provided an enjoyable conclusion for the artist.... The clarity of line and the special luminosity emanating from the plates that were produced in this manner constitute in a way the direct profit from the periods of sustained effort that had preceded them and offer delightful variations on the theme preoccupying him at the moment."[40]

The artist's deft hand comes through in the two following monotypes, both of which took their themes from paintings. The goldfish bowl emerged in 1911 as an important element of form and color in his paintings and was taken up again in a series of drawings in 1929. Three well-known masterpieces stand out in this series of six compositions: *Goldfish* (1915; Pushkin Museum, Moscow), *Goldfish* (1914–15; Museum of Modern Art, New York), and *Interior, Goldfish Bowl* (1914; Musée National d'Art Moderne, Centre Georges Pompidou, Paris).

In the paintings the scarlet color of the fish – often counterbalanced with black – dominates the composition and determines the final tonality. In contrast, in the monotypes the artist attempted to create contrasts between form and texture in order to bring the elements of the picture into harmony again: vegetation set against architecture, the dynamic form of the leaves juxtaposed to the static fish bowl. The plants and glass give off an abundance of light, as does the pumpkin. They act like fireworks, "generators of light." "I have been aware for a long time that I am expressing myself through light or even in light, which seems to me like a block of crystal in which something is happening," Matisse later explained.[41]

23
1914–15. Monotype. 17.5 × 12.5 cm. On laid paper, signed "monotype Henri Matisse" in ink, lower right. Duthuit no.355. Private Collection, New York

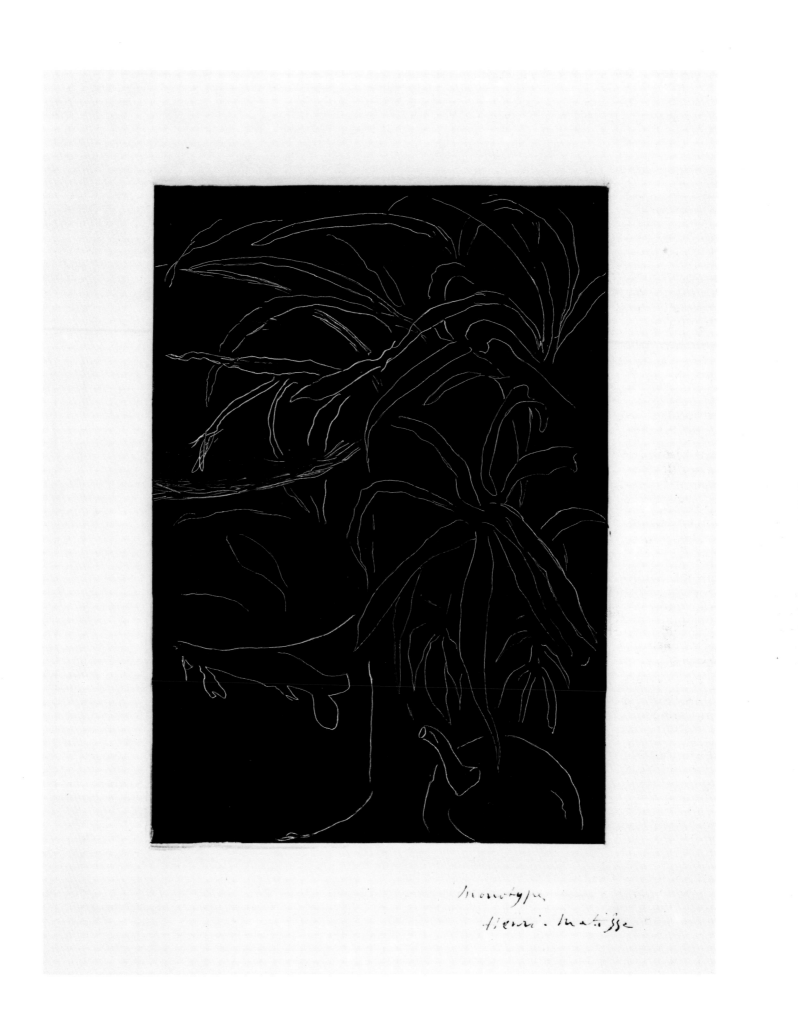

monotype
Henri-Matisse

24 GOURDS

(Les Coloquintes)

Matisse had his first experiences of art as a child in northern France and he was particularly influenced by Dutch still lifes. It remained a major theme in his work — always the source of artistic tension, it helped him to clarify and assess experiments, serving him as a yardstick. Thus it was that in his major painting *Still Life after de Heem* (winter 1914–15) he worked on cubist ideas, which had been given new relevance as a result of his many conversations with Juan Gris. The artistic tension captured in still life represents a continuous reassessment of the subject. Matisse never forgot the effectiveness of the glow that radiates from an object like a bottle or a pewter jug in the paintings by the old Dutch masters. The fruit bowl or plate motif obviously attracted him particularly because he used it in numerous works. The subtropical pumpkin plant, the gourd, drews his attention and appeared in his work after his first visit to Biskra, Algiers. The artist was presumably attracted both by the richness of its form and its luminous color. Matisse's choice to portray plump, glowing pumpkins befits the critical assessment of Apollinaire: "If one had to compare the work of Henri Matisse with something, one would have to choose an orange. Like an orange, Henri Matisse's work is a fruit of light."[42] A gourd will do just as well as an orange. *Gourds* (1916; Museum of Modern Art, New York) was also the title of an oil painting with objects that exist in an imaginary space of black and blue-gray, with no overlapping. The monotype separates the three pumpkins similarly, but also shows the arrangement of the room. In other versions there is the Moroccan platter and wall decoration.

Here the objects have become luminous bodies; they are given volume by the swelling and deflating lines and fragments of lines that rise up like simple signs from the dark ground. The way the lines breathe and generate their own power, which seems to extend into the darkness, is strikingly evident in the original from heavy corrections made to the pumpkin on the right with a black brush. The dynamism of the lines, their clearly differentiated, sensitive interpretation points to the artist's later work and again recalls the advice noted by Sarah Stein: "One must always search for the desire of the line, where it wishes to enter or where to die away" (F. 43).

24
1916. Monotype. 17.7 × 12.6 cm. Signed, on Lepage wove paper. Duthuit no.387. Bibliothèque Nationale, Paris. Donation Jean Matisse

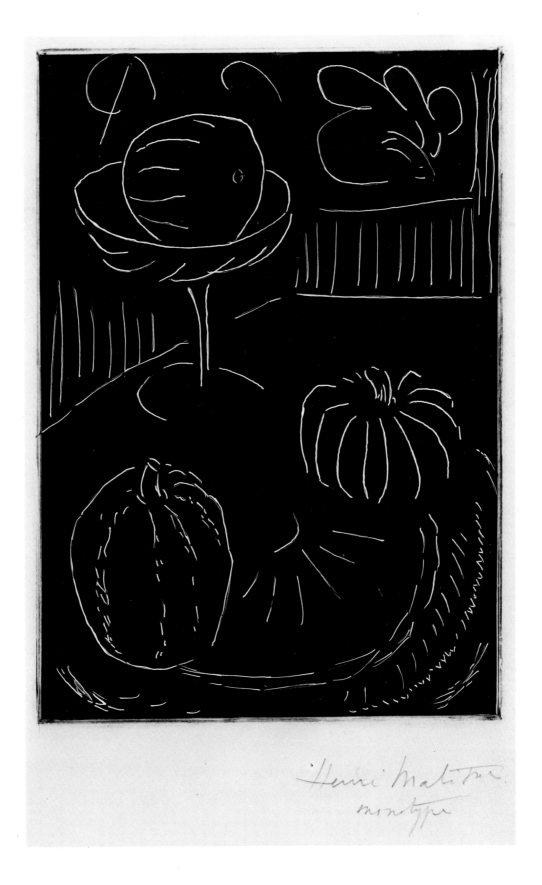

Henri Matisse
monotype

25 THE PAINTER ALBERT MARQUET

(le Peintre Albert Marquet)

In their first years as students in Paris Matisse formed his most durable friendship with another artist – Albert Marquet. The two of them took courses together at the Ecole des Arts Décoratifs, visited Gustave Moreau's studio, copied in the Louvre without a cent in their pockets, sketched passersby together in the streets of Paris or nudes in Henri Manguin's studio, lived next door to each other and traveled to the south of France and Algiers. In 1908 Marquet took over from Matisse the small three-room apartment with the splendid view of the Seine at 19 Quai Saint-Michel, the theme of numerous pictures. He worked there until 1931. When in autumn 1913 Matisse rented another studio in the same house – this time a floor below Marquet – they became neighbors again. Contact between them intensified during the war, when many friends were at the front. Matisse wrote to Camoin in 1914: "I have just gone off to Paris, thinking I might see Marquet,"[43] or during the worst of the wartime confusion: "I have no news of my parents or my brother. The Germans don't want to pass on news...Marquet and I have ended up by starting to work again...I am doing a lot of etchings."[44] The concentrated, intricate work with the engraving tool and needle obviously took the artist's mind off his troubles. The following message reached Camoin: "At Marseilles for almost a week with Père Marquet [a common nickname among friends]. We are not bored, although our behavior is nothing if not respectable. Even when we went to Rue de Boutry (a prostitutes' district) we maintained a seriousness of mind that allows us to see everything without lowering ourselves."[45]

Matisse is alluding in his friend's portrait to the great gift for rapid observation, expressed in the peculiar gaze through half-closed eyes. The sketched head shown could have been drawn from memory, like the picture of his mother in a telephone booth years before. It is a concise, eloquent portrait of his friend. André Salmon described the model thus: "The pince-nez of a bureaucrat – the pinched but sensitive smile which never leaves him."[46] Georges Besson characterized him as follows: "Physically and in his personality Marquet was nothing special in the least. His slight limp, his rather thin frame, his nearsightedness apparent through the pince-nez, his soft little flat hat, oddly, pulled down over his eyes – none of this would seem liable to attract the interest of young ladies."[47]

Certainly, the human qualities and shared memories kept the two together rather than intellectual, artistic problems. Just as at the turn of the century, it was Matisse who was fascinated by Marquet's sketches, in Marquet's later nudes there is more of Matisse.

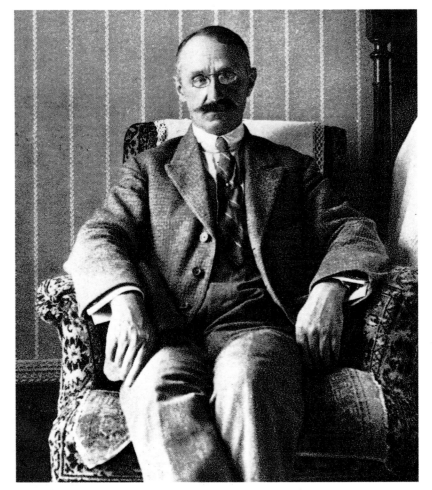

Albert Marquet at Estaque. 1918. Photograph by George Besson

25
1914–15. Monotype. 14.5 × 10.5 cm. On Tochon-Lepage wove paper, signed "monotype Henri Matisse, le peintre Marquet" in pencil, lower right. Duthuit no. 329. Private Collection, New York

monotypie
Henri Matisse
le peintre marquet

Friendship with the American collectors the Steins, particularly Michael and Sarah Stein, brought Matisse a large international circle of acquaintances made up of writers, philosophers, and intellectuals. A close relationship developed between him and the Englishman Matthew Stewart Pritchard, an enigmatic, mystical character who introduced him to the philosophy of Henri Bergson, whose *Creative Evolution* (1907) was much discussed at the time. The circle also included the Brazilian brother and sister Albert and Yvonne Landsberg. Yvonne, a shy and withdrawn young woman nineteen years of age, had a receding chin and was no beauty. A portrait was commissioned from Matisse in the spring of 1914 with the hope that this would diminish her complex. Matisse was very interested in artistic work of this kind since it challenged him to explore the limits and possibilities of a face's structure. It was for that reason that he did not look for classically beautiful models for his work, but expressive and often asymmetrical faces. The result was several drawings, an unusually abstract painting in oil (now in the Philadelphia Museum of Art) and a series of full-faced etchings that did not reveal the model's imperfection, but a delicate, spiritualized portrait. Only an experienced eye can still detect the overlong and disproportionate chin area.

Albert Landsberg left notes on the sitting: "On the day of the first sitting, we found that before we arrived at the Quai Saint-Michel Matisse had spent the whole morning making lovely drawings of magnolia flowers – or rather *buds* (which, he said, my sister reminded him of). He had been doing this all morning and was bothered by the buds opening and turning into full-blown flowers so quickly."[42] The poetic analogy of the flower bud and the girl is a marvelous one, and in fact Matisse used this decorative motif, which was probably inspired by Oriental art, in other portraits during that period. The combination of leaves, flowers, and women (models) went on, in fact, to be of great significance in his oeuvre. It is strange that none of these drawings has apparently survived. Matisse clearly regarded such sketches purely as practice sheets and destroyed them afterwards. He was a thoroughly conscientious artist and used to prepare for work with finger exercises of all kinds, even including playing the violin.

26
1914. Etching, pl.16. 20.1 × 11 cm. Edition of 15, signed and numbered, on laid paper. Duthuit no.33. Private Collection

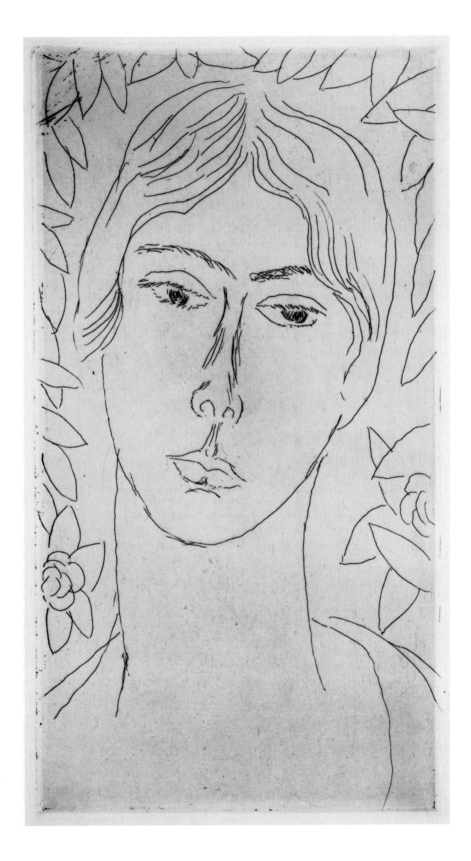

A talented actress, particularly known for her interpretations of Ibsen, Greta Prozor (1885–1978), frequented Parisian literary circles already in the days of Lugné-Poë. She had been exposed to a cosmopolitan lifestyle from early on, coming as she did from a diplomatic background. Her mother Märtha Bonde was a Swedish countess, and her father Maurice Prozor, also himself a count, was a Lithuanian serving in czarist Russia's diplomatic corps. Her father's talent as a translator of Ibsen seeped into his theatrical daughter.

Marriage to the Norwegian painter Walter Halvorsen brought Greta into contact with her husband's teacher Matisse, and the couple was soon welcomed as members of a group that gathered round Matisse on Sunday afternoons at his home in Issy-les-Moulineaux, near Paris. Her recollections of the artist are insightful: "One day Matisse asked me to pose for him in a studio in Paris on Quai Saint-Michel. He wanted to do a large canvas but started with drawings, lots of them. 'Talk,' he said to me and asked me questions on the theater, naturally. I talked with vigorous gestures.[53] Suddenly he stopped me with a movement of his hand and began to draw with a few lines an attitude that pleased him. He gave me one of those drawings. As for the painting, though, Matisse declared, after a few sittings that he could not continue; he was not satisfied with the results."[49] Matisse, however, did keep the oil painting for himself for a long time and called it one of his most important portraits. It is presently at the Centre Georges Pompidou in Paris (Cahiers du Musée d'Art Moderne, no. 11, 1983).

With this model Matisse was not under pressure to do a commissioned portrait and felt free in his interpretation. The theatrical atmosphere that Greta Prozor brought with her made him quick to stylize and isolate the individual features of the model. In the final version of the picture he produced an icon-like figure with a majestic, imperious radiance. The fact that the model was an actress guided his hand and gave him the motivation to conjure up a magic scene, with its own principles and terms. With Greta Prozor Matisse experienced in a double sense (as model and actress) the dynamic relationship between subject and object into which each model inevitably drew him. Her stage personality had something of the specter and the juggler, a characteristic of his vocation too. The only things that counted were the power of conviction and the reality of what was depicted.

The engraving shown here is a stage in the process that leads to a picture. It seems to have been a very important stage for Matisse because he did not destroy the work in spite of the fragmentary nature of the head. The enigmatic quality as well as the strong presence of the face, with the hard, determined lines of the drypoint engraving, must have been decisive in the artist's conception of picture and portrait. The model's expression, set off by the brim of the hat, is lively with perhaps an agitated air. Yet the features are indefinite, with a mask-like quality. Matisse succeeded here not only in capturing the face of Greta Prozor but also in portraying her as an actress in an Ibsen drama.

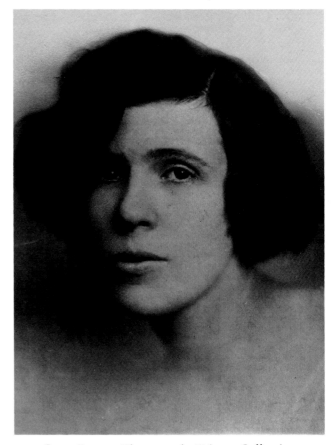

Greta Prozor. Photograph. Private Collection

27
1916. Drypoint, pl. 105. 15.1 × 11 cm. 3 trial proofs, one on Rives paper; edition of 15, signed and numbered, on laid paper. Duthuit no. 72. Private Collection

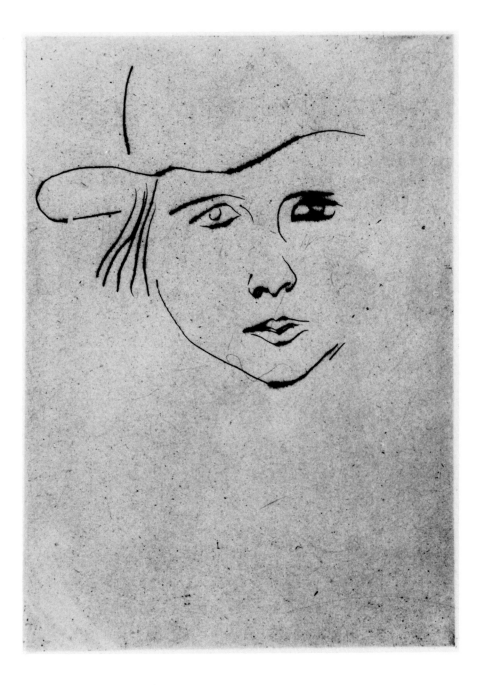

In Issy-les-Moulineaux in 1912–13 Matisse produced an unusual painting in shades of blue, *The Blue Window* (Museum of Modern Art, New York). He was capturing the view from his bedroom of the garden and the gable of the nearby house containing his studio. Individual objects on the windowsill and frame obstruct the view and hold it, before it roams out into the open landscape. The objects can just be made out in some cases: a lamp, a square mirror, an ornamented plate, a flower vase, a primitive sculpture, a small jug, and a Chinese vase. The blue background tones pour out over the whole picture area and are not graduated to convey differing atmospheres. In a radio interview later Matisse answered a question on the open-window motif: "for me the space from the horizon to the inside of the room is continuous and ... the boat which passes lives in the same space as the familiar objects around me: the wall around the window does not create two worlds."[50]

What held true for the view from the window in Nice with the boat sailing by applies here. The small drypoint engraving takes up the same theme, reducing the objects on the windowsill. The view from the window is identical. Matisse worked directly into the plate (we have the counterproof view); in one he obviously started with the room-window arrangement, and in the other he began with the objects and then added the window detail. Matisse played with the motifs and it seems that he reproduced them from memory onto the picture, which was already planned. The pressure used in the print is uniform. There is no differentiation to indicate perspective and this gives the same homogeneous level to the picture that the shades of blue provided in the earlier painting.

Matisse used the same engraving plate for flower and plant studies of astonishing vividness. These studies were executed by an artist at ease, free of any constraining pressures. Matisse would gain access to the world of creativity through apparently aimless, free sketches, trying to arouse his artistic powers and to sensitize his hand for what was to come: "One gets into a state of creativity by conscious work. To prepare one's work is first to nourish one's feelings by studies which have a certain analogy with the picture, and it is through this that the choice of elements can be made. It is these studies which permit the painter to free his unconscious mind" (F.66).

When he did keep practice sketches and have a limited number of prints made, he presumably did so because they were important for the continuity of his work, as examples of solutions to technical problems or as reference works.

28
1913. Drypoint, pl.51. 14.9 × 9.8 cm. Edition of 12, signed and numbered, on wove paper. Duthuit no.10. Private Collection

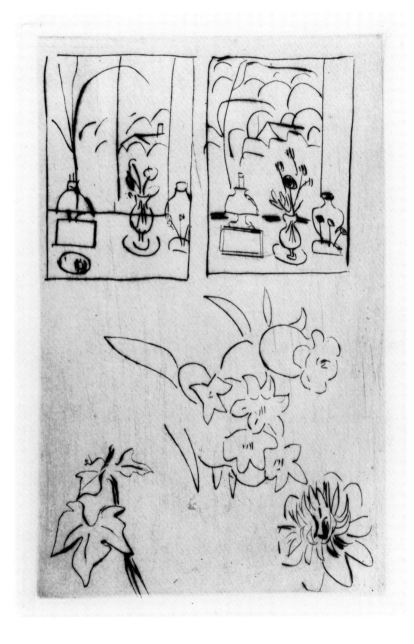

29 HEAD OF MARGUERITE II

(Tête de Marguerite II)

After pushing the portrait of Greta Prozor to a high degree of abstraction, Matisse approaches an unusually realistic style in this portrait of his daughter Marguerite. Perhaps he was trying to question anew the features of this well-known face. It turned out to be the last portrait in a long series since Marguerite's birth in 1894, with the exception of a few pictures produced in the 1920s in which she figured in interiors and landscapes with the model Henriette. Not until the end of the Second World War does her face appear again in a number of lithographs. During the war years Marguerite acted as the artist's model in numerous portraits, some of great expressive power and realism. The artist may have found traces of his wife in the young twenty-six figure of his daughter. When he married Amélie, Matisse also took the four-year-old daughter Marguerite into his home. The child had delicate health and was lovingly looked after. A gifted painter herself, Marguerite looked after her father's graphic works (except for occasional breaks) during his lifetime and later his estate. It was she who gave collectors and dealers information, helped to oversee the quality of the prints, and looked after correspondence. Matisse often asked for her opinion of his work.

The portrait illustrated is the frontispiece to the first volume of drawings published in 1920 that Matisse himself put together. This volume contains sketches of the model Antoinette, often produced in connection with paintings that were planned. He discovered Antoinette in Nice in 1918 and took her with him to Issy-les-Moulineaux in the summer. He painted the large work *Tea* (1919, Los Angeles County Museum of Art) with Antoinette and Marguerite as models. The latter is recognizable by her velvet neckband. Antoinette does not appear in the graphic work, for presumably Matisse did his etchings mainly in Paris when he was near his printing press.

Marguerite always fulfilled her function as a model with patience. The works she inspired often point to new artistic breakthroughs, as can be seen in this portrait done in the realistic style of the 1920s, rendered in the same spirit as numerous pencil drawings of Antoinette that Matisse modeled so delicately during the same period.

Marguerite. c.1922. Photograph. Henri Matisse Archives. Claude Duthuit Collection

29
1920. Etching, pl.198. 14 × 9.5 cm. Frontispiece of *Cinquante dessins* by Henri Matisse, published by the artist in 1920; edition of 1,000, on laid paper, signed, with printer's numbers. Duthuit, vol.1, p.68. Private Collection

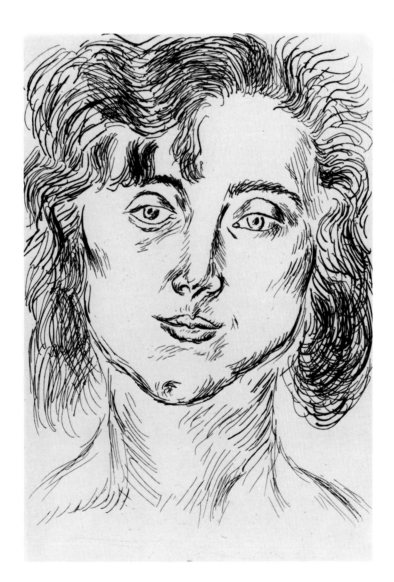

30 SELF-PORTRAIT

(Autoportrait)

"I work enormously hard all day, and passionately; I know that only that is good and certain. I am no politician, which is what, unfortunately, almost everyone else is; to compensate I am forced to paint hard, sensitive canvases. Slaves that we are, without the certainties that bring a good night's sleep. One has to have labored all day to accept the irresponsibility that lets one's conscience rest," Matisse complained to his friend, the painter Charles Camoin.[51]

This was no empty sigh, yet nobody, from looking at the brightly lit and airy interiors with their sensuously conceived and dazzling subject matter, would have guessed the artist's struggle to put his surroundings and his ideas into a picture. The works radiate tranquility, sensual pleasure, and ease of craftsmanship. The self-portrait of the artist brings darker tones to his palette; it is gravely contemplative, critical, and sceptical, worked in harsh contrasts, and purposeful outlines. The subject is a man of forty-five, thoughtful, inner-directed; he is not looking in the mirror as he was in the first portrait of himself engraving at the turn of the century (see Pl. 1). There is a second version of him with a hat and noticeably wide-open eyes. Both versions resonate with a melancholy undertone. The artist also gives the impression of an official or a professor – as many of his contemporaries have described him – while Man Ray's photograph from the end of the 1920s radiates wit and character.

The self-portrait is surprisingly direct, as if the artist was carrying out a relentless self-interrogation. Matisse was on the way to becoming the most sought-after international artist. Of the earlier generation, only Monet was still alive, in Giverny, and Picasso did not at that time excite the same degree of public interest. Matisse's works sold quickly and well with exhibitions following in Europe and America (New York, London, Copenhagen, Paris). Material hardship was no longer a worry. Was the artist affected by the departure of his daughter Marguerite, his most regular model until that time? In 1923 she married the art critic Georges Duthuit, and disappeared from Matisse's work almost completely. Or, was it a general artistic disquiet that had seized him, coupled with unavoidable artistic isolation in the narrow, closed-off world of the studio, which was only enlivened by the regular presence of a model? Renoir had died in neighboring Cagnes; his faithful friend Camoin had married; Marquet usually painted in Algiers; Bonnard lived a solitary life, and Matisse remained untouched by the merry-go-round of cubism, futurism, and orphism. His awareness of his own creative achievement weighed on him more than ever. Moreover,

in his opinion, apparently his work did not yet have a power commensurate with what his imagination conceived. Success among the collectors did not cause this tireless artist to slacken his demands on himself and his art.

Matisse. c.1930. Photograph by Man Ray. Lucien Trelliard Collection, Paris

30

1923. Lithograph, pl.132. 32.5 × 25.5 cm. Edition of 10, signed and numbered, on China paper. Duthuit no.440. Art Institute of Chicago. Gift of Mrs. Homer Hargrave

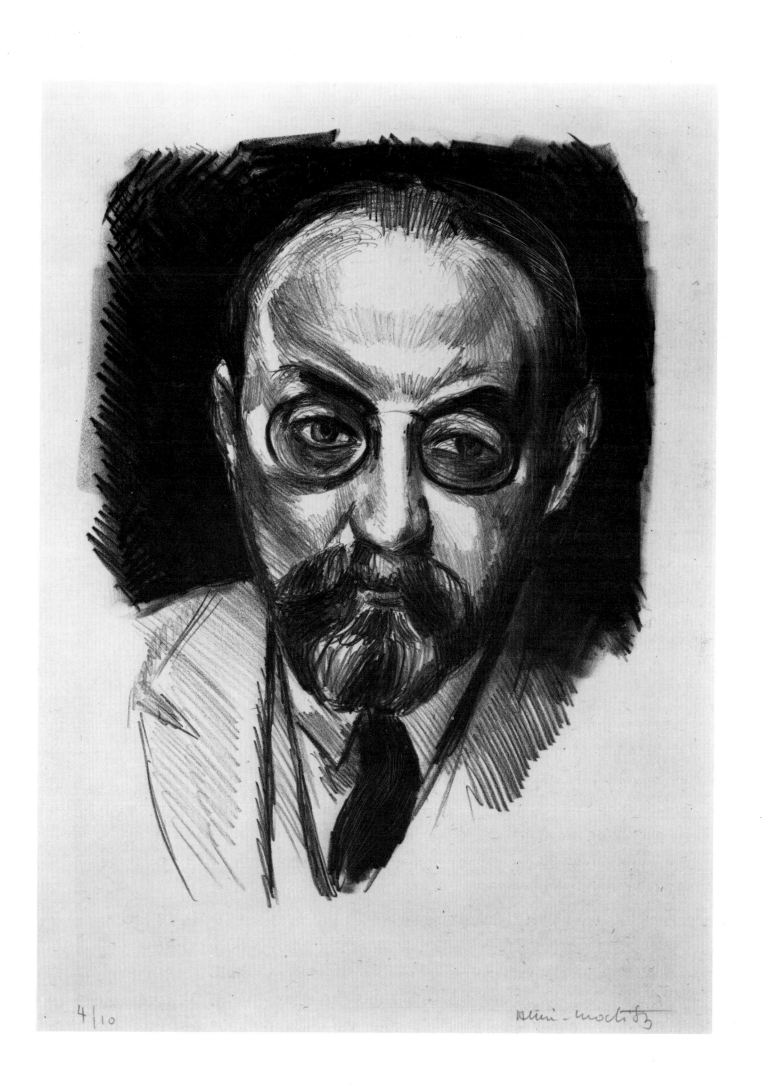

4/10 Henri-Matisse

31 YELLOW DRESS WITH BLACK RIBBON

(La Robe jaune au ruban noir)

Matisse stayed in Nice from December 20, 1917, according to Jack Cowart – first in the Hôtel Beau-Rivage overlooking the Quai des Etats-Unis and then in rented apartments – until the spring. He avoided the hot summer months in the south, however, returning each year to the Paris region. After the war he lived in various rooms in the more comfortable Hôtel Méditerranée on the Promenade des Anglais (the hotel was demolished in the 1930s). In autumn 1921 he moved into an apartment at 1 Place Charles-Félix, not far from the sea and with a magnificent view. He stayed there until 1938. The warm, silver light and the southern climate kept him there, as he wrote to Charles Camoin: "It's as though this is a paradise that I have no right to analyse, but I'm a painter, for God's sake. Ah! Nice is such a beautiful place! Such a gentle, soft light in spite of its brilliance. I don't know why it often reminds me of the light in Touraine (that may need two r's [sic]). In Touraine it is a little more golden, whereas here it is silvery. Even though the objects that it touches are highly colored, like the greens for example."[52]

Matisse gave free rein to his enthusiasm and passion for painting primarily in the area round Nice, in a series of works with silvery olive groves and delightful gardens. He says in the same letter to Camoin: "I have just had a siesta under an olive tree and what I saw was such tender harmony and color." In the fullness of such an Arcadian life and in the new light conditions after the gray days of wartime Paris, Matisse also found a new relationship with objects, interiors, models. The title of this lithograph reveals that Matisse often thought in colors and that this medium was closely associated with painting for him. Until that point the artist had rarely worked with soft litho chalk and certainly not in this painterly style. Formerly the prints had been line lithographs, mainly nude studies. In 1922, in the southern light of the Mediterranean, close to where Renoir – who had recently died – used to live, Matisse immersed himself once again in this printing method, going through all the registers from the most delicate modeling clay to angular outlines and deep black.

The human figure, especially the female body, in its infinite versatility and in the magical light of the Mediterranean world of "such tender harmony" became after 1920 a major theme that fed and brought joy to his work, as it did to his endlessly toiling creative spirit. What had begun with the model Lorette under the gray Parisian sky on Quai Saint-Michel – intense work with a paid model which lasted months – now continued with Antoinette (1918–19) and then Henriette (1919–27).

31
1922. Lithograph, pl.34. 39.2 × 28.8 cm. 1 trial proof; 10 artist's proofs; edition of 50, signed and numbered, on China paper. Duthuit no.424.
Private Collection

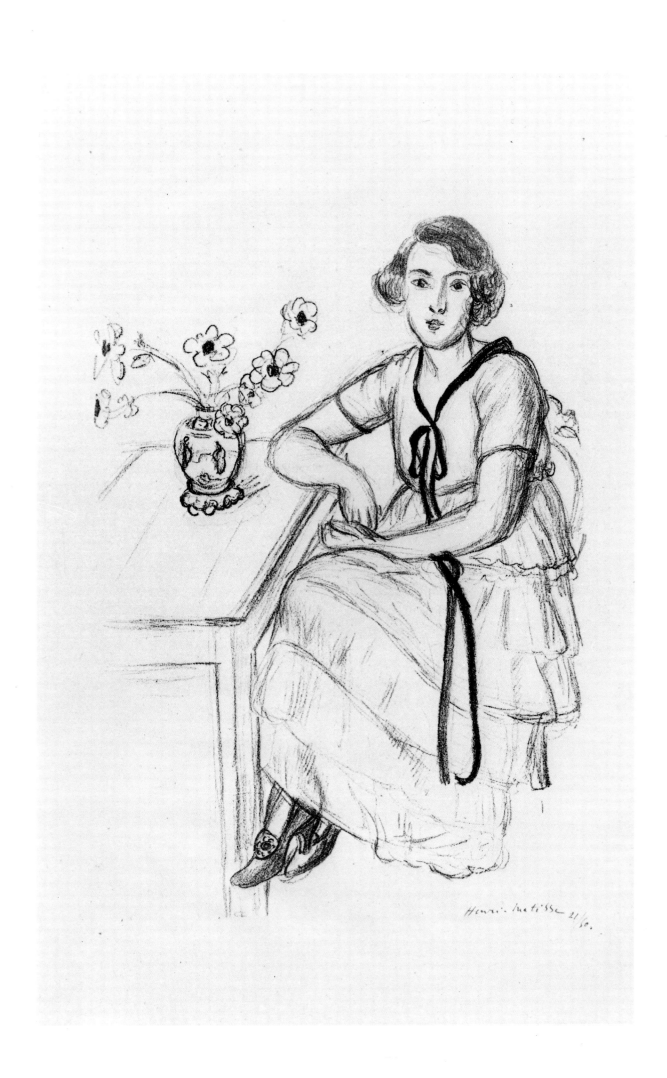

Henri-Matisse 21/50.

32 GIRL SITTING WITH FLOWERS

(*Jeune Fille assise au bouquet de fleurs*)

Prompted by Editions Frapier (Galerie des Peintres-Graveurs), who planned a series of volumes on various artists, Matisse took up his litho chalk again in 1922. Their invitation resulted in a copious output. Until 1927 it consisted of an uninterrupted dialogue with the model Henriette Darricarrère. Henriette was nineteen when Matisse first saw her "at the studios de la Victorine performing as a ballerina before the camera. The artist arranged for her to begin modeling shortly thereafter [1920]; her family recounts that he encouraged her to continue her lessons in piano, violin, and ballet, also allowing her time to paint and attend musical and other social events in Nice."[53]

Shortly before, in 1919–20, Matisse had been commissioned by Serge Diaghilev to produce the costumes and sets for the ballet version of the Stravinsky opera *The Nightingale*, and spent some time with the Ballet Russes de Monte Carlo at the beginning of 1920 in London. It was the first time Matisse had designed for the stage and followed Picasso's sets for *La Parade* (1917) and *Le Tricorne* (1919). He also formed a lively friendship during this period with Jules Romains, who was then teaching philosophy at a high school in Nice and who was an enthusiastic devotee of the theater. The atmosphere of theater and dance presumably prompted the artist to take on Henriette, who performed as a dancer. Matisse found in her someone with an interest in art and with a sculptured, elastic body. Henriette held his attention for seven years. The artist was able to get used to Henriette's features and figure as never before. She not only fitted in with Matisse's preferred classical image in terms of her physique, but her spirit, too, suited the artistic, theatrical atmosphere of the interiors in the paintings created in the studio. Henriette assumed all kinds of guises in fashionable clothes with constantly changing accessories, and her apparel brought harmony and brilliance to the composition.

Many of the lithographs of Henriette resemble paintings, as the illustration opposite demonstrates. In finely graduated shades of gray and delicate tones and in highly contrasted areas of dark and light on extremely thin China paper, the artist conjures up an infinitely rich light show that not only creates plastic and spatial values but also evokes colors. The figure of the model, the texture of her hair, and the pattern of her dress have the same importance as the vase of flowers on the table or the striped pattern under the window; they structure space in the picture. A view from the window of the top of a palm-tree and the sea indicate a light source, yet the picture is dominated by a diffuse light of unusual brightness that creates a vibrant, dazzling effect, and which seems to radiate from the objects themselves. The result is a chiaroscuro-like painting of great quality.

Henriette, 1921. Photograph. Henri Matisse Archives. Claude Duthuit Collection

32
1923. Lithograph, pl.51. 17.2 × 19 cm. 5 trial proofs on China and Japan paper; 10 artist's proofs numbered from 51 to 60; edition of 50, signed and numbered, on Japan paper. Duthuit no.438. Private Collection

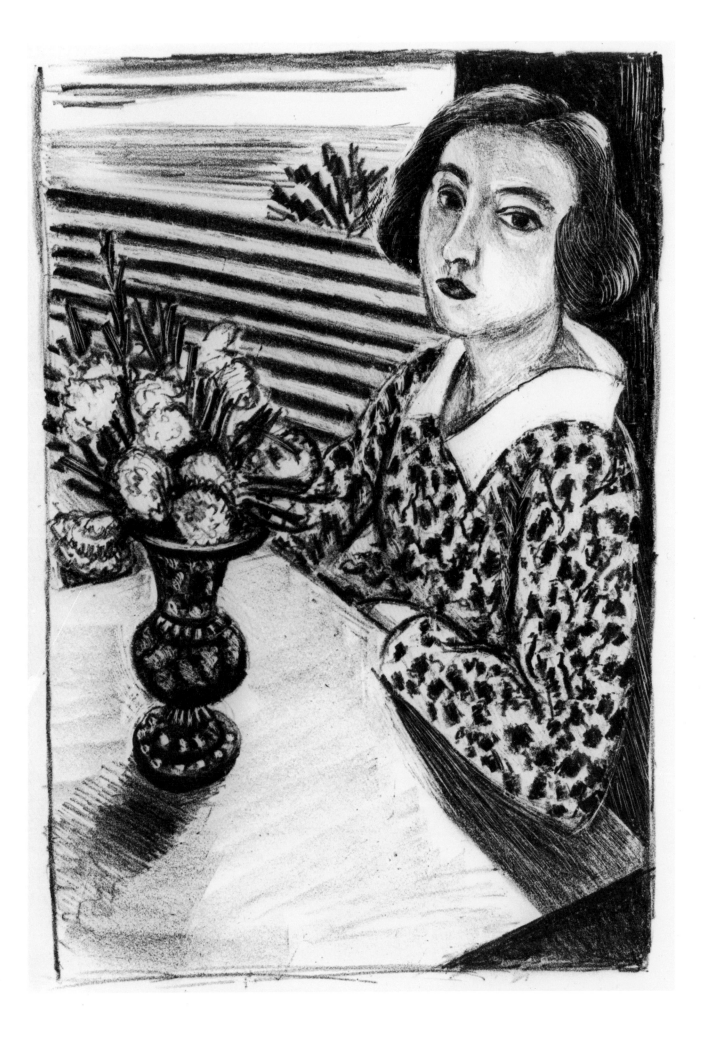

33 ODALISQUE IN STRIPED PANTALOONS, REFLECTED IN A MIRROR

(Odalisque à la culotte rayée, reflétée dans la glace)

"My models, human figures, are never just 'extras' in an interior. They are the principal theme in my work. I depend entirely on my model, whom I observe at liberty, and then I decide on the pose which best suits *her nature*"(F. 81–82). This admission by the artist makes explicit the central position held by the model within the creative process. It is significant that this comment was made in the context of drawing, fixing the subject matter and the reactions that it produces in him in the first creative phase. "I have never considered drawing as an exercise of particular dexterity, rather as principally a means of expressing intimate feelings and describing states of mind..."(F. 81). The artist tried to capture on paper the impressions and feelings aroused in him by the presence of the model. In this way the drawing became the product that stood closest to the reality, to the nature of the subject matter. What may appear to us as the apotheosis of a sensuous and sumptuous world represents for the artist above all an instrument to master the subject matter. Matisse placed the model in his familiar studios to act as a foreign body, exposing her to the field of tension in this world. He became a voyeur first of all. The stimuli and visual tensions that were produced then went into the drawing and became the "expression of intimate feelings" and "descriptions of the state of the soul," a work of art.

For this working method Matisse seems to have preferred drawing in soft pencil or chalk before venturing into virtuoso line sketches: "charcoal or stump drawing, which enables me to consider simultaneously the character of the model, the human expression, the quality of surrounding light, atmosphere and all that can only be expressed by drawing. And only when I feel drained by the effort, which may go on for several sessions, can I with a clear mind and without hesitation, give free rein to my pen. Then I feel clearly that my emotion is expressed in plastic writing"(F.81).

It is clear, from the lithographs from 1922–23, how Matisse traced the three-dimensional structure of Henriette's body, worked on its imposing structure and delicate lines, and gave them static form in a fixed and clearly developed pictorial structure. He contrasted her vibrant, gleaming skin with patterns, creating the light and texture of a painting.

It is difficult to prove whether the lithograph came before or after the composition *Standing Odalisque Reflected in a Mirror* (1923; Baltimore Museum of Art). Around this time Matisse struggled, in a series of pictures of figures and interiors, for a way of representing rooms through color and texture alone, a method that would con-

vey the southern light. The subjects for his pictures frequently went into the lithographs. The image here is the reverse of that in the painting due to the printing process. Another detail to take into consideration is that the oil painting contains structural variations in the room, which were prescribed by the color problems encountered with paint, and which would thereby suggest that the lithograph was the precursor of the final painted version.

33
1923. Lithograph, pl.43. 40 × 30 cm. 9 trial proofs; 10 artist's proofs; edition of 50, signed and numbered, on China paper. Duthuit no.433. Bibliothèque Nationale, Paris

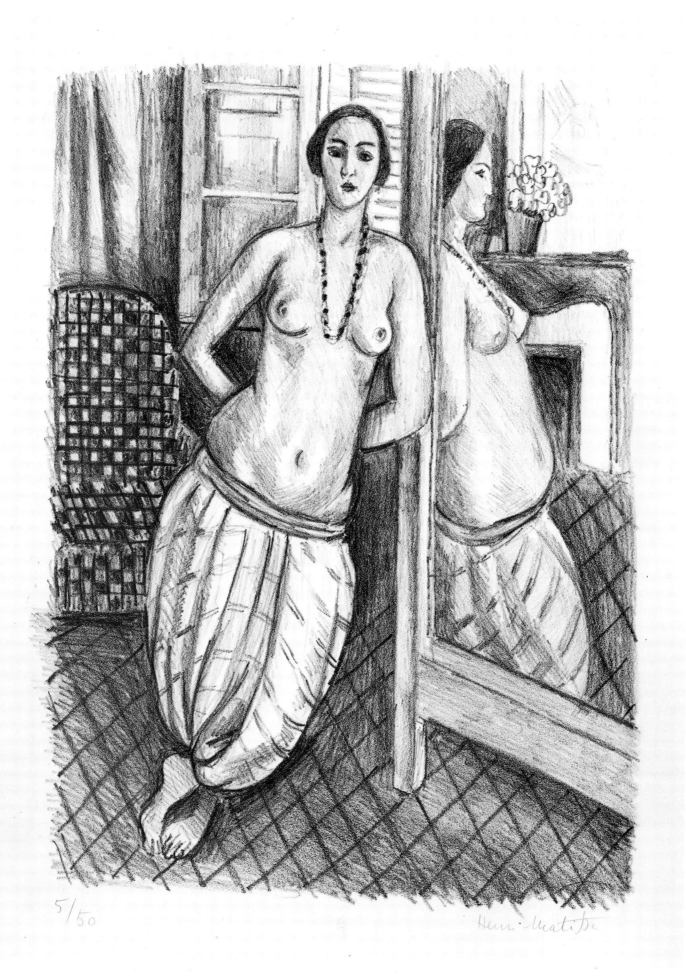

5/50 Henri-Matisse

34 ODALISQUE WITH MAGNOLIA

(Odalisque au magnolia)

When questioned by the publisher E. Tériade in 1929 on the frequent appearance of the odalisque motif in his work, Matisse answered: "I do Odalisques in order to do nudes. But how does one do the nude without it being artificial? And then, because I know that they exist. I was in Morocco. I have seen them"(F.59). He had met these beautiful concubines before in the Louvre, however, in works by Ingres *(Large Odalisque)* and Delacroix *(The Algerian Women)*. Both these artists had freed the nude from the boudoir and set her in an Orientally inspired ambience that was as rich in sensuous motifs as the Renaissance's use of mythology in pictures. Delacroix's visit to Morocco in 1832 again brought a full measure of Oriental themes into the art language of the West. "I found the landscapes of Morocco just as they had been described in the paintings of Delacroix and in Pierre Loti's novels," Matisse asserted in 1951 (F.133).

The great breakthrough of Far Eastern and Islamic artistic styles was the result of the first exhibitions of Muslim and Asiatic art in Paris at the end of the nineteenth century. Matisse even traveled to Munich in 1910 to see the comprehensive exhibition of Islamic art there. The Ballets Russes also introduced a wealth of Eastern motifs in the splendidly colored costumes and sets of Léon Bakst. Matisse was familiar too with Japanese woodcuts showing richly adorned courtesans, and he encountered the Byzantine heritage of Russian art on his visit to Moscow in 1911. "Thus my revelation came from the Orient. It was later, before the icons in Moscow, that this art touched me and I inderstood Byzantine painting. You surrender yourself that much better when you see your efforts confirmed by such an ancient tradition. It helps you jump the ditch"(F.116).

The southern sky of Nice also aroused the artist's imagination, by conjuring up the seductive atmosphere of a harem in his somber studios. Initially, particularly in the work in 1925–26, Matisse tackled the portrayal of figures in rooms, providing his models with a great diversity of clothing and accessories, presumably more to give the scene a framework than out of wish-fulfillment.

Matisse had made special studies of Gustave Courbet. He admired the great master and owned pictures by him *(Red-haired Woman Sleeping, Lady by the Seine, Blonde Woman Sleeping,* and a few drawings). He experienced in these pictures the sensuous and erotic presence of the nude, partially covered in scarves out of necessity and in part seductively naked with no artistic sublimation of the theme of sensual pleasure. "Needless to say, many of my students were disappointed to see that a master with a reputation for being revolutionary could have repeated the words of Courbet to them: *I have simply wished to assert the reasoned and independent feeling of my own individuality within a total knowledge of tradition"* was his reponse to Jacques Guenne in 1925 (F.56). More than ever Matisse was searching for his identity as an artist in the stillness of the studio.

34
1923. Lithograph, pl.42. 30 × 40.2 cm. 6 trial proofs on China and Japan paper; 10 artist's proofs; edition of 50, signed and numbered, on Japan paper. Duthuit no.432. Private Collection

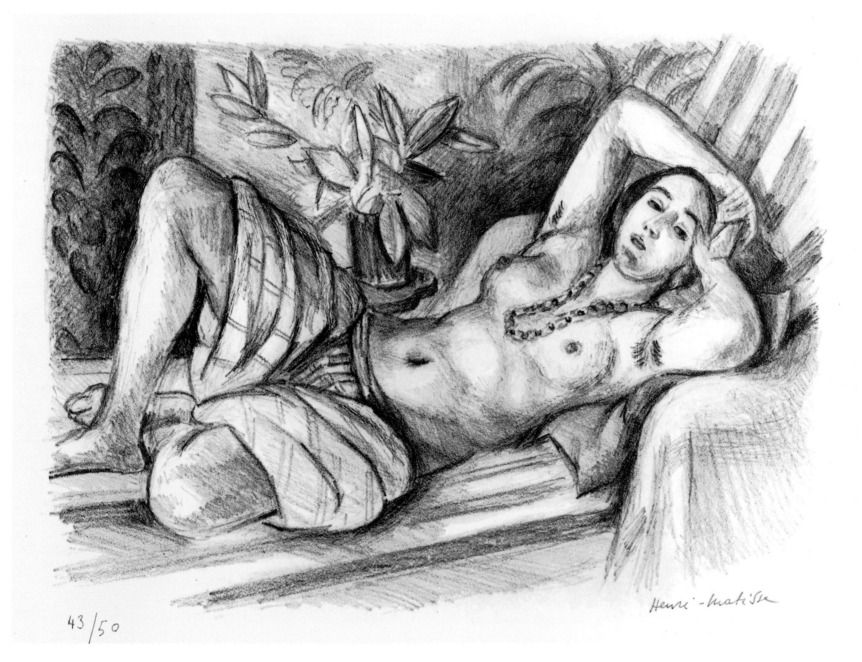

43/50

Henri-Matisse

35 GIRL ON DECK CHAIR IN A GROVE

(Jeune Fille à la chaise longue dans un sous-bois)

The inspiration previously given to Matisse's work by the vegetation and views in the garden at Issy-les-Moulineaux was again provided by the environs of Nice. The Mediterranean setting increasingly encouraged him to produce landscapes, as the lush meadows and parks of Tangiers had ten years before.

This was not expressed in his graphic output; with the exception of a few prints, it remained for Matisse a medium for figure work. There are no Bonnard-like vistas over wooded hills giving views of sea and mountains, no pictures of harbors or coastal landscapes – here the painter has sought the shade of the undergrowth and escaped from the dazzling light that bleaches out colors. He set the model in a thicket among trees, not on the grass like Manet or Courbet, but in a comfortable deck chair with a blanket. This provides solid, geometrical structures that have formal correspondences in nature's arrangement of the tree trunks. The lithe model fits like a bush or a plant into this framework, the flowing lines of her dress continue in the wildly growing tufts of grass, bringing out her closeness to nature. Her head and hat are suggestive of a bud. She is not reclining there casually or obliviously, but is instead watching the observer, the person opposite. The painter himself is a witness to the scene. He marks his presence by portraying his hat on the ground. In other words the artist is a magician, putting a spell on his subject matter, urging it into a fixed form and creating new realities and contexts. Although he puts his model among nature, she remains strangely indifferent and unaware of her surroundings, just as the chair has the effect of a foreign body that has been imposed upon nature. The elements in the picture have diverse origins: the model and chair from the studio, the cropped trunks and tufts of grass from a landscape that is infinite in size. Matisse unites them in a new symbiosis by creating pictorial areas that connect texture and pattern – the undergrowth, which makes it impossible to see far, has the character of a carpet and harmonizes with the fabric of the rug-chair-figure structure.

In this work the artist's pencil becomes a brush expressing possibilities equivalent to color not only in the depth of the tones but also through a uniform pattern that alters the function of objects and creates relationships within the picture without the qualities of the subject matter being lost. These are the beginnings of nothing less than a tightrope walk between abstraction and figuration, the difficult balance between taking distance from the subject matter and faithfully rendering nature.

35
1922. Lithograph, pl.36. 41 × 51.5 cm. 3 trial proofs; 10 artist's proofs; edition of 50, signed and numbered, on China paper. Duthuit no.425. Private Collection

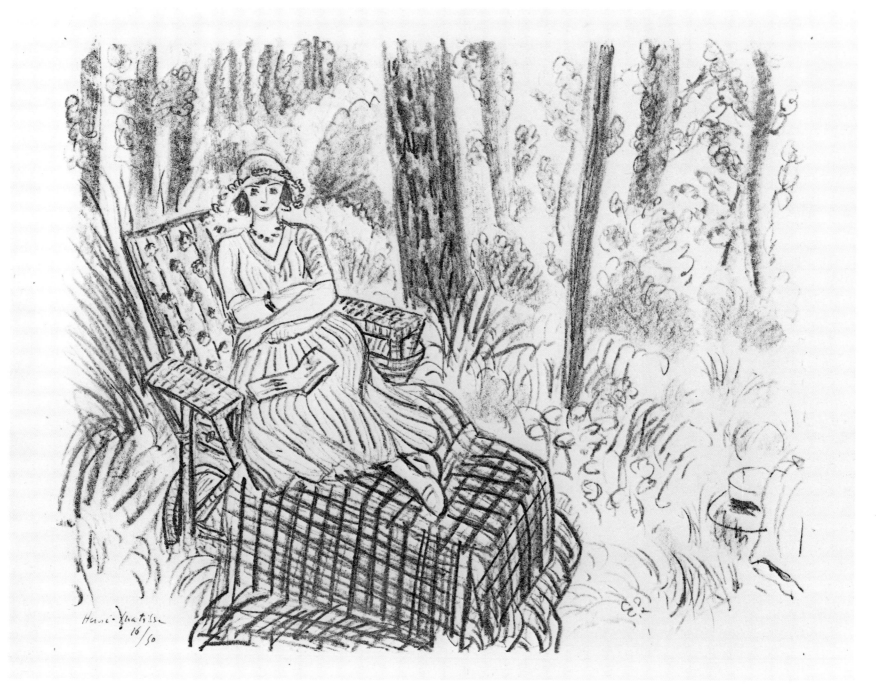

36 DAY

(Le Jour)

NIGHT

(La Nuit)

In spite of his intensive work on half-tones and painterly effects in lithography, Matisse constantly returned to line drawing as a kind of touchstone. Here it is an elemental artistic medium for capturing the three-dimensional physical form of his model, volume. Henriette's powerful, sculptural physique and intensive work on depicting the figure in an interior brought him back again to classical models, the Greeks and in particular Michelangelo. Matisse worked mainly in his studio but he maintained contacts with the Ecole des Beaux-Arts in Nice. Paul Audra, a friend and fellow-student from Gustave Moreau's studio, was administrator and frequently helped Matisse find new models. The artist found casts there by the old masters and had some made for himself, such as Michelangelo's *Dying Slave.* Drawing from these casts was a welcome change from his daily concentrated work and allowed Matisse to compare his own work with volumetric forms. That was how Matisse often came to spend an hour in the Ecole des Beaux-Arts: "He draws the plaster models freely there and takes the course of the sculptor Combier. Several sculptures from this period were to be cast in bronze and kept."[54]

Matisse worked in particular on casts from Michelangelo's tomb of the Medici, as the titles of the lithographs and the models' poses show. Michelangelo's baroque sculptures turn in on the room, twisting expressively, but Matisse seemed less interested in capturing a figure in space than in the rhythm of the limbs, which are shown in waking and resting poses. In order to bring out the subtle interplay of the parts of the body, he simplified the pose and traced the inner center of this positioning of the body with sensitive outlines. *Day* has a more tense sitting position and more animated lines, while for *Night* the artist pressed for a more relaxed reclining position – the poses deviating only slightly from their axial point and from their center of balance between sitting and lying. He once told his students at his own academy: "To feel a central line in the direction of the general movement of the body and build about that is a great aid. Depressions and contours may hurt the volume. If an egg be conceived as a form, a nick will not hurt it; but if as a contour, it certainly will suffer.... Draw your large masses first. The lines between abdomen and thigh may have to be exaggerated to give decision to the form in an upright pose"(F.43). Matisse found examples of this "central line" in classical sculpture: the line connects the fixed points from which flow the dynamic energy and volume of the sculpture. It was against these works that he gauged the strength and vividness of his own creations.

36 I
1922. Lithograph, pl.33. 25.5 × 29 cm. 1 test proof; 4 trial proofs; 10 artist's proofs; edition of 50, signed on the plate and numbered, on Japan paper. Duthuit no.419. Bibliothèque Nationale, Paris

36 II
1922. Lithograph, pl.32. 25 × 29.5 cm. 2 trial proofs; 10 artist's proofs; edition of 50, signed and numbered, on Japan paper. Duthuit no.418. Bibliothèque Nationale, Paris

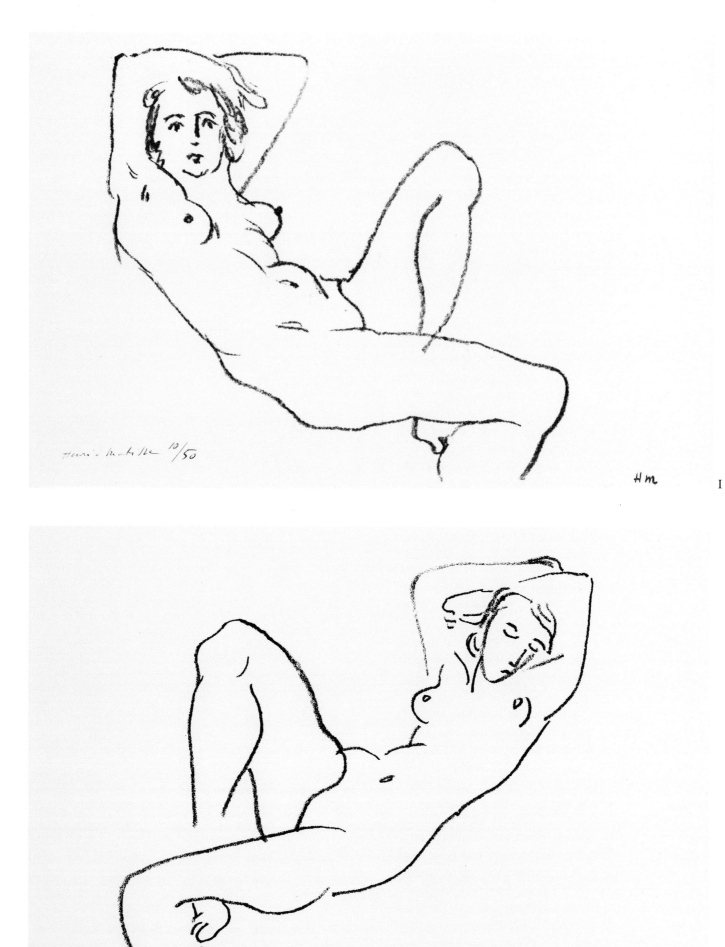

Henri-Matisse 10/50

Hm I

Henri-Matisse 8/50 II

37 NUDE SEATED IN AN ARMCHAIR, ONE LEG TUCKED UNDER

(Nu assis dans un fauteuil, une jambe repliée)

The model's "sleeping" pose does not evoke the relaxed position of someone asleep. In spite of her closed eyes and lounging air, the model's actual wakefulness is fully depicted by her complicated sitting position. The artist's models did not sleep and their poses always betrayed their inner tension and alertness. Matisse did not only call for full concentration from himself – he also required the active involvement of the model. This consisted of the total commitment of the body's energies and often required uncomfortable movement and positions that had to be maintained. "When I take a new model, I intuit the pose that will best suit her from her unselfconscious attitudes of repose, and then I become the slave of that pose. I often keep those girls several years, until my interest is exhausted. My plastic signs probably express their souls (a word I dislike), which interests me subconsciously, or what else is there? Their forms are not always perfect, but they are always expressive"(F.82). With Matisse the "attitude of repose" was more complex because it was generally taken from a series of movements, even when this took the form only of arm or leg movements while the torso remains still.

In this example the artist captures the momentary relaxation of the model's body when seated, adding the outline of the armchair afterward, as the lack of connecting lines shows. This massive armchair with the rounded angles was a prop in the interiors of that time and formed part of the model's sitting poses in many works during the early Nice years. Its soft curves make it an ideal partner in the picture and gently frame the form of the model's body. Matisse seems to have found the armchair he dreamed about in 1908: "What I dream of is an art of balance, of purity and serenity, devoid of troubling or depressing subject matter, an art which could be for every mental worker, for the businessman as well as the man of letters, for example, a soothing, calming influence on the mind, something like a good armchair which provides relaxation from physical fatigue"(F.38). Unpretentious, everyday objects are transformed in Matisse's work into important, formal motifs in the composition and vehicles whose interplay of forms complements, contrasts, or competes with the figure. "The emotional interest aroused in me by them does not appear particularly in the representation of their bodies, but often rather in the lines or the special values distributed over the whole canvas or paper, which form its complete orchestration, its architecture"(F.82). Here once again Matisse was embarking on a new orchestration of figure and object.

37
1922. Lithograph, pl.30. 39 × 25 cm. 1 trial proof; 10 artist's proofs; edition of 50, signed and numbered, on Japan paper. Duthuit no.420. Private Collection

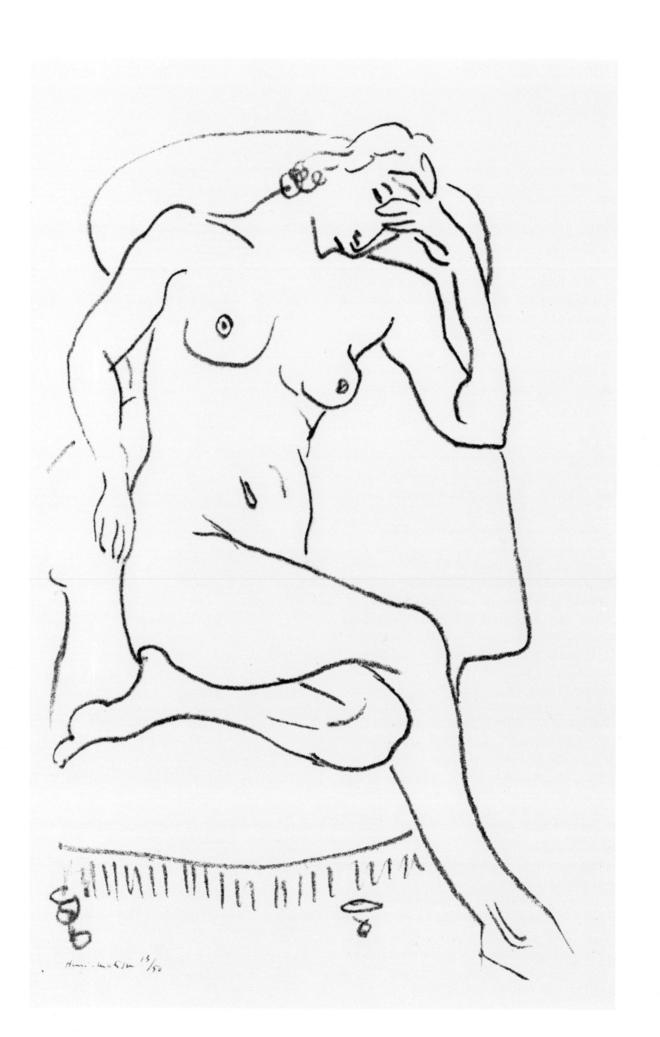

38 INTERIOR, READING

(Intérieur, la lecture)

This work is one of the most pictorial of the whole series of lithographs from the 1920s. The portrayal of the figure is suppressed in favor of the unusually large portion of the room depicted. Sitting in the armchair, Henriette, the model, is not treated any differently from the objects around her. The human figure is incorporated as an ornamental part of a larger setting.

All the elements of this composition can be found in the painting of the early 1920s. It is the third-floor apartment at Place Charles-Félix with views of the waterfront and the sea: "The third-floor apartment had regular size windows set at waist height.... There were two principal working rooms in the front, on the sea side. The larger of these with two windows and a fireplace, served as the primary painting and drawing studio.... He could look outward posing his women or still lifes by the windows... to the low line of houses on the Quai des Etats-Unis between his building and the beach."[55]

Matisse seems little concerned with perspective since the figure and chair do not fit in with the dimensions of the room, but the objects and parts of the room themselves are based on reality and appear to be accurate reproductions of the apartment and its furnishings. It seems as though Matisse wanted first to become familiar with his environment and restrained himself here from free interpretation. Individual elements in this lithograph had already appeared in paintings dating from autumn 1921 and 1923, when Matisse was settling into new living arrangements at Place Charles-Félix. These paintings fill out the color scheme of the objects in the lithograph: the brightly colored carpet (red, blue, and gold) beneath the window, Henriette's black-checkered skirt and the transparent, half-length curtains, as well as the shutter with the pink flowers and green leaves on a light background. A variation of this picture with a slightly altered angle of view, *Woman in an Interior at Nice* (1921–22), is now in the Barnes Foundation in Merion, Pennsylvania. The drawing shown here was probably produced somewhat earlier than 1925 – about 1922.

Matisse illuminates the room here with an oblique light that is reflected off the shutter and diffused to objects inside. He does not, however, represent the light conditions realistically in terms of the shadows, translating instead the tonal values that objects give off and grading them into rich black and white. In so doing he achieves a strange, unreal atmosphere of light. Matisse was a keen and relentless observer of light and color values: "I copy nature and I make myself even put the time of day in the painting"(F.56).

38
1925. Lithograph, pl.65. 27.2 × 19 cm. 6 trial proofs, one on Japan paper; 10 artist's proofs; edition of 50, signed and numbered, on China paper. Duthuit no.457. Bibliothèque Nationale, Paris

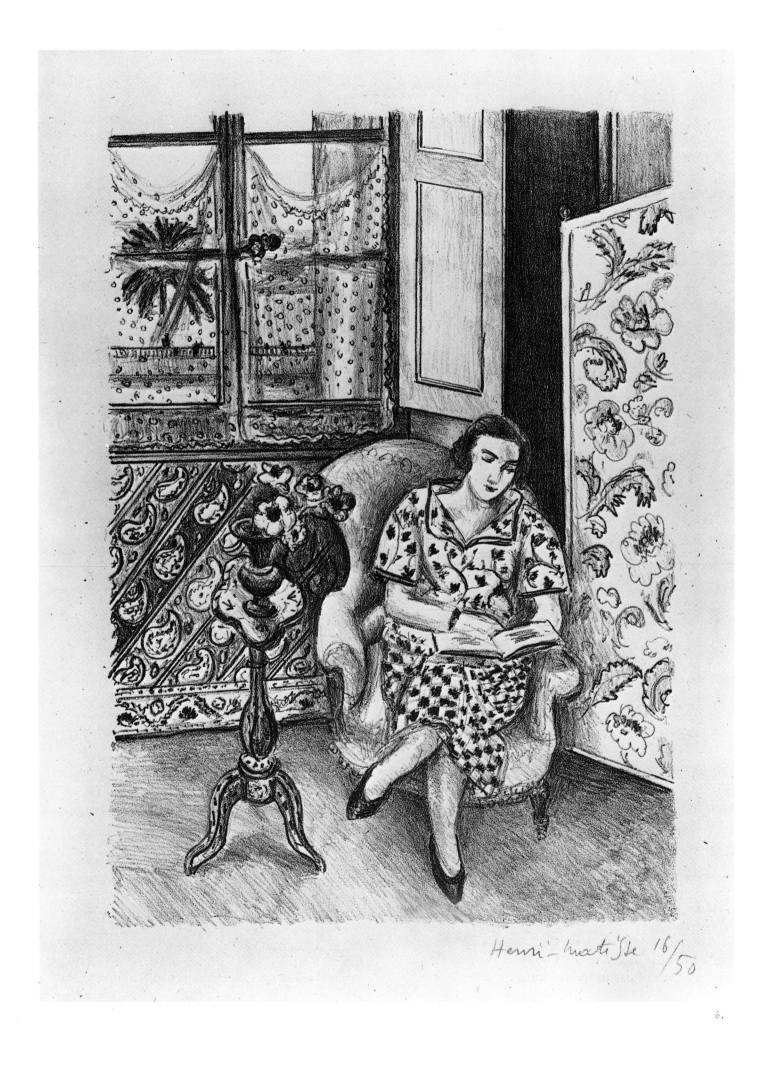

39 FIGURE IN AN INTERIOR

(Figure dans un intérieur)

In early 1929 a visitor came to Matisse's studio in order to collect material for a feature article entitled *High Society on the Riviera and in Italy*, which appeared in installments. He noted the following:

"On the last landing of the stone staircase with walls painted with frescoes, a card over an electric button: M. Matisse. Ring twice.

"An antichamber at the end of which was a window with views of the sea. To the right, a square room with two windows, curtains made of 'point d'esprit' tulle. Between the windows a piece of furniture from a pastry shop or a milliner's with oval mirrors on white lacquer panels standing on red tiles. On the mantelpiece a plaster Michelangelo's Slave, oranges, a birdcage, a phonograph with a pink, embossed horn that Matisse often plays on while he paints. On the wall the kind of paper you would find in a maid's room; on the ground an Arabian stool, some boxes. And running across the room above the famous paper-cutout screens, depicting an Arab woman, [a subject] which he painted so often, a wire for the oil lamp – a portable lamp with the skeleton of a shade. Behind the screen a model is cleaning the brushes on a bar of household soap. Over there hangs the violin, between the recent canvases, some still lifes. Matisse paints near the window. He is wearing a raw silk pullover. His wide-open eyes peer from behind gold-rimmed spectacles. At the moment he is fixing to the wall, with thumbtacks, some pieces of cloth which, moving in the sunlight, will become precious patches: 'The light cleans everything,' he says, pointing to some dusty corner of the town glinting under the sky."[56]

The lithograph shown records a section of this apartment and is a rare example among the prints. It is closely connected with the pictures *Interior with Phonograph* (1924) and *Interior, Flowers, and Parrot* in which one can see many of the objects the reporter described. The 1920s should not be dismissed in the work of the artist merely as his odalisque period. It is clear from this example that the figure has the function simply of an object in the work and is part of the whole architecture of the picture, which is composed of surfaces and patterns creating perspective. The artist is concerned here with spatial problems.

39
1925. Lithograph, pl.60. 47.9 × 32 cm. 4 trial proofs on Japan and China paper. Duthuit no.452. Private Collection

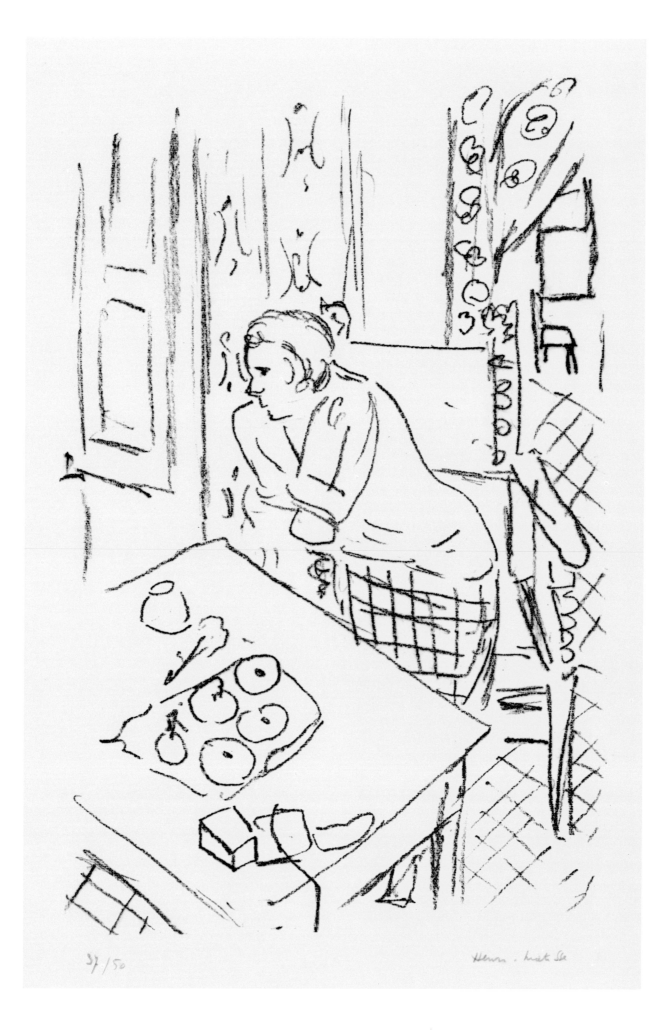

37/50 Henri · Matisse

40 NUDE WITH BLUE CUSHION (I)

(Nu au coussin bleu (I))

The title of this lithograph and the next – they are two stages – comes from the painting of the same name *Nude with Blue Cushion* (1924), although the blue cushion does not appear in either of these prints. The cushion was, presumedly, added for painterly effect. The focus here is completely on the model Henriette's beautiful, sculptural body. She fits into the contours of the armchair in a sensual sitting position that surpasses earlier variations of the picture in its monumentality and expressive power. In this much-varied pose with the arms folded above the head, the classical, uninterrupted physique is like a Greek torso. The breasts are set high, idealized. (Matisse, in fact, possessed an ancient cast of a torso that he had in front of him everyday.) The model's position with her arms raised effected this correction and created ideal conditions to capture the three-dimensionality of the body. The baroque position, with the foot jutting out into the undefined room and powerfully flexed knees, is reminiscent of *Day* and *Night* (Pl. 36) and thus a direct reference to Michelangelo. Matisse had already written to his painter friend Camoin in 1918: "I am working with Michelangelo's Lorenzo di Medici; I hope to instill in me the clear and complex conception of Michelangelo's construction."[57]

Parallel to the figure painting, Matisse turned to sculpture during this period and tried to solve three-dimensional problems by studying works by Michelangelo – the allegorical figures *Day* and *Night* on Giuliano de Medici's tomb in the San Lorenzo Medici chapel in Florence were of particular relevance. This lithograph comes at the drawing stage of this composition and it is not important whether Michelangelo's sculptures exerted a direct or an indirect influence on the seated position. The pose becomes a central theme of the picture and Matisse had a profound knowledge of sculpture that is reflected right down to the model's musculature. He was not interested here in the nude in a specific environment under certain light conditions, but in volume, mass, and internal dynamics, as we see in his treatment of surfaces and in the weight of the model. As Matisse had already advised his students: "Give the round form of the parts, as in sculpture. Look for their volume and fullness. Their contours must do this.... A drawing is a sculpture, but it has the advantage that it can be viewed closely enough for one to detect suggestions of form that must be much more definitely expressed in a sculpture which must carry from a distance" (F. 43–44).

40
1924. Lithograph, pl.55. 61.5 × 47.5 cm. 2 test proofs; 5 trial proofs; 10 artist's proofs; edition of 50, signed and numbered, on Arches wove paper. Duthuit no.442. Private Collection

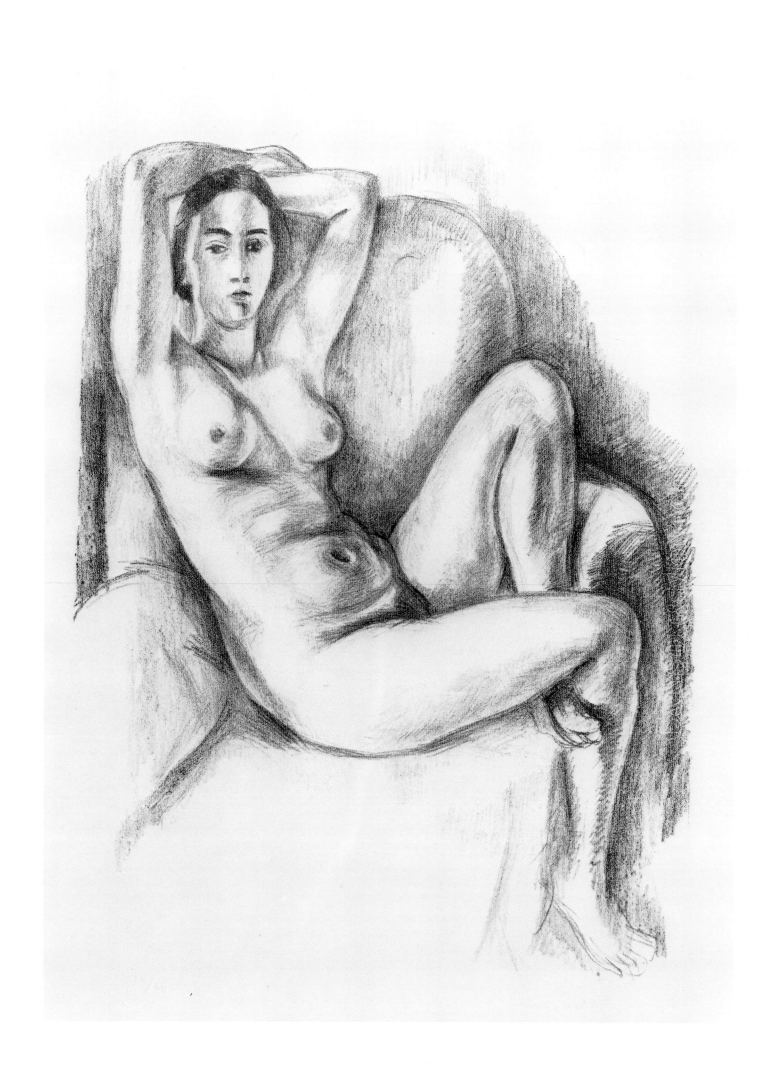

41 NUDE WITH BLUE CUSHION (II), BY FIREPLACE

(Nu au coussin bleu (II), à côté d'une cheminée)

This reworked version of the preceding lithograph highlights again a three-dimensional view of the body and is a close companion of the great bronze sculpture *Large Seated Nude* completed in 1925. Matisse drew a short distance from the model, hence the unusually impressive monumentality. While in his early creative phases he was more interested in surfaces, contours, and the effects of light, he now developed an almost scientific curiosity for mass, its weight and function. Examples from Michelangelo helped him in the baroque excess of the bodily twisting and the inner mobility of his figures. These skills are to be seen in Matisse's work in the uneasy highlights and shading, which do not follow any one source of light, conveying three-dimensional values instead.

The second stage of the lithograph shown here brings this out clearly. The contrast of light and dark is increased, and the highlights begin to dazzle and vibrate. This heightens the body's sensuous radiance. Although the sitting position was not changed, the model seems more tense and active, closer to *Day* than to *Night* in the subtle balance of reclining and sitting. The effect of the picture is intensified by the precise setting, with the fireplace added in the background and with the delicate pattern of the cloth laid prominently over the armchair. These are elements from painting; they rely on the artist's distinctive perception of the material and formal relationship between things. Matisse portrays the model extremely vividly, particularly in the torso area, and this is picked up by the chair, creating an illusion of depth, while the geometrical, flat section of the fireplace takes up this perspective again and drives it back into the picture's surface. A peculiar interplay of forces is thus established; the picture can never quite be fixed and the attention is constantly taken back to the model's torso and lap.

This impression is reinforced by the fragmentarily worked extremities. "The painter who composes on the grand scale, carried away by the movement of his picture, cannot stop over details...," the master replied to his friend Louis Aragon (F.73). And in 1935 he wrote: "What is significant is the relation of the object to the artist, to his personality and his power to arrange his sensations and emotions"(F.73). The artist's feelings towards his subject matter as conveyed in the composition are prerequisite conditions for a living art which is not frozen into formality or mannerism. Matisse had learnt this from Michelangelo but also from Courbet, Cézanne, and the old master Renoir, whom he had frequently been to see in Nice.

41
1925. Lithograph, pl.63. 63.5 × 48 cm. 1 trial proof; 10 artist's proofs; edition of 50, signed and numbered, on Arches wove paper. Duthuit no.454. Baltimore Museum of Art, Cone Collection

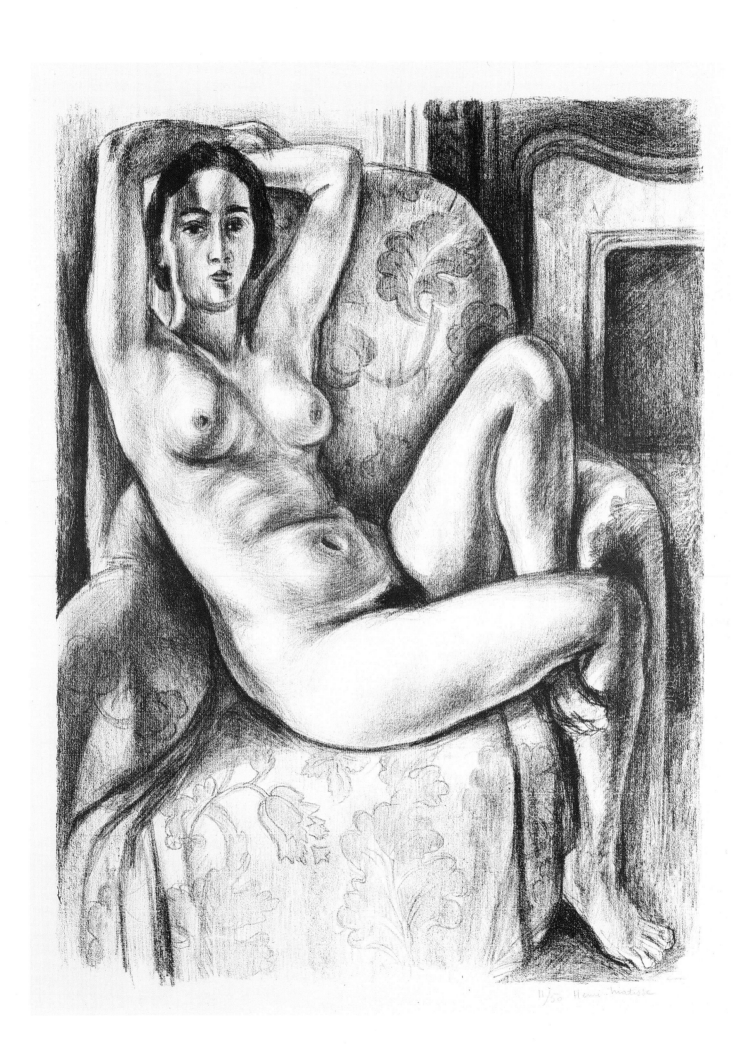

42 LARGE ODALISQUE IN BAYADERE PANTALOONS

(Grande Odalisque à la culotte bayadère)

"To achieve a direct and pure translation of emotion you have to possess intimately all the means and to have experienced their real efficacy."[58]

Matisse now put everything into his black-and-white art. He increased the contrast of light and dark to an almost intolerable level and gave the black tones a great quality of depth with the litho chalk. Tricks such as using various quality paper (from Arches wove paper to China paper) in each pull helped the print to turn out differently. Experience previously gained with materials obviously increased the artist's pleasure in exploiting the palette more intensively from deepest black to dazzling white and applying the methods even more effectively. The print that issued from this laborious process is considered today to be the most valuable, and hence the most sought after, of Matisse's lithographs. This process also produced the outstanding example of an odalisque picture, symbol of leisure, luxury, splendor, and sensuality, just as Ingres and Delacroix had created.

Henriette, the model, is less sculpturally depicted – the Oriental pants with the strong stripe pattern catch the eye and make the upper body appear delicate. This impression is supported by the fine floral pattern of the armchair which in its front-on position acts like a frame, similar to the mandorla in an icon picture, and gleaming out of the darkness of the background. We are reminded here of the first odalisque pictures, of the Italian model Lorette, which were made during the First World War. There, too, the model-chair motif against a dark background was treated in a monumental but very flat manner.

Matisse went back to previous masters again and again. *"For my part, I have never avoided the influence of others, I would have considered it cowardice and lack of sincerity toward myself.* I believe that the artist's personality affirms itself by the struggle he has survived. One would have to be very foolish not to notice the direction in which others work" (F.55). He always let himself be guided by great masters like Manet, Courbet, and Rembrandt: "Rembrandt's painting is obviously painting in depth," he declared early on (F.140).

In spite of the warmth and depth provided by the paint-like black, the model's portrait takes on a strangely cool air. Her passivity and resting pose reinforce this impression and as a result prevent the viewer's complete emotional identification with the person. Our gaze is consciously trained on the grand appearance of things, on material things rather than the individual figure. The artist has also ruthlessly left out part of one foot, which would only have dis-

turbed the balance were it there. The result is a figure that is neither an idol nor an individual, that both attracts and alienates at the same time.

42
1925. Lithograph, pl.64. 54.5 × 44 cm. 1 test proof; 3 trial proofs; one on Arches wove paper; 10 artist's proofs; edition of 50, signed and numbered, on China paper. Duthuit no.455. E.W.K. Collection, Bern

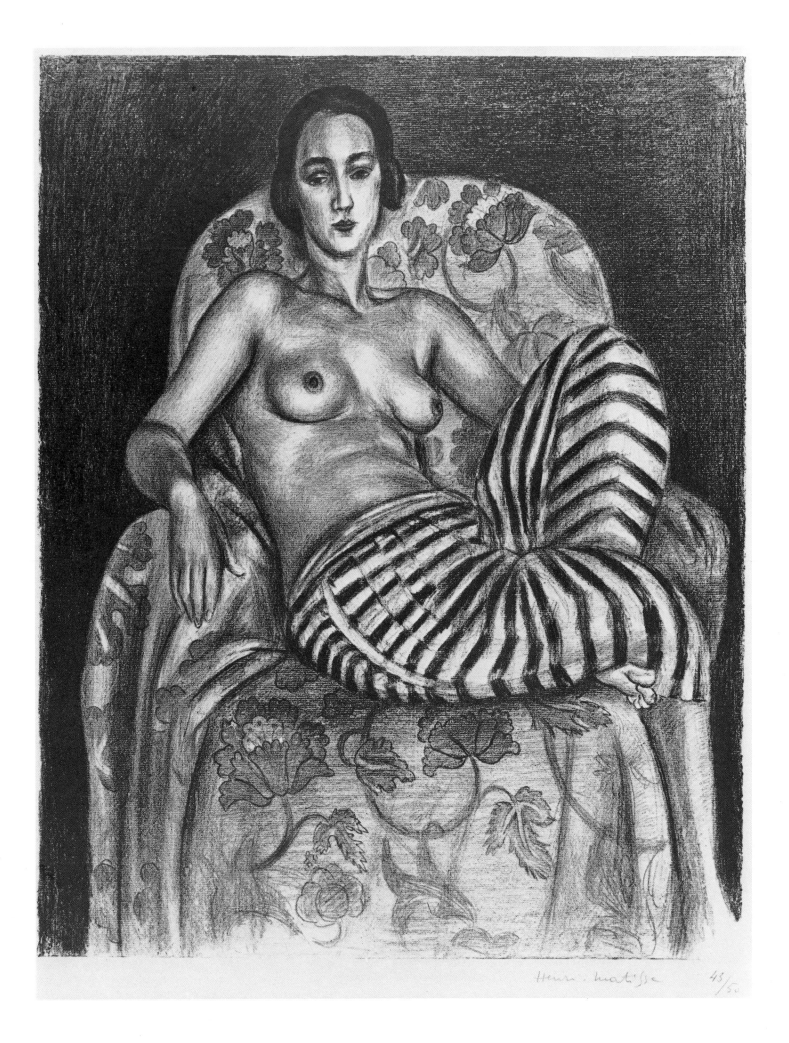

Henri-Matisse 43/50

43 NUDE, LEG CROSSED, STUDY OF LEGS

(Nu, jambe repliée, étude de jambes)

STUDY OF LEG

(Etude de jambe)

Line drawing developed in parallel to chalk and pencil drawings, from picture to picture. This quicker form of noting movements as the model made them was a more efficient way of grasping ideas for pictures. "To draw is to make an idea precise. Drawing is the precision of thought," was Matisse's definition of this act of creation (F.123).

The line drawings look spontaneous but are actually products of much reflection. He already carried a picture of the subject matter within himself and transformed it through his imagination onto the paper; it was here that his great artistic creativity operated. The spontaneity that the observer feels is due to the expressive distortion, to Matisse's carefree attitude to revising his work, and to the fragmentary nature of individual portrayals. They leave the impression of rapid studies, a preliminary stage of the picture. Frequently, in fact, no such experiments precede the picture, as Waldemar George, a contemporary of Matisse, pointed out in 1925: "Matisse's drawings are the drawings of a painter. But most of them do not represent, properly speaking, drafts for pictures. If the artist made use of them in this way he changed them subsequently, according to the requirements of rhythm and color."[59]

Although it was in the 1920s that drawing was most closely interwoven with painting and sculpture, reflecting – as already noted – problems in these domains, it nevertheless represented for the artist a world of its own with its own principles. It was possible to heighten realistic aspects in chalk drawing, and from time to time Matisse came close to depicting graphically an object in terms of its structure, material, and appearance. In fact, though, it would have been difficult to sustain this high degree of realism in painting without risking bad taste. Rapid line drawing, in turn, runs the danger of slipping into the grotesque. For Matisse, however, rapid line drawing meant fixing on paper, in a virtuoso manner, his models' numerous sequences of position. These rhythmic variations revealed to the artist the scope of display of which the body was capable.

Six versions of the studies of legs were produced, and when put side by side, they are reminiscent of film clips. These sketches follow from the nude studies of 1906 and 1913, seeking to convey contours that contain outlines and movement. The leg study is the first of a rich series of variations for pictures and led to what is probably the most well-known version *Pink Nude* (1935; Baltimore Museum of Art). Twenty-two stages of this picture have been photographed and recorded, documenting the long and often arduous creative process behind a painting. In Matisse's prints, however, there are very few stages, although there are numerous variations of certain motifs. Matisse concentrated more and more on such individual picture themes and their variations.

43 I
1925. Lithograph, pl.68. 29 × 54 cm. 5 trial proofs; 5 artist's proofs; edition of 25, signed and numbered, on Japan paper. Duthuit no.463. Private Collection

43 II
1925. Lithograph, pl.71. 25 × 50 cm. 4 trial proofs; 10 artist's proofs; edition of 50, signed and numbered, on Japan paper. Duthuit no.460. Private Collection

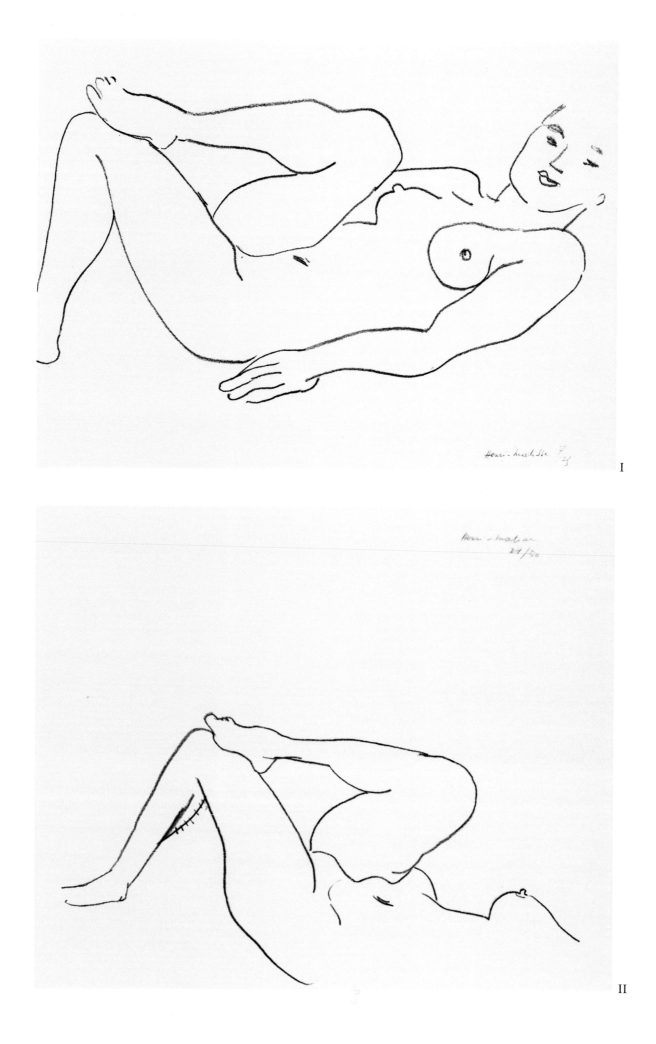

I

II

44 WOMAN WITH NECKLACE

(Femme au collier)

The odalisque theme brought Matisse to the attention of a wider public during the 1920s. This is attributable not least to the busy exhibition schedule after the First World War. Matisse showed his work almost every year from 1919 in the Galerie Bernheim-Jeune at 83 Rue du Faubourg Saint Honoré, Paris. He had had a contractual agreement with this gallery since 1909, and he maintained the arrangement until 1926. In the first half of the decade his paintings dominated these exhibitions, whereas his drawings and prints were predominate afterward. Thus, his drawings were shown in 1925, and then a large series of prints in Paris (Bernheim-Jeune) in 1927 and in London (Leicester Galleries) in 1928. Demand for works by recognized artists had increased the world over, and America was in the forefront. "A great desire for objets d'art is spreading in the United States; really fine galleries are now to be found even in very small towns.... They are making magnificent efforts to popularize art. The generations coming up will be more versed in art than the present one.... There is also what is sometimes called an 'atmosphere of art' in the United States," was the news heralded in Paris by 1922.[60] An explanation for this upswing in the American art market came in 1930: "American enthusiasts would not have managed so well in recent years to bring together so many treasures if political, economic, and financial troubles after the war had not led to the dispersal of some of the great English collections and most German and French collections."[61]

A network of new galleries and young art dealers grew up in Paris as it did in London, Germany, Great Britain, and the United States. Pictures sold quickly and well. Matisse commanded the highest prices and his work spread throughout the world, often changing hands for a second time. After the death of Renoir in 1919 and Monet in 1926, he was one of the most sought after living artists, until Picasso challenged this supremacy at the end of the 1930s. The 1920s also saw Matisse receive his first official signs of recognition: in 1925 he became a Chevalier de la Légion d'Honneur, and in 1927 he was awarded the first prize by the Carnegie Institute in Pittsburgh for *Still Life with Bowl of Fruit* (1925). Art critics began to write about Matisse: Elie Faure, Jules Romains, Charles Vildrac, Léon Werth (Paris 1920), the collector and politician Marcel Sembat (Paris 1920), Florent Fels (Paris 1929), Roland Schacht (Dresden 1922), Adolph Basler (Leipzig 1924), Henry McBride (New York 1930), and numerous newspaper articles.

The first volume of drawings dates from 1920, selected by the artist himself, and in 1925 a new collected volume appeared. Litho-

graphs printed by Clot and Duchâtel also enabled a wider public to buy a work by this artist. It should not be overlooked, therefore, that the increased graphic ouput of this period was connected with a growing art market that put new demands on the artist beginning in 1922, after a break of several years.

44
1925. Lithograph, pl.74. 51.5 × 39.5 cm. 4 trial proofs; 10 artist's proofs; edition of 50, signed and numbered, on Japan paper. Duthuit no.467. Private Collection

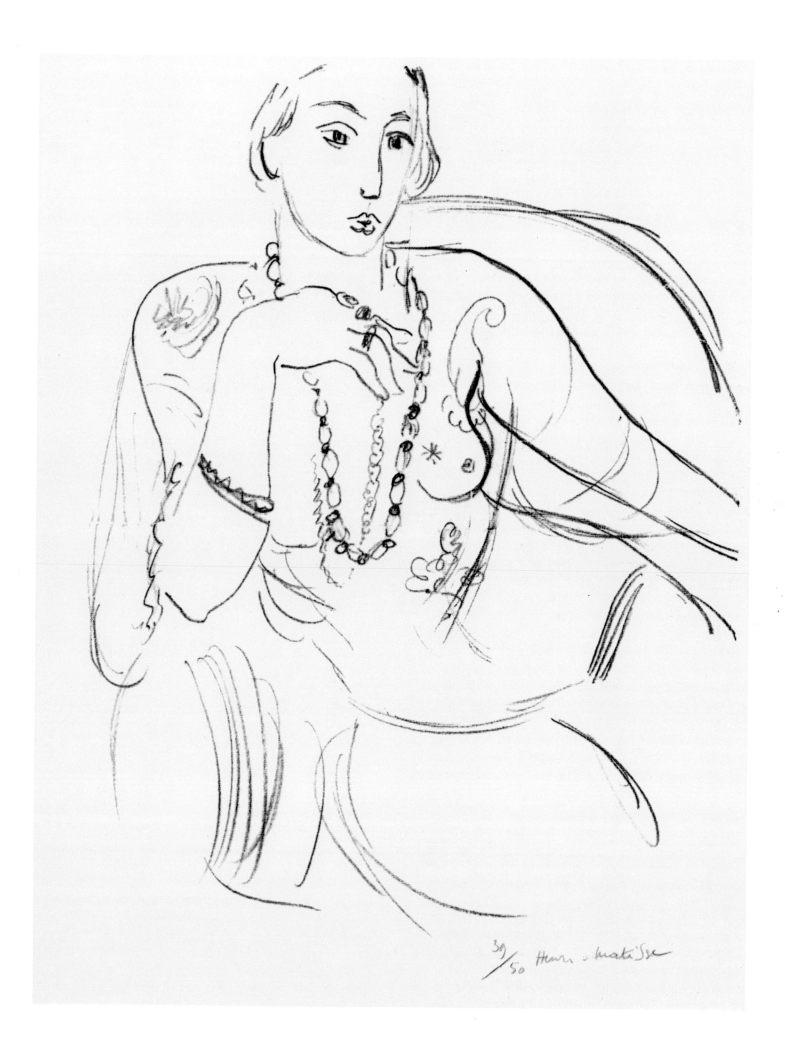

45 SEATED NUDE IN TULLE BLOUSE

(Nu assis à la chemise de tulle)

Henriette, the model, is sitting on the floor rather than in the customary rounded armchair. The curves of her body are set against the strong geometrical lines of the room and the background, making for a simple, clean composition. Matisse had cut loose from portraits in the armchair and began now to explore this floor pose. This model's characteristic knee position has been retained, but the room adds to the quality of the picture and its tone. The room is defined simply by the line on the floor that separates the carpet from the striped pattern on the wall. The room has neither perspective nor accessories yet conveys an impression of being large through the contrast created by the loud decor. The model's pose matches the rhythm of the pronounced vertical stripes and the horizontal line of the floor. The earlier partnership of nude and armchair is translated here into the pattern of the room, again creating a new relationship of body and environment, model and interior. The lithograph became a preliminary stage to the most unusual work in the second half of the 1920s, *Decorative Figure on Ornamental Background* (1925–26; Musée National d'Art Moderne, Centre Georges Pompidou, Paris). This painting is a highly concise and severe composition that expresses what Matisse had said as early as 1908: "Composition is the art of arranging in a decorative manner the diverse elements at the painter's command to express his feelings. In a picture every part will be visible and will play its appointed role, whether it be principal or secondary. Everything that is not useful in the picture is, it follows, harmful. A work of art must be harmonious in its entirety: any superfluous detail would replace some other essential detail in the mind of the spectator"(F.36).

Nudes were now in vogue, and much sought after. They were used more and more in photography. Earlier, at the turn of the century, nude photos served the artist as an aid in specialized journals such as *Etude Académique* or *Mes Modèles* and went some way towards replacing paid models. This medium was gradually becoming an art form of its own with master photographers. Man Ray's nude photographs of Kiki de Montparnasse in 1922 prove this point. It was also Man Ray who visited Matisse in his studio, leaving us photos of Henriette and Matisse.

Matisse was no photographer but, although he worked from nature, he appreciated the assistance that this medium offered: "Photography has greatly disturbed the imagination, because one has seen things devoid of feeling. When I wanted to get rid of all influences which prevented me from seeing nature from my own personal view, I copied photographs," and "I copied... photo-graphs, forcing myself to make the greatest resemblance possible; an image with as good a likeness as possible. I thus limited the field of possible evolutions from my imagination"(F.66, n.2).

45
1925. Lithograph, pl.69. 36.8 × 27.9 cm. 7 test proofs; 1 trial proof; 10 artist's proofs; edition of 50, signed and numbered, on China paper. Duthuit no.465. Private Collection

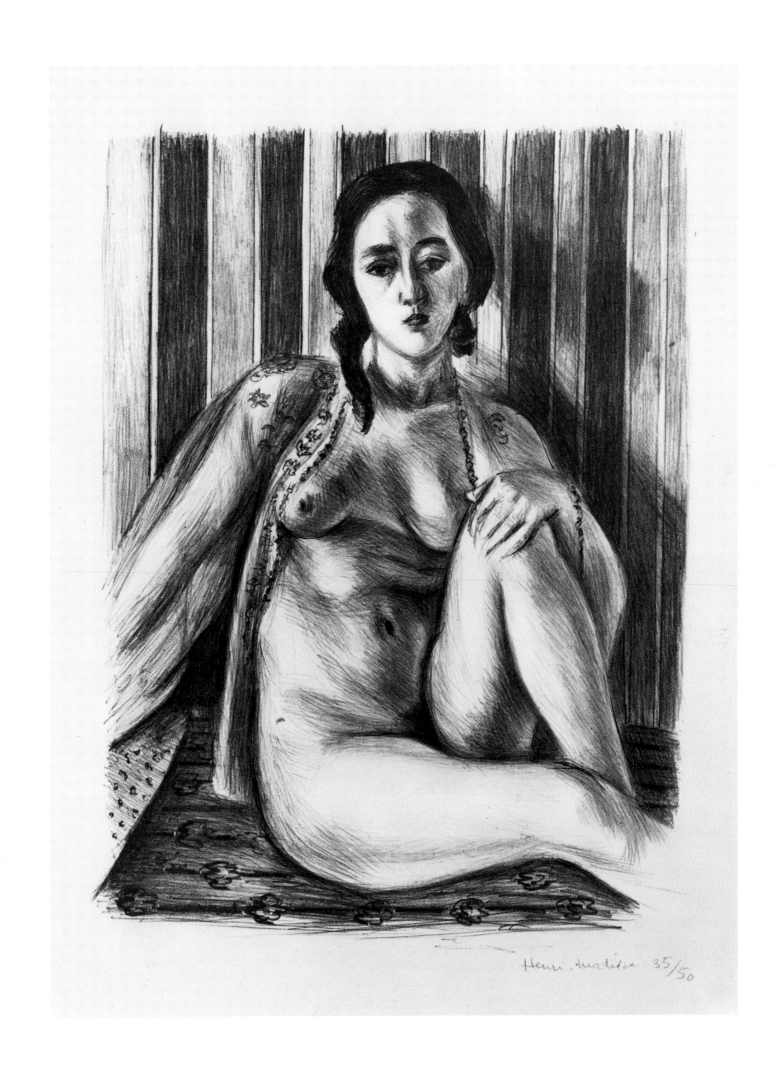

Henri Matisse 35/50

46 ARABESQUE

The term *arabesque* is often used to characterize Matisse's art. It covers the decorative, ornamental, and vine-like elements in his pictures. Matisse himself employed the description many times and it is in keeping with his deeply rooted sense of decor, which he obviously gave great consideration to. Pierre Schneider has pointed out that both the artist's mother and father were initially involved with textiles (salesman in a textiles business and milliner respectively): "From his earliest childhood in Bohain-en-Vermandois, a small village situated between Le Cateau and St Quentin, Henri Matisse had had close contact with the world of fabrics. In common with most other villages in the region, the locals worked in the fields for most of the year and spent winter indoors weaving for the big Paris firms. 'We used to make Indian shawls,' Matisse later recalled. 'It was when they were commonly worn across the shoulders, as in old Flemish paintings, and they were decorated with palmettes and fringed at the edges.' Down in the cellars where the looms were kept, they also used to weave blankets, dotted muslin, Lyons-style articles and brocades."[62]

When Matisse arrived in Biskra (Algeria) for the first time in 1906 he found Oriental articles pleasing to the eye and took fabrics, carpets, and ceramics home with him. Matisse loved to be surrounded by brightly colored, sometimes expensive, textiles and objects. They helped him to find new inspiration for his work in their often expressive forms, their gleaming colors, and rich variety of patterns. The rooms of his studio must at times have looked like a fabric shop. He used to hang the fabrics over a high scaffold-like framework. It served as a new wall pattern, a kind of walk-in wardrobe, and its motifs became important pictorial elements in his interiors. A rich selection of background materials appears in the work of the 1920s. It shows the artist's distinct preference for floral patterns. These extended increasingly and over ever greater areas of the background and seem even to continue beyond it, becoming autonomous parts of the picture, as the lithograph illustrated here shows so clearly. The scene, the model in the armchair, seems to be caught with a zoom lens, while the fine background material with its bird design gives the impression that it is on the same focal plane as the familiar floral seat cover and the model's embroidered blouse. The blouse's paisley pattern seems to be freed from the body, independent, and it is only by looking closely that we see the curves of the breasts and make out Henriette's body. Model, objects, and pattern are compressed into a uniform focal plane, and the patterns of climbing flowers and curves overrun the whole surface of the pic-

ture. Only the head and arms retain a certain three-dimensional presence, and the smooth whiteness of the skin stands out in sharp contrast to the floral pattern.

46
1924. Lithograph, pl.58. 48.3 × 32 cm. 8 trial proofs; 10 artist's proofs; edition of 50, signed and numbered, on China paper. Duthuit no.449. Bibliothèque Nationale, Paris

9/50 Henri Matisse

47 UPSIDE-DOWN NUDE WITH BRAZIER

(Nu renversé au brasero)

The arabesque has now completely taken over the figure, which in form and position fits in harmonically as a decorative part into the fabric of the picture. Or, rather, the unusual arrangement of the figure dictates the decorative character of the background. The patterns here do not overwhelm the objects – instead the objects co-exist as fragmentary patterns in the picture and form a decorative, thoroughly composed whole. If a parallel is to be drawn with painting, then the previously mentioned picture *Decorative Figure on Ornamental Background* (winter 1925–26) comes to mind, as do the pictures of the odalisque lying on the floor with brazier and table (1926–27). They are connected with the lithographs of 1926, which were conceived in the same spirit (Duthuit nos. 110 and 128). If one assumes for the print shown here (as also for Duthuit nos. 147, 151, 153–54, 156–57) an earlier date of origin (1926–27) – which shines through stylistically and in terms of motif – then the graphic version would be contemporaneous with the painting, suggesting thereby a fruitful interaction between the media Matisse employed. (The jump in time to 1928–29 would then occur at Duthuit no. 150.) Dominique Fourcade's remarks on painting in general and on *Decorative Figure on Ornamental Background* in particular are appropriate: "The decorative is not the decor! The figure holds itself against the decor, but it is the figure that is decorative, the decor is only ornamental.... Here the decorative is a strongly accentuated volume. It is not an architecture of light as before; it is an architecture of forms, supported by a system of very firm and structured lines. The decorative in this painting is a sculpture isolated from its environment, separate and distinct, a presence without ambiguity, distracted from a space that is more ambiguous than ever."[63]

One further feature can be added – clearly the long-standing model Henriette inspired this lithograph. This establishes a direct line to the virtuoso studies of legs from 1925 (see Pl. 43). The brilliant pictorial invention with the physical contours of the nude in an upright perspective and the perplexing, ambivalent room made up of fragments, relies on great knowledge of the subject matter, figure, and setting. It seems here to be his first apartment at Place Charles-Félix (1921–27). The comparison Matisse made with the juggler in 1942 is apt here: "I think of a juggler who learns to juggle with two balls then with 4, 5, 6, then he adds to all these a spoon, then his hat. One should not work with elements from nature which have not been exposed to one's feelings."[64]

47
1929. Lithograph, pl. 120. 56 × 46 cm. 3 trial proofs; 10 artist's proofs; edition of 50, signed and numbered, on Arches wove paper. Duthuit no. 500. Bibliothèque Nationale, Paris; trial proof

48 THREE MODELS

(Les Trois Modèles)

This large-format lithograph, in which the third model is not immediately evident, has close ties with the companion painting and takes up the same pictorial motif of Orientally dressed models in an elaborately ornamented interior, similar to Delacroix's *Algerian Women* (1834).

The models are sitting or lying on the floor in relaxed poses, surrounded by objects and fabrics. We are familiar with the Oriental tray, the vase of flowers, scent bottles, and saucer from various pictures. The oversized and heavily stylized large pattern has highly varied qualities of color in the painting. The draped curtain is golden yellow, the round shape to the right represents a Moroccan floor cushion, presumably yellow in color to counterbalance the curtain, the lemons, and the brassy gleam of the tray. The floor and clothing must also have had brilliant tones of red, blue, and green – in short the attempt to color the lithograph in line with the picture he created at the same time becomes a game, making one aware just how much Matisse worked on his line drawings with colors in his mind. It was color and light values that guided his pencil over the bright surface of the paper. "My line drawing is the purest and most direct translation of my emotion. The simplification of the medium allows that. At the same time, these drawings are more complete than they may appear to some people who confuse them with sketches. They generate light; seen on a dull day or in indirect light they contain, in addition to the quality and sensitivity of line, light and value differences which quite clearly correspond to color" (F.81).

Matisse was thinking above all in patches and areas when he drew lines here, and less in contours that defined volumes. The figures work like walk-on parts on a stage, no longer possessing any individuality, no volume or weight of their own. The great experience of color that the artist had gained from several years of working on the same themes in the more or less constant light conditions of an interior allowed him now a high degree of abstraction in line drawing.

48
1928. Lithograph, pl.109. 44 × 74.2 cm. 4 trial proofs; 10 artist's proofs; edition of 50, signed and numbered, on Japan paper. Duthuit no.495. Bibliothèque Nationale, Paris

49 DANCERS (FROM THE SERIES *TEN DANCERS*)

(Danseuses (de la série "Dix Danseuses"))

In 1919–20 Matisse had worked for the Ballets Russes for the first time and designed the costumes and decor for a ballet version of Stravinsky's opera *The Nightingale.* There was another production in 1925. Frequent contact with Serge Diaghilev and Leonide Massine introduced Matisse to the atmosphere of the theater and, in addition, he was an assiduous concertgoer in Monte Carlo: "on Friday afternoon... I give myself some time off. It is the day when concerts are held in Monte Carlo," he wrote to his friend Camoin.[65] The organizers of the Ballets Russes in Monte Carlo tried again and again to persuade Matisse to collaborate with them. Oddly enough, he did not agree again until 1939, when he worked on the ballet *Rouge et Noir* from Dimitri Shostakovitch's First Symphony.

Matisse had come to know Henriette, his model, in the "Studios de la Victorine," and for him she also embodied the world of dance. In 1927 the first and only volume of graphics by Matisse, *Ten Dancers,* was published by Duchâtel in Paris on various qualities of paper (China, Japan, and Arches). Unfortunately the order in which the prints came into being is not known. They were produced over one or two years. The most we can assume is that the sequence of the line drawings and the sequence of the prints modeled in half-tones form a block, since at that time Matisse often used to move from a realistic concept to a free, improvized line interpretation.

The dancer is never shown dancing, but she creates a movement of her own in the succession of poses. She is presented in delicately graduated tones of light and shade or in rapid outlines where the wealth of material from the tutu plays constantly about her body. The tutu breaks the flow of the body's lines, extending decoratively into the room but suggesting the dynamics of dance in the flying material. This is not the "farandole" seen in the great panel *Dance* (1909–10) for the Russian Sergei Shchukin – these are resting poses that capture the dancer's profession and inner physical tension in its graceful elegance. The tutu and the pose both serve to bring out these dynamics and to lend weight to the artist's comment: "I feel the connections between things that delight me."[66]

49 I
1927. Lithograph, pl.91 or 99. *Danseuse endormie au divan (Dancer Sleeping on the Couch).* 28 × 46 cm. 8 copies on Arches H.C.; marked A to H, 5 copies on China paper; 15 copies on Japan paper; 130 copies on Arches. Duthuit no.485. Private Collection; on China paper

49 II
1927. Lithograph, pl.97 or 90. *Danseuse étendue (Dancer Stretched out).* 25.3 × 42 cm. Copies same as above. Duthuit no.488. Private Collection; on China paper

150 copies of album, each containing 10 original lithographs, signed and numbered, on different quality paper; published in 1927 by the Galerie d'Art contemporain de Paris

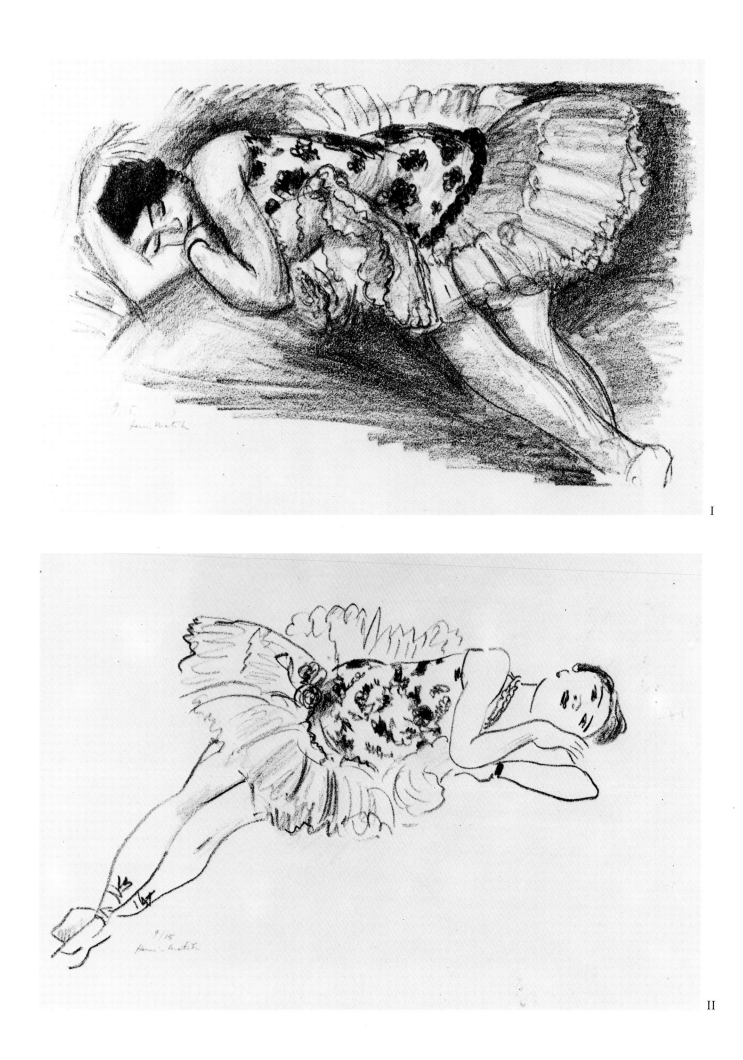

I

II

50 THE PIANIST ALFRED CORTOT

(Le Pianiste Alfred Cortot)

Matisse had a profound relationship with music. He played the violin and during the First World War took lessons from the Spanish violonist Juan Massia. He would later play with the Belgian violinist Armand Parent. Pierre Matisse, the artist's son, recalls that his father had hoped to see him become a violinist. Matisse played his instrument almost every morning – for him playing meant practice for his fingers, concentration, and mental tuning. A violin or violin case occasionally features in pictures, as does a piano. Nevertheless, portraits of musicians are a rarity in the artist's work – the previously mentioned Juan Massia (1914), Eva Mudocci (1915), the violinist and lover of Edvard Munch, the Argentinian cellist Olivares (1914), and Alfred Cortot (1926–27). He produced drawings of Cortot playing the piano and four prints of studies of heads.

In the version shown here Matisse did not choose the musician's improsing profile, going instead for the difficult three-quarter view. He seemed, however, to know the face with its roguish locks already from previous studies, and was able to achieve an almost mask-like abstraction. A photograph of the musician taken at the same time emphasizes Matisse's masterly hand in this brief, expressive portrait, a testimony to the artist's strong gift for observation and transposition. The pianist's introverted expression and the way the head is held suggest that Matisse was trying to capture the musician as he played. Matisse began the portrait on January 25, 1926 in Cannes while Cortot was practicing. Stimulated by the musician's striking face, Matisse caught him in these rapid stokes. On January 30, of the same year Cortot referred to a concert in Nice followed by dinner with Matisse.

The unusual portrait was an isolated work from the harem series from the 1920s and prefigures the many studies of heads from the 1930s and 1940s.

Alfred Cortot. 1926. Photograph by Jean Cortot

50
1927. Drypoint, pl.106. 13.8 × 8.6 cm. 2 proofs with printing directions; edition of 15, signed and numbered, on laid paper. Duthuit no.112. Private Collection

3/15

Henri-Matisse

51 PERSIAN WOMAN

(La Persane)

In the fall of 1926 Matisse changed apartments, moving to the top storey of the same building at Place Charles-Félix which had large studio rooms. In 1927 he also changed his model; dark-haired, full-breasted Lisette brought the Orient closer again. She became "Persian," "Indian," with a veil or turban, a nude, in harem pants or a transparent tulle skirt – never less than sensuous and seductive. She was pictured with the Moorish chair on many occasions. Her poses were a continuation of earlier variations. While the works from the model Henriette reflect contact with Michelangelo and sculpture, Lissette reminds us more of Ingres. Icon-like in her face-on pose, idol-like in her southern charms, she is reminiscent of previous models such as Lorette and Antoinette.

In the lithograph shown here she is enveloped in the sensuous, mysterious atmosphere reminiscent of Ingres's *Madame de Senonnes* or Leonardo da Vinci's *Mona Lisa*. It follows essentially a fine preliminary drawing in pencil, which has the quality of an Ingres. Matisse concentrates on material substance, highlights, and shadows, sensuous aspects approached paradoxically with hard, cool realism. The model sits in front of a geometrical network – which are, in fact, the imitation wall tiles commonly found in studio apartments. A heavily contrasted relationship between round, soft, glazed forms and simple geometrical structures emerges, unified by the paint-like tonal values of the chalk that fill the whole picture and give it its warmth.

In his writings Matisse often referred to the direct influence of the East: "If I instinctively admired the Primitives in the Louvre and then Oriental art, in particular at the extraordinary exhibition at Munich [a major exhibition of Islamic art] it's because I found in them new confirmation. Persian miniatures, for example, showed me all the possibilities of my sensations. I could find again in nature what they should be" (F.116). Impressions from this experience often came back to him years later and found new artistic interpretation. The delicate concubine in the first pencil drawing became in the lithograph an iconical portrait that is monumental, yet has a miniature quality at the same time.

51
1929. Lithograph, pl.100. 45 × 29 cm. 8 test proofs on different quality paper; 9 proofs on different quality paper; 10 artist's proofs; edition of 50, signed and numbered, on Arches wove paper. Duthuit no.507. Private Collection

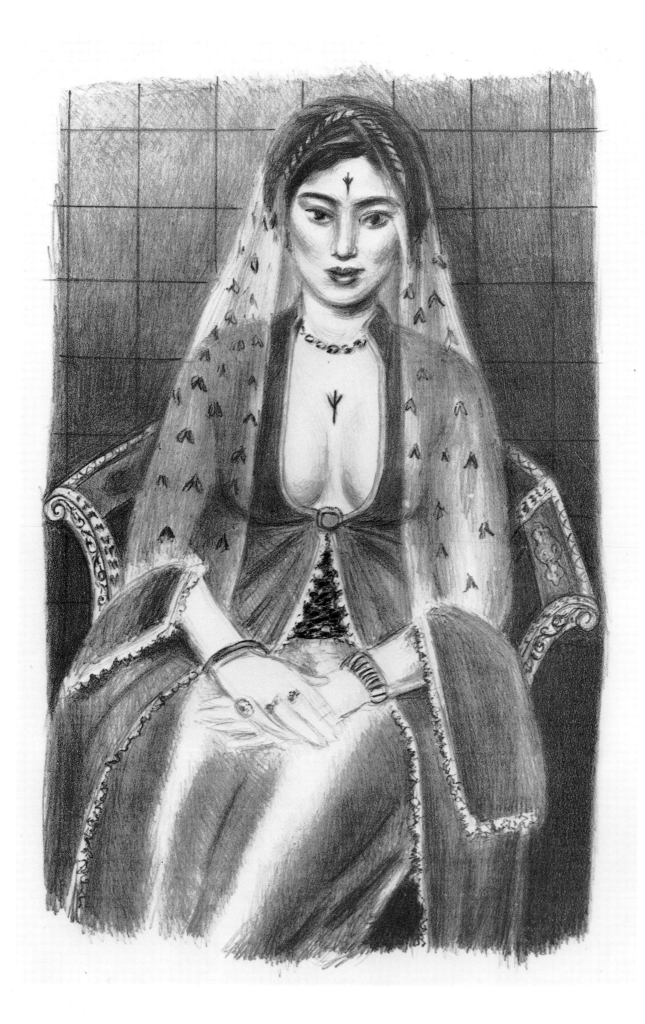

YOUNG WOMAN ON BALCONY LOOKING AT PARROTS

(Jeune femme au balcon, observant des perruches)

The top floor of the house at place Charles-Félix contained not only a large studio room with a new-style window opening to the floor but also a balcony that circled the whole building: "This apartment let in much more of the outside world. Matisse now had a dramatic light chamber with a grand view of the entire Promenade des Anglais, the bay, and most of the city and the mountains behind. The walls of the center studio were white with an unusually painted false tile squaring. The walls of the corner studio were false marble set in trompe l'œil rectangles, and there were green baseboards in both rooms."[67] The new quality of light and the panoramic views there began to liven up the pictures, and around 1930 the window motif became more and more frequent in his paintings.

In 1929, after the rich series of lithographs, Matisse began to work with unaccustomed vigor with his engraving tool and published small line drawings of great spontaneous quality. Most, if not all, were designed straight into the plate. Descriptions given by Jack Cowart on these living circumstances help us to identify individual motifs and interiors in the 1929 series. They also underline how Matisse's point of departure was always a visual experience.

The model with the bird cage is standing here on the terrace, giving a view of the house fronts of Les Ponchettes and the harbor. This light sketch appears to have been produced in a break between sittings, in a moment of relaxation in which the artist was surprised and stimulated by a subject. A studio motif – model with cage – is suddenly transposed outside and is given new points of reference, yet this kind of subject is rare in his graphic work.

Matisse looked on such sketches as play, enriching exercises, and a chance to express inspiration, with no direct pressure or obligation involved.

52
1929. Etching, pl.186. 24 × 16.8 cm. 2 test proofs; 1 trial proof; edition of 25, signed, numbered, and dated on the plate, on laid paper. Duthuit no.214. Bibliothèque Nationale, Paris

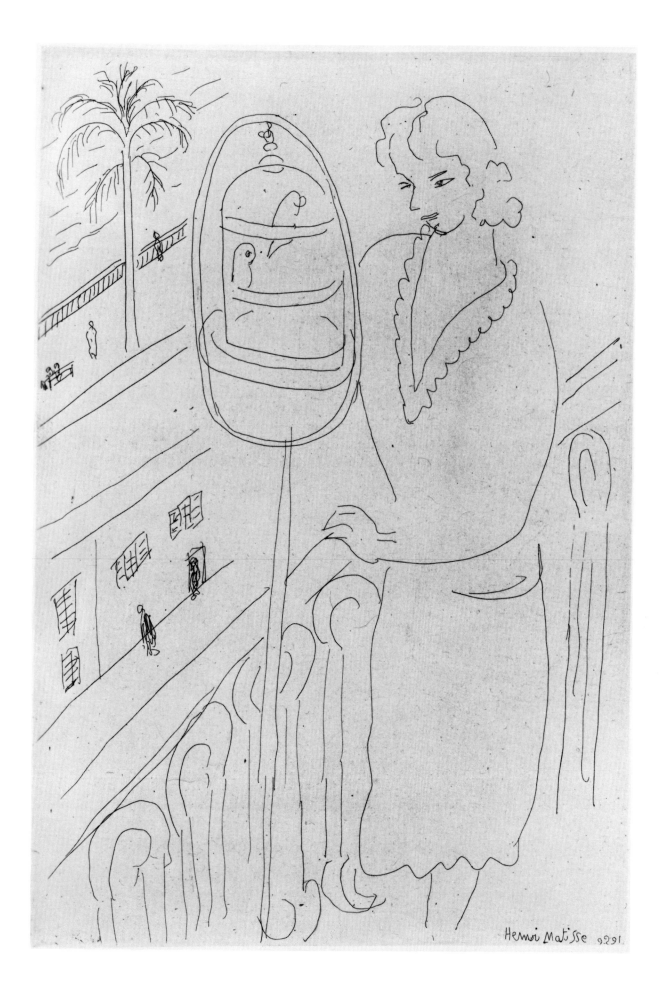

53 SEATED NUDE WITH STAR-PATTERNED BACKGROUND

(Nu assis, fond de carreaux étoilés)

In early May 1926 an announcement appeared in the Paris art magazine *Le Bulletin de la vie artistique* on the model's social position: "Models – and should we not adopt the term *'poseuses,'* which at least is a feminine noun in French? – female models posing for artists are complaining about how hard times are. They are objecting to their insufficient wages... posing each morning for four hours at the Ecole des Beaux-Arts for the meager sum of sixty francs at the end of the week?... How many women posing like this are there in Paris? What is the size of this special proletariat, still so badly defined? There are no statistics on the subject and it would be all the more difficult to arrive at any because the occasional model is generally confused with the professional. Nevertheless, there is no doubt that we are faced with a relatively sizable group of women that is growing in line with the increase in studios and the current fashion for the nude, which was so neglected a few years ago. As this kind of work is not subject to any legal contract, a number of these artists' handmaidens have to resign themselves to a very difficult existence. They are therefore proposing to resort to what we are pleased to call the welfare of the public. We should not take this matter lightly. It is more distressing than one might think. It is rather rare to find fallen women among the professional posers. Being used to going nude protects the model more surely than clothes held together with hooks and equipped with pins would, and the familiarity of an artist's studio is certainly less dangerous than what you find in a workshop."[68]

We know that brothels were frequently used by young artists – occasionally also by Matisse – to draw nudes; we also know that painter friends often shared a model. With the growing status of artists and the great international demand for pictures, models also gained in standing. Many artists, such as Bonnard and Picasso, lived with their models.

Matisse's creative process required a model. He had hired *poseuses* since the First World War. The hours working with the model were among the most prized of his creative life and the whole structure of the day was determined by the sittings. The artist's children remembered how any noise or disturbance was forbidden, and even eminent guests often had to wait until the master was ready to see them. This was how the exceptional photograph of Bonnard came about as he was whiling away time with Swiss friends in the waiting-room of Matisse's studio by lying on the divan in the pose of a Matisse odalisque, to the amusement of those present. Matisse, conscious of their value, rewarded his models well.

53
1929. Etching, pl.116. 14.8 × 10.1 cm. 1 trial proof; edition of 25, signed and numbered, on laid paper. Duthuit no.156. Private Collection

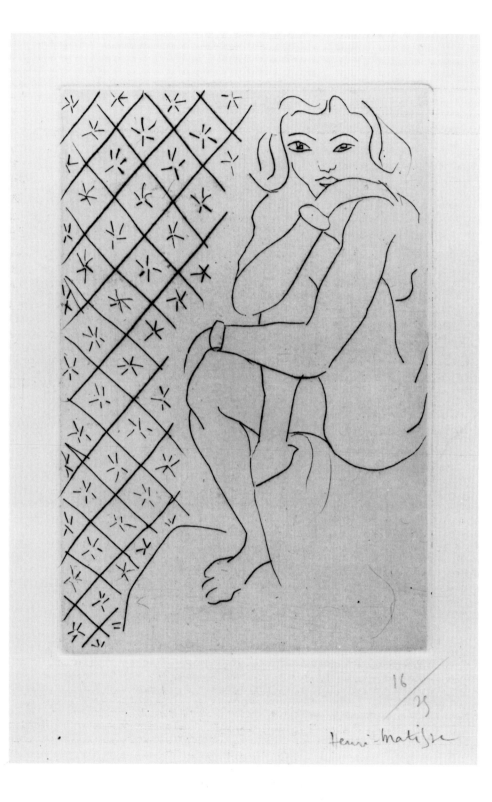

16/25

Henri-Matisse

(Figure endormie sur fond moucharabieh)

The artist's concentration on his model required his mental energy, his senses, and instinct, which allowed for little distraction: "While working on drawings requiring inspiration, if my model asks me the time and I give it my attention, I am done for." Matisse often spoke of the "intimate relationships between the artist and his models."[69] These links were based on visual familiarity stimulated by the artist's curiosity and led to a relationship of mutual trust. Matisse was aware that he had an uncovered creature before him from whom he demanded unrelenting exposure, and that as a consequence he had to proceed cautiously and gradually, particularly with non-professional models. He wrote to his friend Rouveyre: "Mine (an English model)... looks me in the eyes the way I am usually looked at when I'm working, that is to say defenselessly, without concern or protection."[70]

But Matisse also knew that without his commitment – he described it as "emotion" or "feeling" – he could not achieve the visual abandon he sought: "The model ought to be relaxed, and feel more confident with his observer; the latter is concealed behind a conversation which is not concerned with particularly interesting things, but on the contrary, runs on unimportant details. It seems to set up a current between the two, independent of the increasingly commonplace words passing between them" (F.152).

This central image of a current characterized the interpersonal relationship between artist and model, which could range from carefree joy to sensuously erotic excitement and dependence – a cause of dramatic conflict in the case of Picasso and of silent suffering for Bonnard. Matisse commented in 1929–30 that "most painters require direct contact with objects in order to feel that they exist, and they can only reproduce them under strictly physical conditions. They look for an exterior light to illuminate them internally. Whereas the artist or the poet possesses an interior light which transforms objects to make a new world of them – sensitive, organized, a living world..." (F.61).

Whether "artist" or "poet," their art called for a commitment that sapped a vital nerve and for an awareness of the rules of the particular game. Matisse was a juggler, a dancer who took endless pains constantly to bring off a convincing, enthralling spectacle. For him the stage was hard reality that required performances that were drawn, in the widest sense, from life, portraits wrung from it. It was not for naught that he often repeated Rembrandt's phrase "I have never painted anything but portraits" (F.119). With what mastery he could render his images life-like, as the example here shows, which is also known under the title *Exhaustion*. As sensuous as a sleeping woman by Courbet or Renoir, as delicately drawn as a Rembrandt and as seductive as a Correggio nymph, the model withdraws in sleep from the observer's rigorous gaze.

54
1929. Etching, pl.89. 25 × 17.9 cm. 6 trial proofs; edition of 25, signed and numbered, on laid paper. Duthuit no.127. Bibliothèque Nationale, Paris

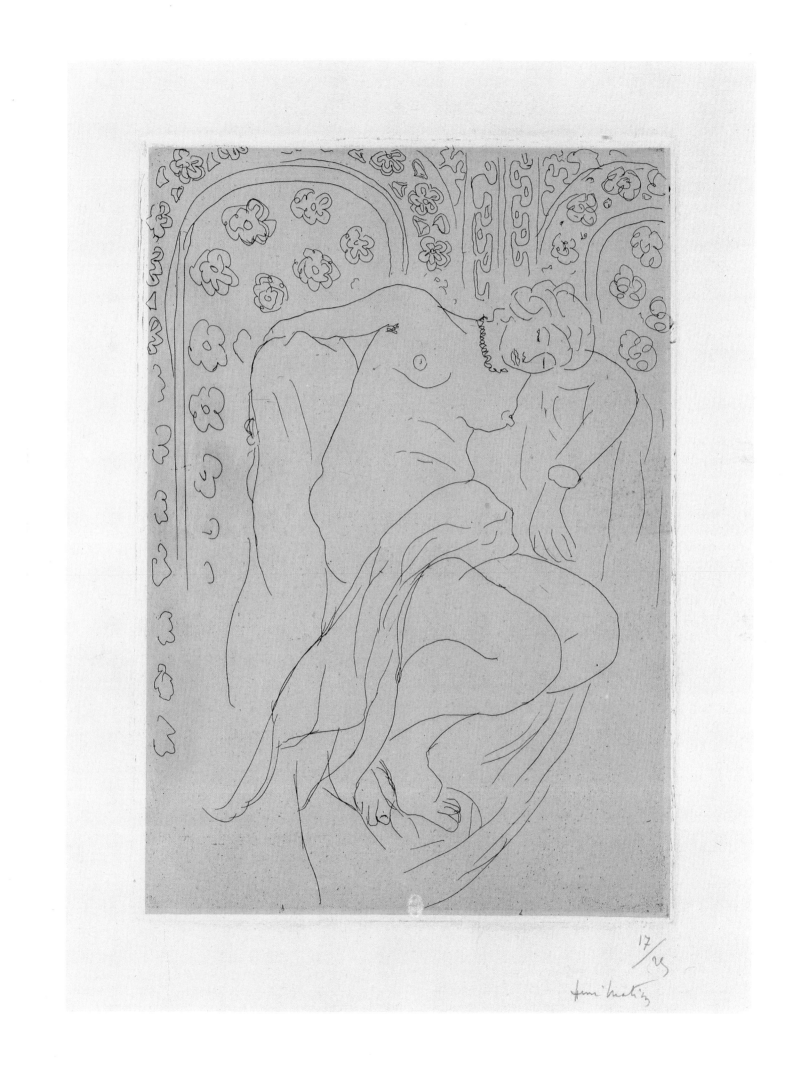

17/25

Henri Matisse

55 THE INTERLUDE

(La Pause)

Matisse was a slave to an unceasing creative process that always had to struggle anew for his figure pictures. He never fell prey to a simple pictorial formular because he was himself also a prisoner of his subject matter. "Each of these drawings, as I see it, has its own individual invention which comes from the artist's penetration of his subject, going so far that he identifies himself with it, so that its essential truth makes the drawing" (F.119).

For the sake of his art the artist became a merciless intruder, voyeur, and thief. Just how far this relationship to the subject matter went depended on the individual artist's own standards. Matisse was thus moved to write to his friend Rouveyre: "After a sorry sitting with a model who, although a beautiful girl, was devoid of expression, I was worn out from flogging myself to death to give her a bit of life..."[71] With Matisse it always needed a man's passion. Something that started merely from information on the constitution of a model was liable to become an emotionally charged obsession "to keep me emotionally charged, like a sort of flirting that ends up with a rape. Rape of whom? Of myself, from a kind of emotion towards the object of affection. I would like to do without this completely one day – I cannot believe I will because I have not cultivated sufficiently a memory for forms. Will I still need forms? It is a question rather of overcoming vertigo while flying. I know enough about how the human body is made. A flower – if I do not find it in my memory I invent it."[72] These were the doubts and certainties of an artist with over forty years of experience in his art!

In contrast to Picasso, who committed his entire being to his more-or-less ephemeral love affairs in order to translate them into his work, Matisse remained more spiritual, more distant, at the same time sensing himself captivated by his model. If his dramas were more human, his goal was the same. "It's as in love – everything depends on what the artist projects unconsciously over everything he looks at. It is the quality of this projection that gives life, much more than the presence before the artist of a living person."[73] As with most great artists, the model-relationship was deeply egocentric. "Even the model only exists to serve me."[74] The work of art was the main thing and demanded total commitment from the artist. The pedantic exactitude with which Matisse executed and nurtured it can be seen in the print illustrated here, in which handwritten instructions have been given to the printer to remove the minute, unintentional specks on the model's thigh for they might have been misunderstood and distracted the observer's attention.

55
1929. Etching, pl.109. 14.9 × 19.6 cm. 2 proofs marked "document" with printing directions written out by artist; edition of 4, signed and numbered, on laid paper. Duthuit no.142. Bibliothèque Nationale, Paris; embossed on wove paper

56 LARGE FACE

(Grand Visage)

For Matisse his models always remained individuals. This is particularly evident in his many studies of faces. "The human face has always greatly interested me. I have indeed a rather remarkable memory for faces, even for those I've only seen once. In looking at them I do not perform any psychological interpretation, but I am stuck by their individual and profound expression" (F.151). His great visual sense and excellent recall produced a storehouse of images that could be used again when the model was not present. These were blessed moments in an artist's life. Matisse relied on this experience throughout his life: "The revelation of the interest to be had in the study of portraits came to me as I was thinking of my mother. In a post office on Picardy, I was waiting for a telephone call. To pass the time I picked up a telegram form lying on a table, and used the pen to draw on it a woman's head. I drew without thinking of what I was doing, my pen going by itself, and I was surprised to recognize my mother's face with all its subtleties" (F.151).

Matisse had practiced the rapid drawing of faces, mainly during the First World War, in the large number of small engraved portraits of his family, friends, and models. He obviously tried working with photographs as well, not in order to get closer to a face but, paradoxically, to free himself from old-established ideas. Photography can be an aid to finding new characteristics when fixing subject matter, exactly the opposite to what is usually assumed: "If you accept that you can do portraits that are so life-like and so real that they give the illusion of nature and appear alive, and if you decorate the walls of a room with them, the result for a spectator would be so terrible and haunting as to make you flee. It would be like living in a room in the Musée Grévin, hallucinating as in one of Poe's stories."[75]

This lithograph with the expressive face takes its substance from the woman's cat-like eyes. They have a magic effect on the observer. The artist found the simplest images to enable him to capture this look and bring it back to life.

56
1929; printed in 1935. Lithograph, pl.128. 50.5 × 34.5 cm. 7 trial proofs on different quality paper; edition of 50, signed and numbered, on Japan paper. Duthuit no.517. Bibliothèque Nationale, Paris; trial proof

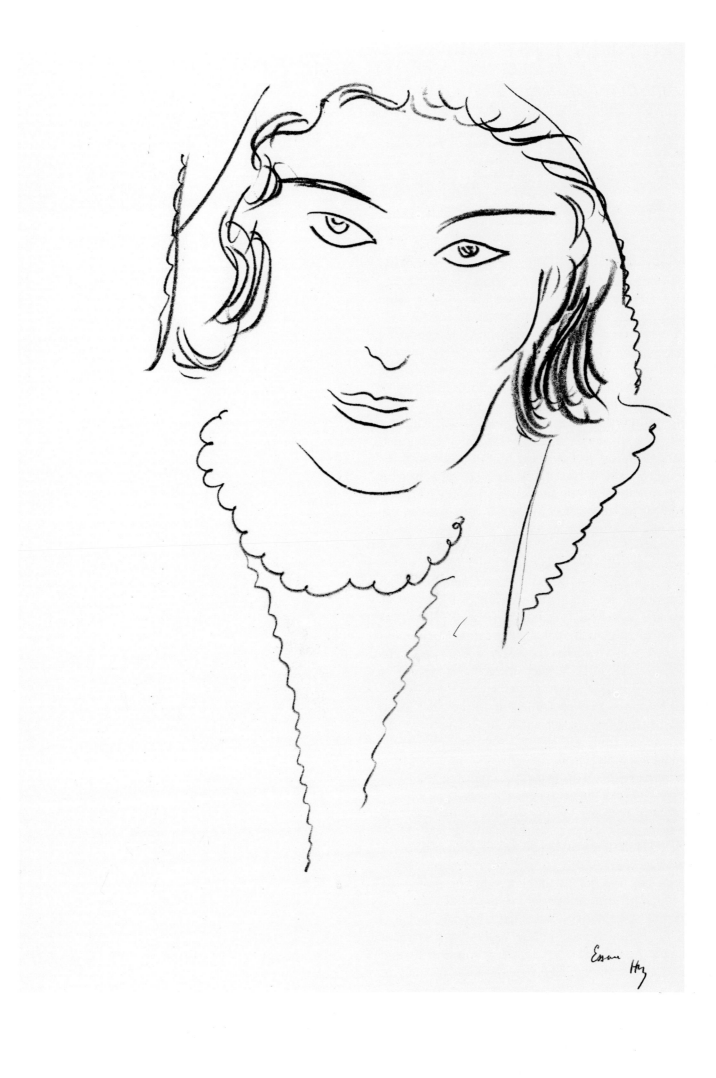

57 SEATED NUDE IN STUDIO

(Nu assis dans l'atelier)

Models and interiors constitute the sole theme of etchings and dry-point from 1929. They were produced in a series of sketches and all come from the same creative area, the closed world of the studio that was filled with the sea air and sunlight of the Midi.

The artist had just turned sixty; his wife Amélie was suffering and bedridden, his children were all leading their own lives and had moved out. Matisse had few people of his own age to talk to. He had a close relationship with Simon Bussy, a friend from his youth who was in contact with literary circles, which numbered André Gide and the Bloomsbury group, and also lived in the south of France. Matisse occasionally saw Bonnard, who lived in Le Cannet, and Maillol in Banyuls. Visits to Paris kept him in touch with the artistic scene, though he seldom traveled far. In 1925 he went with his family on a trip to southern Italy and Sicily. "I am too anti-picturesque for traveling to have given me much," he used to say (F.135). He was not looking for a change, seeming only to be focusing on one objective – his pictures. "I've asked myself every day if I've done what was necessary to keep me trained for painting. It's all very difficult. It means that one must remain calm, balanced, free from all distractions," he said in an interview in 1934.[76]

His daily program was filled with regular work. This was confirmed by all his friends, such as the Swiss couple Arthur and Hedy Hahnloser, collectors who often visited the artist in the 1920s together with Bonnard. Hedy Hahnloser noted: "His life was of exemplary discipline. Got up at seven o'clock on the dot then did the usual physical exercises. Between nine and ten he went up to the studio." Model sittings or corrections to uncompleted works would then consume his time and energy. Almost every day he would mold odd looking figures from a block of clay which he then immediately refashioned – he explained this as follows, according to Hedy Hahnloser: "Just as a pianist is instructed to do daily finger exercises, it was equally necessary for him to sensitize his fingers to shapes and keep them agile. He was thus prepared as soon as he started work [Hedy Hahnloser added Matisse's own words 'to waken my sensitivity']. Work with a paint brush, and more particularly with a black pencil, was greatly influenced by this manipulation of the clay, which became obligatory for him."

There is no doubt that Matisse was a hard, precise, and disciplined worker. "One must work at set hours every day. One must work like a workman. Anyone who has done anything worthwhile has done that," and later, "All my life, I have worked all my waking day" (F.123).

57
1929. Etching, pl.95. 20.4 × 15.4 cm. 2 test proofs; 2 trial proofs; edition of 25, signed and numbered, on laid paper. Duthuit no.134. Art Institute of Chicago. Gift of Frank Hubachek

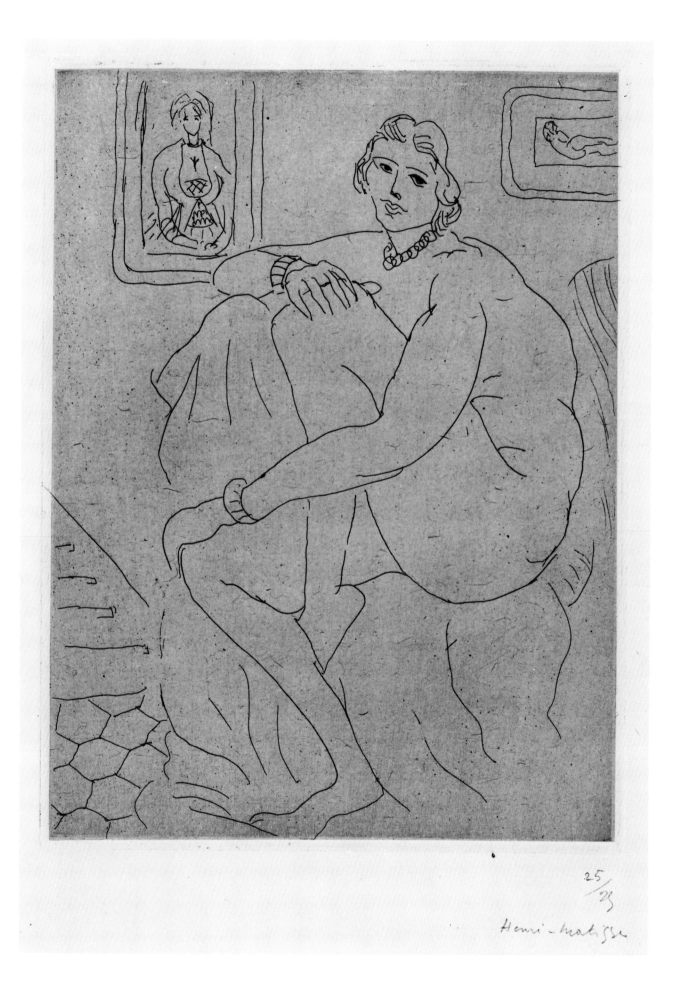

25/25

Henri-Matisse

58 FIGURE SEATED IN INTERIOR, HEAD PARTLY MISSING

(Figure au visage coupé, assise dans un intérieur)

The altered light conditions in the studio on the top floor at Place Charles-Félix with the large window area obviously caused new problems in painting because the light no longer filtered through blinds but instead flooded the whole room. His palette brightened up and colors became generally more fluid. Presumably these new working conditions stimulated the artist to tackle once again the problem of form and light with pencil, as Hans Hahnloser commented after a visit in 1929: "If the master had not, at the time of each crisis, started to draw again he would not have achieved the same freedom and richness."[77]

Matisse began to etch and untiringly varied his models' sometimes complicated sitting and reclining positions in a highly decorative interior. Yet we only experience this interior – his studio – in fragments, sections that are often hard to identify. Matisse seemed to be moving away from a plastic conception of the figure and thus also from the individual personalities of his models. The artist did not hesitate to crop the picture, even when this involved the model's most personal feature, her head, and in this way he depersonalized and fragmented the whole figure. She becomes as much an object as the goldfish bowl or the lamp. Her coat, slippers, hair, and body form an ornamental block, a harmonious image in a series of rhythmically applied elements that make up the picture. In other words, Matisse orchestrated his compositions.

The artist used musical terms when attempting to describe his art, drawing attention to its constructive aspect, to the interplay of components, assembled not according to established norms and hierarchies of values but rather according to functions and laws analogous to those of music. "The canvas is painted in flat tones without gradation.... It is the drawing and the harmony and the contrast of the colors that give the volume, just as in music a certain number of notes form a harmony that is as profound and rich as the talent of the musician who has put them together."[78] Matisse composed picture harmonies from elements and fragments of objects found in his studio. In the process he juxtaposed dynamic and static symbols, which recur in the paintings as well as the graphic works: flowing, serpentine lines on the wall (the marblized wallpaper), parallel stripes (the green border of the floor), the continuous pattern of the carpet. These elements enliven the room, and create an association of different tones. Matisse derived artistic benefit by reducing the size – these etchings are small – and the complexity. "Seven notes, with slight modifications are all that is needed to write any score. Why wouldn't it be the same for plastic art?" (F.99)

58
1929. Etching, pl.179. 15.1 × 22.6 cm. 2 test proofs; 3 trial proofs; edition of 25, signed and numbered, on laid paper. Duthuit no.187. Art Institute of Chicago

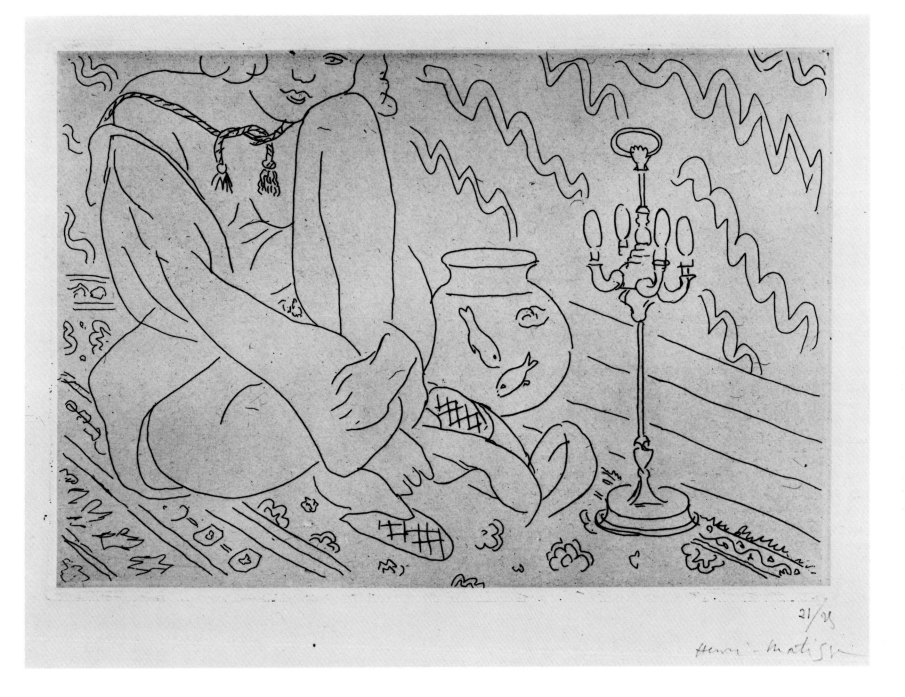

21/25

Henri-Matisse

59 UPSIDE-DOWN NUDE ON CHECKERED BACKGROUND

(Nu renversé, fond à carreaux)

It is noticeable how often the etchings produced around 1929 show the model in a crouching position, as if the artist had hoped to discover new physical rhythms in these poses. They give the impression of an obsessive search for maximum expressiveness and distortion pointing the way toward a degree of abstraction that had yet to be reached. Matisse wanted to get away from the immediate object, from the model – he did this simply by using line, which became a distinctive feature. Matisse called this "the almost unconscious transcription of the meaning of the model" (F.151).

In order to understand this abstract and enigmatic process, which is intimately connected with the individual creative temperament of an artist, we might turn to Matisse's comment: "The ideal would be to have a studio with three floors. One would do a first study after the model on the first floor. From the second, one would come down more rarely. On the third, one would have learned to do without the model" (F.56). In his drawing Matisse strived to create works from the store of images he had accumulated in complete freedom and independence, without allowing them to ossify into mere virtuoso exercices. He wanted to create engrams that were taken from life and which themselves reflected life.

Matisse was aware that the way to this objective was through areas of his own experience, which always had to be approached anew. The artist relied constantly on receiving "affective shocks." In painting this meant continual confrontation of light and color, while in drawing it represented the constant return to the model, the object.

59
1929 (print found at the artist's residence in 1966; numbering and seal affixed at this date). Etching, pl.138 bis. 12.7 × 18 cm. 2 test proofs; edition of 10, numbered and bearing the seal "HM," signed on the plate, on laid paper. Duthuit no.164. Bibliothèque Nationale, Paris

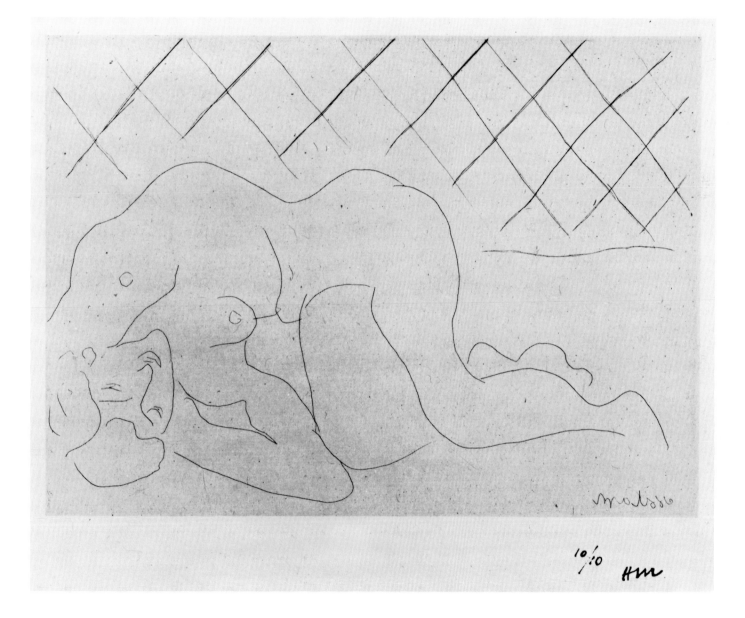

10/10
HM

60 HEAD OF GIRL AND TWO GOLDEN CARP II
YOUNG WOMAN, GOLDFISH, AND CHECKERED CLOTH I
YOUNG WOMAN SLEEPING BESIDE GOLDFISH BOWL

(Tête de jeune fille et deux cyprins dorés II; Jeune Femme, poissons rouges et nappe à carreaux I; Jeune Femme dormant près d'un bocal)

In November 1929 a series of ten etchings of a female head and goldfish bowl were produced. The plates are small and oblong, about 9 by 19 centimeters. Matisse, who drew directly into the plates, forced himself to approach the motif anew each time to enable him to set down all his sensory impressions.

Whereas Picasso was fascinated by experiencing and documenting the metamorphosis of a print by producing numerous stages for a composition, Matisse was interested in the possible variations on a theme. This was an elementary part of his daily work. He generally noted down his first impressions of a subject on a sketch pad but during the working process he destroyed many of the connecting links between these sketches, so that the drawings from this period are of less documentary value than the prints. In his painting only a few photographs record the many intermediate versions of each picture before the artist deemed the work completed. For *Large Sleeping Nude* (1935; Baltimore Museum of Art) twenty-two versions remain, which Matisse left to his great American patron Etta Cone. The fact that the graphics from 1929 contain these stages in the work proves that the artist had ventured towards new discoveries in the expressive medium. Surprisingly few paintings were produced during this time, while over a hundred small prints came from his etching needle – his highest output apart from in his late period.

The three etchings shown here illustrate the artist's concern with reducing the picture's subject matter to the most concise shorthand. He tried to find symbols for his objects that would grant him greater artistic freedom and impress themselves indelibly and timelessly like trails in rhythmic, figurative transformations. "It is enough to invent signs. When you have a real feeling for nature one can create signs which are equivalent to both the artist and the spectator"(F.116).

60 I
1929. Etching, pl.149. 12.8 × 18.1 cm. 2 test proofs; edition of 25, numbered, signed on the plate and in pencil, on laid paper. Duthuit no.176. Bibliothèque Nationale, Paris

60 II
1929. Etching, pl.142. 9.3 × 12.6 cm. 2 test proofs; 3 trial proofs; edition of 25, numbered, signed on the plate and in pencil, on laid paper. Duthuit no.178. Bibliothèque Nationale, Paris

60 III
1929. Etching, pl.178. 12.4 × 16.8 cm. 3 trial proofs; edition of 25, numbered, signed on the plate and in pencil, on laid paper. Duthuit no.178. Bibliothèque Nationale, Paris

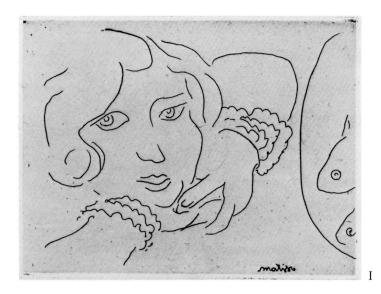

I

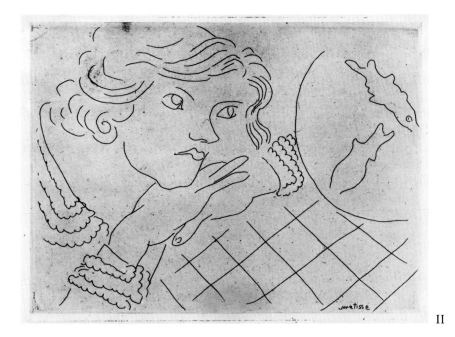

II

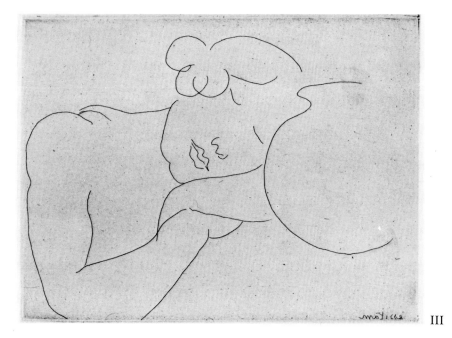

III

61 REFLECTION IN THE MIRROR

(Le Reflet dans la glace)

Model and mirror were typical elements in Bonnard's pictures. In numerous variations he captured his model dressing in a mirror, creating new angles and ideas from the unusual arrangement of space and object. Matisse admired Bonnard and was interested in what he was painting in his pink house in Le Cannet. This interest kept the artists in close contact with one another and a friendship developed between them based above all on their mutual awareness of the loneliness and isolation of the creative and artistic sphere. "When am I going to see you?" came the call from Nice, and from Le Cannet the reply "I need to think of you in order not to find myself alone."[70]

The mirror found its way into Matisse's painting as an object from hotel interiors – not so much as the vehicle of a new reality, as in Bonnard, but because it had a beautiful shape. For Matisse the mirror either functioned like a window, giving a view of the room (*Sitting for a Painting,* 1919, Edinburgh), or it became an essential vehicle for color (*Anemonies with Black Mirror,* 1919). Bonnard's images may have had some influence in the example shown here, since the reflected reality is interpreted with more complexity. The mirror remains a studio prop like any other object, of course, but it does record the scene and at the same time opens up to the viewer what is reflected in the mirror. Although this reflection gives merely a fragmented view, it does add information: a chair and an easel. The figure appears twice but then only in cropped form. This objectifies the relationship with the model, an effect which is reinforced by the fact that the two perspectives in the picture are not drawn in different styles. The focal plane remains uniform, yet the content is extended. The mirror reflects the easel, a tool of the artist, who therefore emphasizes his presence.

Here in the major thematic field of "The Artist and His Model" Matisse found a picture formular that has as its object the visualization of the subject matter and identification with this subject matter as its creator. The artist felt himself increasingly to be the creator of his own pictorial world, and he may have been aware that he was simultaneously a slave to this world. In 1930 he broke away, leaving Europe for a few months in search of other rooms, other dimensions, tones, colors, and fragrances. This quest led him to Tahiti.

61
1929. Etching, pl.86. 25.5 × 15.2 cm. 2 test proofs; 1 trial proof; edition of 25, signed and numbered, on laid paper. Duthuit no.116. Bibliothèque Nationale, Paris

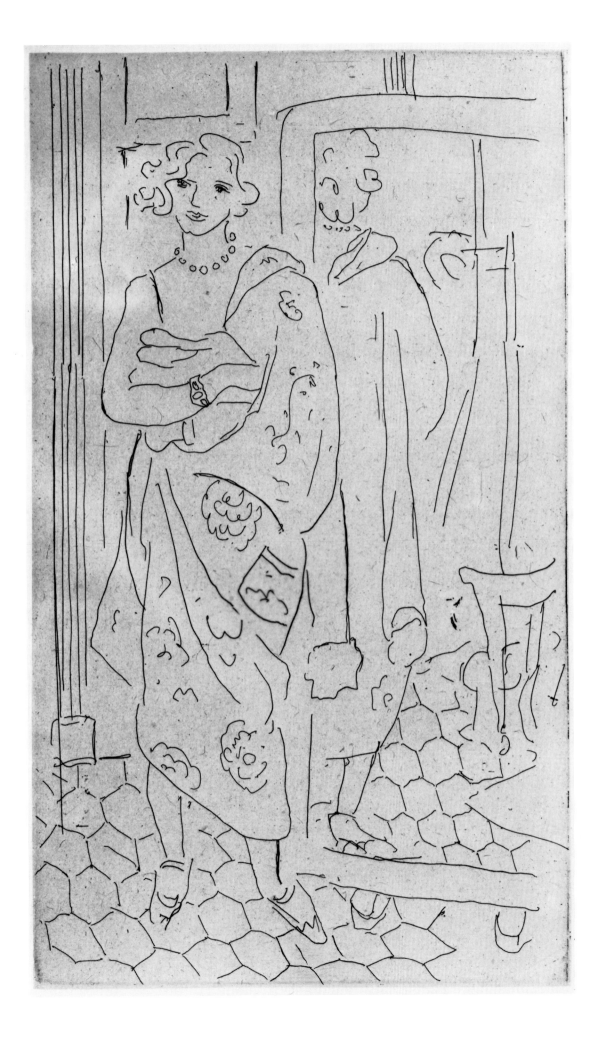

62 INTERIOR WITH LEAVES

(Intérieur au feuillage)

After years of working in the enclosed world of his studio in Nice, the generally settled Matisse decided in February 1930 – in contrast to his customary changes of location – to undertake a real voyage that took him to the United States and Tahiti. It was an unusual break in the otherwise regular and disciplined life of the artist, but it should not be put down merely as an escape or an adventure of a sixty-year-old man. Matisse was too much of an artist and painter, and his work perpetually incited him to take such decisions, as he had shown in Biskra, Collioure, and Tangiers. Why did he dream of the South Pacific and Polynesia? As an artist he had long ago assimilated Gauguin's legacy. Nice provided him with ideal climatic and atmospheric conditions, and the stable light that was vital for his painting. In 1929 he painted hardly any pictures, however, devoting himself completely, as we have seen, to his drawing work. Problems of color and light, in fact, kept him drawing, because when Matisse drew he tended to think of light and color, and when he painted he thought of shapes and volume.

When Matisse embarked on his journey, he took his dreams with him: "Having worked forty years in European light and space, I always dreamed of other proportions which might be found in the other hemisphere. I was always conscious of another space in which the objects of my reveries evolved. I was seeking something other than real space. Whence my curiosity for the other hemisphere, or a place where things could happen differently. (I might add, moreover, that I did not find it in Oceania.)" (F.60)

He had already had a taste of the dream for space and light in his small etchings of 1929, and these notions were so powerful that his subsequent disappointment was not surprising. Nevertheless, he did enthuse: "The light of the Pacific has the peculiarity that it has an invigorating effect on the spirit, like looking into a golden bowl."[80]

What Matisse found was not his dream – he found different atmospheric conditions that helped him to evaluate his previous output and visions and to define a new field of work. His inquisitive, artistic nature made him continually watchful for new sources of inspiration, which included new experiences with light and space. Upon his return to France Matisse took up portraying models, interiors, and window views; however, plant motifs now made increasing incursions into his pictures, works featuring great lush foliage that emerged in the form of drawings from his recollections of the vegetation in the Pacific paradise.

62
1935. Etching, pl.209. 14 × 10.9 cm. 1 test proof; 2 trial proofs; edition of 25, signed and numbered, on laid paper. Duthuit no.244. Bibliothèque Nationale, Paris

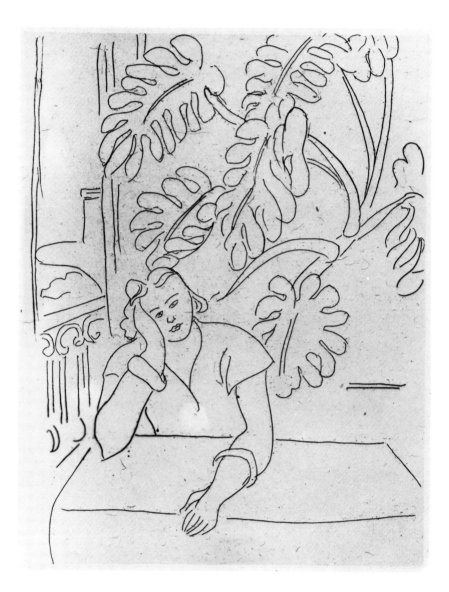

63 DANCE

(La Danse)

The voyage to Tahiti took the artist to America, the continent from which his first collectors came and the home chosen by his youngest son Pierre. It must have made an overwhelming impression on the artist: "'I feel twenty years younger... What you have here is the grandeur of space and order,' he wrote home to his bedridden and seriously arthritic wife."[81] The new feeling of space ("immense, immense... if I were thirty, this is where I would come to work") awakened his creative will and was clearly more in tune with his dreams. He went back to America in the same year in order to be a member of the jury for the Carnegie International Exhibition in Pittsburgh. It is no coincidence that Bonnard, who was one of the jury in 1926, recommended Matisse, and that Matisse then nominated Picasso. *Time* magazine reported: "In 1927 the Carnegie International Jury awarded first prize ($1,500) to Henri Matisse. This year it was Matisse's turn to award the prize. He gave it to Pablo Picasso's calm, masterly portrait of Mme. Picasso."[82] It should not be forgotten that these artists were still highly controversial and only regarded with enthusiasm by a small minority, a reserve attested to by the number of participants: 137 European and 99 American artists.

Matisse appeared in all the newspapers but he made few comments on his art. The same edition of *Time* stated: "Reporters, hostesses found him silent behind his whiskers, only occasionally willing to act the oracle." More important to Matisse than public recognition was the opportunity to see his friends and pictures again. As a guest of many collectors, including Stephen Clark of New York, Albert C. Barnes of Merion, Pennsylvania, and Etta Cone of Baltimore, he saw hanging on walls whole series of works from all his creative periods. Matisse had not been able to see such a comprehensive show for more than ten years. For him, these visits became retrospectives, a priceless artistic experience, and a help in orienting himself. Barnes, who was considered a major art collector at that time, owned already about sixty works by Matisse. He commissioned the artist to produce a huge decoration for the vault-like arch over the windows of the large exhibition hall at the Barnes Foundation.

The dimensions of the projet challenged Matisse, and he agreed to take it on in spite of the complexities posed by the structure of the building. With the intensity of a Michelangelo, he began working on the panels in a rented former garage in Nice, completing the work in a relatively short period of time thanks to an ingenious stencil technique. However, incorrect measurements at the outset necessitated a second version, which required enormous effort. He wrote to Barnes on February 23, 1932: "Well, that's how it is and I had better just start again. But as I do not want to waste the work I have done, I am finishing the canvases [the three sections] using the present, incorrect measurements. I have worked every day from morning to evening since returning to Nice – I am sending you a photograph and a gouache done last Saturday which will give you some idea of the way I feel... my courage remains intact in spite of this real shock" (Barnes Foundation archives, Merion, Pennsylvania). Matisse had a color etching taken by Lacourière from the first, unused version (now in the Musée de la Ville de Paris). The rough illustrated here for this work, which is atypical of his graphic output, is in the Musée Matisse in Nice. The artist gained experience of large dimensions with the laborious work on *Dance I* and *II*, experience which made a mark on his subsequent production and lent it an unusual airiness.

63
1935–36. Color etching (black, gray, pink, and blue), pl.213. 23.6 × 74 cm. 10 test proofs; 5 artist's proofs; edition of 50, signed and numbered, on Arches wove paper. Duthuit no.247. Baltimore Museum of Art. Cone Collection

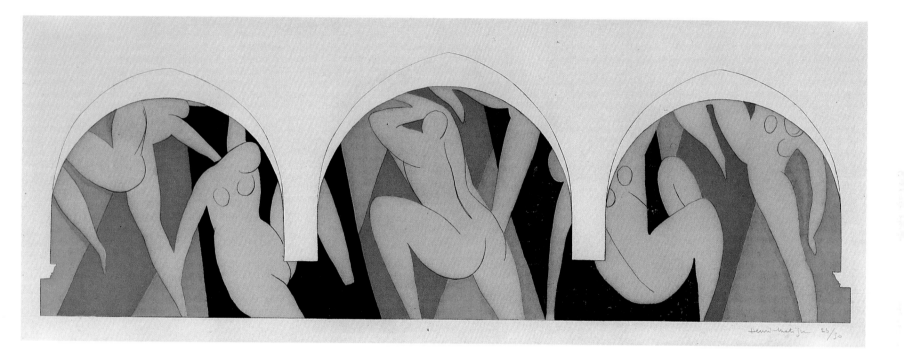

64 ACROBATIC DANCERS

(Danseuses (de la série "Danseuses acrobates"))

The major commission of *Dance* for the Barnes Foundation brought Matisse back to the themes of dance and of joie de vivre. In Merion he was reunited after many years with his most important early work *Joie de Vivre* (1905–6). Interest in dance was also sustained by the Ballets Russes de Monte Carlo and friendships with musicians and choreographers. André Masson recalled in 1933: "During my stay in Grasse I was working on sketches for a ballet, to be called *Les Présages*, with Massine. Massine was a friend of Matisse.... I naturally went to watch the dance practice. Matisse joined me sometimes, which was extraordinary! He would join me, watch the dancers practicing and say 'Look at that one, look at her hands, her hands are soft, she'll never make it! It's not the dancers' feet you have to look at, only the extremities count.' There was not a moment when his mind was not working visually. It was an extraordinary recording machine, astonishing!"[83]

After the static odalisque pictures Matisse broke into the movement of dance. These were no longer the resting poses found in *Ten Dancers* (1927, see Pl. 49 I and II) but moments of violent movement containing great tension that enthralled the artist and also found monumental expression in the Barnes decorations. Concentration on their unusually large size obviously prompted the artist to approach the theme on another level – spontaneously, playfully – as if he wanted to break out emotionally with a dancer's touch on the paper. Matisse could tune into his subject matter by singing, and thus release his nervous tension: "When I did the first large composition, drawing it, I sang the tune of a farandole and all my actors had their origin in this same movement."[84]

Matisse produced twelve virtuoso, stenographic line sketches of acrobatic physical positions that all give visual form to the great inner dynamism of the body, capturing energy in lines of power that seem to move outward from the center. He took the process of reduction so far that only a skeleton of these lines was needed to capture the dancing pose and to symbolize the feeling of movement. Picasso, too, was inspired by dance scenes at the same time and produced pictures of acrobats, although he was interested in the largest possible expressive distortion of the contours of the body and less in the expanding force just of the lines. Matisse took up the theme again shortly before his death in the paper cutout *The Acrobats* (1952) and pen-and-ink drawings. His experience with acrobatic movements carried over later into the nudes, which began to appear in more varied positions, deviating further from his usual notations, and thereby carrying the intrinsic energy beyond the picture.

64 I–IV
1931–32. Lithograph in red chalk, pls. 413, 416, 419, 421. 37 × 33.8 cm, 38 × 29.7 cm, 43 × 34 cm, 25.9 × 24.7 cm. A few trial and artist's proofs; edition of 25, numbered, on Arches wove paper. Duthuit nos. 529, 532, 535, 537. Bibliothèque Nationale, Paris; with artist's seal "HM."

The series (pl. 410 to 421) was designed about 1931–32, modeled after *Danseuse au tambourine (Dancer with the tambourine)*, and printed in 1967.

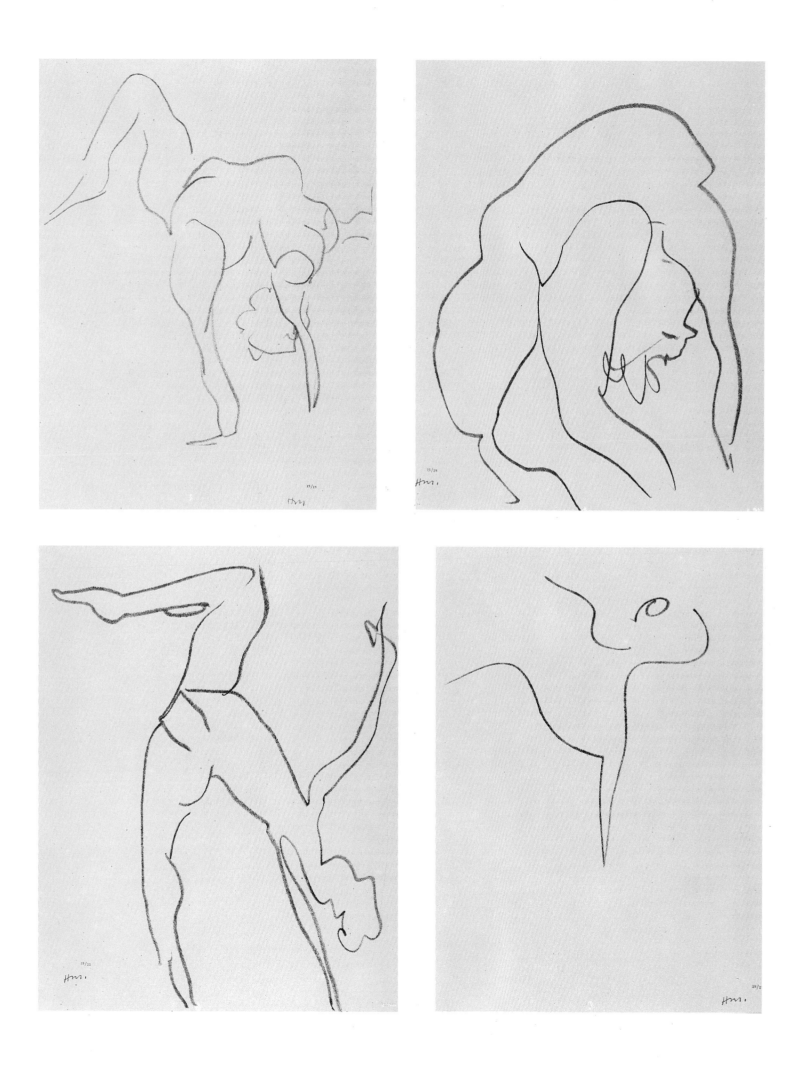

65 THE CONCERT

(Le Concert)

The exciting year of 1930, already marked by the voyage to the United States and Tahiti and the work on *Dance* in the Barnes Foundation, also brought the artist the commission from the young Swiss publisher Albert Skira to illustrate the poems of Stéphane Mallarmé. Matisse had previously produced only individual prints for editions and reproductions of drawings (*Les Jockeys Camouflés* by Pierre Reverdy, 1918). *Poésies* by Stéphane Mallarmé, however, was his first proper commission for a book. The commission came at a propitious moment, since Matisse had acquired a solid experience in etching through his intensive work with the technique prior to his trip to Tahiti. Furthermore, the commission had unusual parallels with *Dance* because here too he had to accommodate himself artistically within a given framework (in terms of both space and content). The constant change of dimension from an architectural scale to book size proved to be productive. The choice of poems to be illustrated also linked the two works thematically: dance and scenes of nymphs and fauns from mythology. Here were paradisiacal, arcadian background shades that suggested the South Pacific for the first time and gave him ideas on Mallarmé. It was probably no accident that the second version of *Dance* relied on a more Dionysian interpretation, as Matisse himself wrote to Alexandre: "the first is aggressive, the second Dionysiac" (F. 68). The theme of *L'Après-midi d'un faune* also began to work on him, and Mallarmé's verse lingered in his mind: "These nymphs, I want to perpetuate them. So clear, their rosy hue, that it hovers in the air made drowsy with thick sleep. Did I love a dream?"[85]

The artist's basic conception lay in the harmonious linking of text and illustration. To this end he chose fine line drawings that called to mind pictorial values of similar content and form. The American collector Etta Cone acquired the ensemble of drawings, prints, and copper plates for the illustrated book. This provides a rare insight into the artist's subtle way of operating and the genesis of a work.

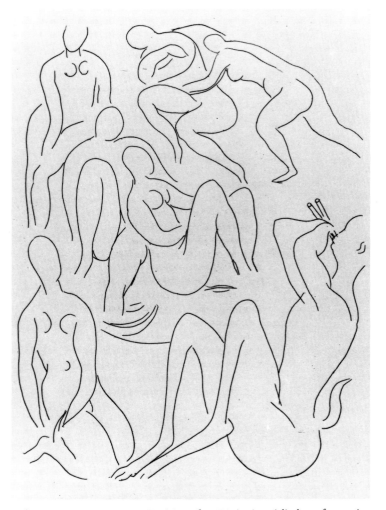

The Concert. 1931–32. Etching for *L'Après-midi d'un faune,* in *Poesies* by Stéphane Mallarmé

65
1931–32. Etching; rejected plate for *L'Après midi d'un faune,* in *Poésies* by Stéphane Mallarmé. 30.1 × 23.2 cm. Baltimore Museum of Art. Cone Collection

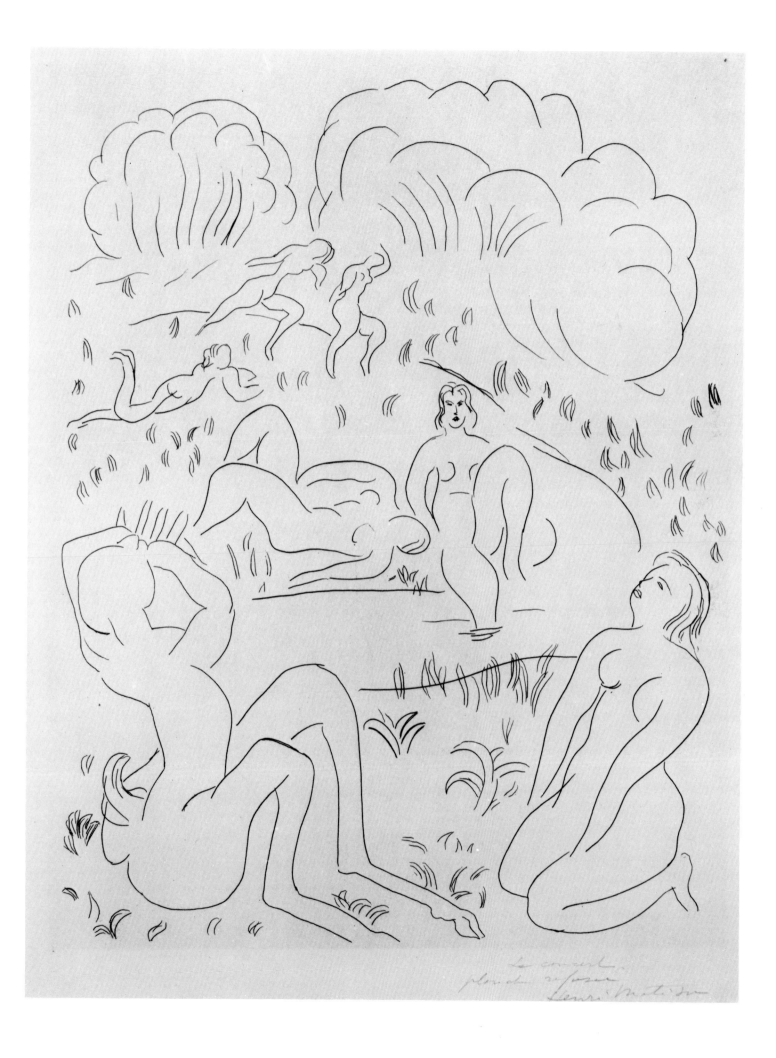

66 THE SWAN

(Le Cygne)

Spurred on by the bold approach of Albert Skira, the young publisher, Matisse took up the challenge of illustrating the book with great zeal, in spite of the depressed economic situation of the times and the poor prospects of quick sales. Picasso worked equally hard on the illustrations for Ovid's *Metamorphoses*, a commission that had come from Skira at the same time. The world of the poet Mallarmé, whose dreams and allusive verse were borne along by inner emotions, liberated Matisse's creative forces in pictures that he put down on paper in a way that was unforced but in harmony with the text. A dummy with blank pages distributed throughout allowed him to fit his own imagination to the text perfectly. Limitations imposed by the book's format incited Matisse to work out his infinite conception of space within a finite context. This often involved a painful birth, as the many sketches and rejected prints show.

Animals are extremely rare in his work. Mallarmé's writings must, however, have inspired Matisse to diversify his iconography. Alfred Barr recorded the recollections of Pierre Matisse, who accompanied his father on a boat in the lake in Paris's Bois de Boulogne: "One of the swans resented the artist's attentions, attacked the boat and had to be beaten off with an oar... it was the image of the swan moving to the attack with wings outspread that most impressed Matisse." Preliminary drawings show that after the swan's attack the artist changed from a classical, peaceful picture of a swan to a monumental portrait of an aggressive swan experienced at close quarters. He concentrated his composition on the most expressive parts of the Swan – the neck, head, and the flapping of wings. Elegance, energy, and expansive power characterize these representations of animals, which are rendered with masterful economy.

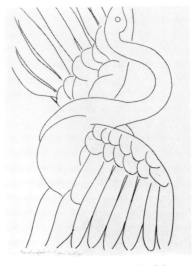

Le Cygne. 1931–32. Etching; rejected plate for *Plusieurs sonnets,* in *Poésies* by Stéphane Mallarmé. 33.3 × 25 cm (sheet). Baltimore Museum of Art. Cone Collection

Le Vierge, le vivace. 1931–32. Pencil. Drawing for *Plusieurs sonnets,* in *Poésies* by Stéphane Mallarmé. 25.2 × 30.3 cm. Baltimore Museum of Art. Cone Collection

66
1931–32. Etching; rejected plate for *Plusieurs sonnets,* in *Poésies* by Stéphane Mallarmé. 33.1 × 25 cm (sheet). Baltimore Museum of Art. Cone Collection

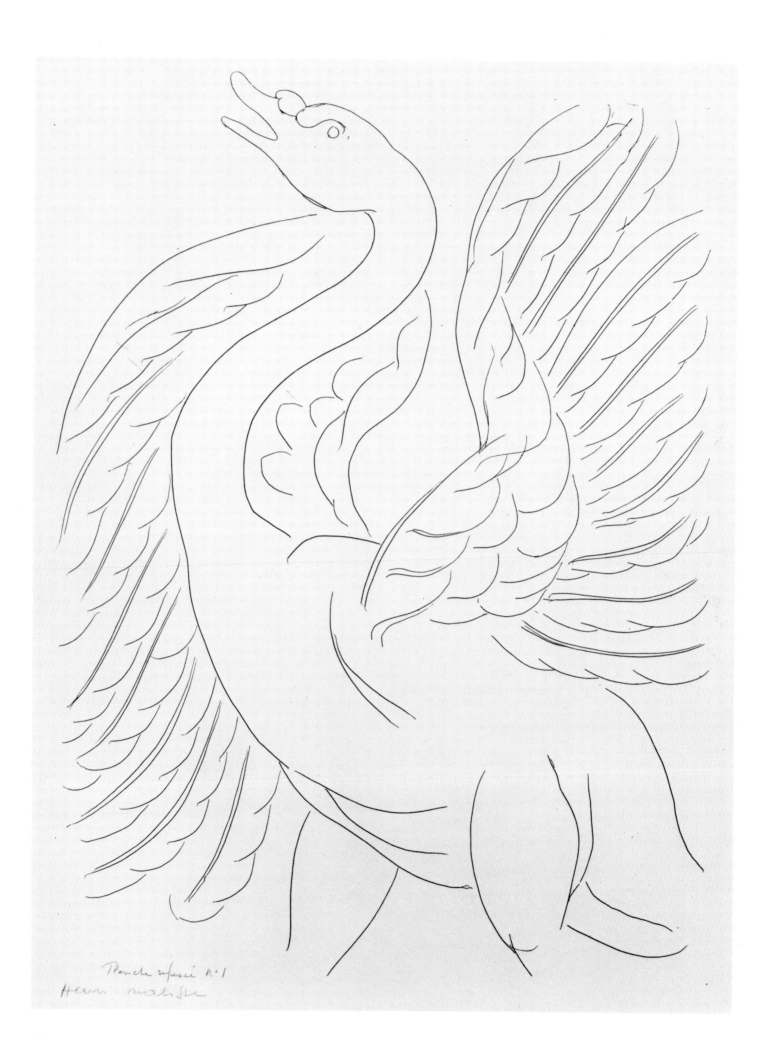

Planche refusée N°1
Henri Matisse

67 FAUN AND NYMPH

(Faune et nymphe)

"The things that are acquired consciously permit us to express our-selves unconsciously with a certain richness. On the other hand, the unconscious enrichment of the artist is accomplished by all he sees and translates pictorially without thinking about it. An acacia on Vésubie, its movement, its svelte grace, led me perhaps to conceive the body of a dancing woman.... The reverie of a man who has trav-elled is richer than that of a man who has never travelled" (F.66). With his strong visual memory Matisse was able to create increas-ingly from his recollections. The mythological theme of the faun is a kind of transformation and sublimation of the artist-model rela-tionship into a universally comprehensible pictorial world in the sense that "Women are children of the desire of man, of his passion. But passion does not appear in them: it remains in the mind of the painter, and therefore in the mind of the spectator."[86]

The theme of love is addressed directly here in the sensuous power of the faun, an incarnation of the emotionally charged plane on which the process by which the artist captures the model operates, as seen again and again in Picasso's bull motif. The artist needs his model not only for information but also, according to Matisse "to keep me in a state of emotion.... For me the model is a springboard — it is a door that I have to break down to gain access to the garden in which I am alone and so happy — even the model only exists to serve me."[87] Matisse was aware of the egocentricity inherent in the needs of the painter and which demands a constant inner struggle. The poet's analogous images evoke his own struggles as the manifestation of eternally human passion.

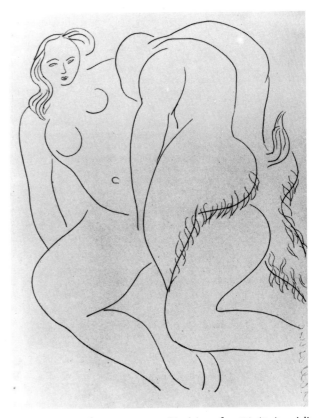

Faune et nymphe. 1931–32. Etching for *L'Après-midi d'un faune,* in *Poésies* by Stéphane Mallarmé

67
1931–32. Etching, rejected plate for *L'Après-midi d'un faune,* in *Poésies* by Stéphane Mallarmé. 32.5 × 25.8 cm (sheet). Baltimore Museum of Art. Cone Collection

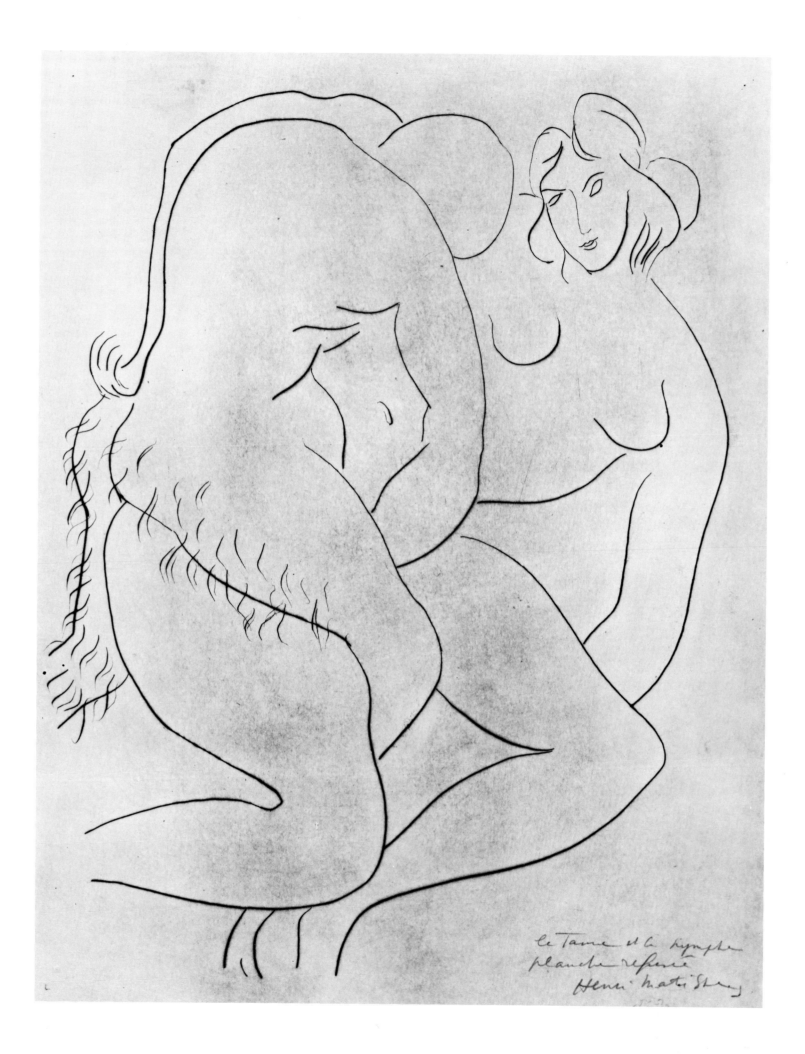

le Faune et la Nymphe
planche refusée
Henri Matisse

68 PROSE "FOR DES ESSEINTES"

(Prose "pour des Esseintes")

Experience of lush vegetation on his Polynesian travels found its way into the artist's pictures. The powerful impression is directly expressed here in the relationship between the proportions of humans and plants. Strangely, Matisse hardly painted or drew at all in this paradise. He wrote to Bonnard: "Saw all kinds of things. Will tell you about it. Lived for twenty days on a coral island: pure light, pure air, pure color: diamond saphir emerald turquoise. Fabulous fish. Done absolutely nothing, except taken bad photos."[88] For his trip Matisse had indeed bought a new camera, but he hardly used it. "When I saw all that beauty I said to myself: I am not going to reduce all this beauty to this little image. It would not be worth it. I prefer to keep it within me. Because after a few years I would have had nothing but that, everything would be replaced, limited by this little document."[89]

Matisse saw with unusual perspicacity the danger of photography as an aid to memory, the consequent loss of one's own powers of recollection. And yet it is precisely these "bad photos" that reveal to us the artist's view and his realm of experience. The photographs, shown in a 1986 exhibition in Nice entitled *Matisse and Tahiti*, are glimpses into the dense vegetation surrounding Matisse during his walks. They echo his own descriptions in his letters: "In the garden caladiums, cannas, extraordinary ferns, magnificent trees"; "All this makes for a paradise on earth that one cannot imagine. Elegant coconut palms and low coconut palms. Their foliage is all silky. It's beautiful, beautiful, beautiful."[90] The giant palms are translated here back into European trees, but the unaccustomed sense of size and space lingered.

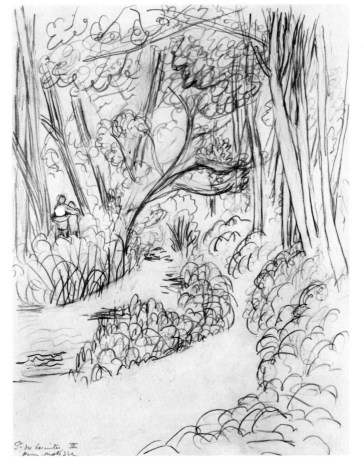

Pour des Esseintes III. 1931–32. Blacklead. Study for *Prose* ("pour des Esseintes") in *Poésies* by Stéphane Mallarmé. 32.4 × 25.8 cm. Baltimore Museum of Art. Cone Collection

68
1931–32. Etching. Illustration for *Poésies* by Stéphane Mallarmé

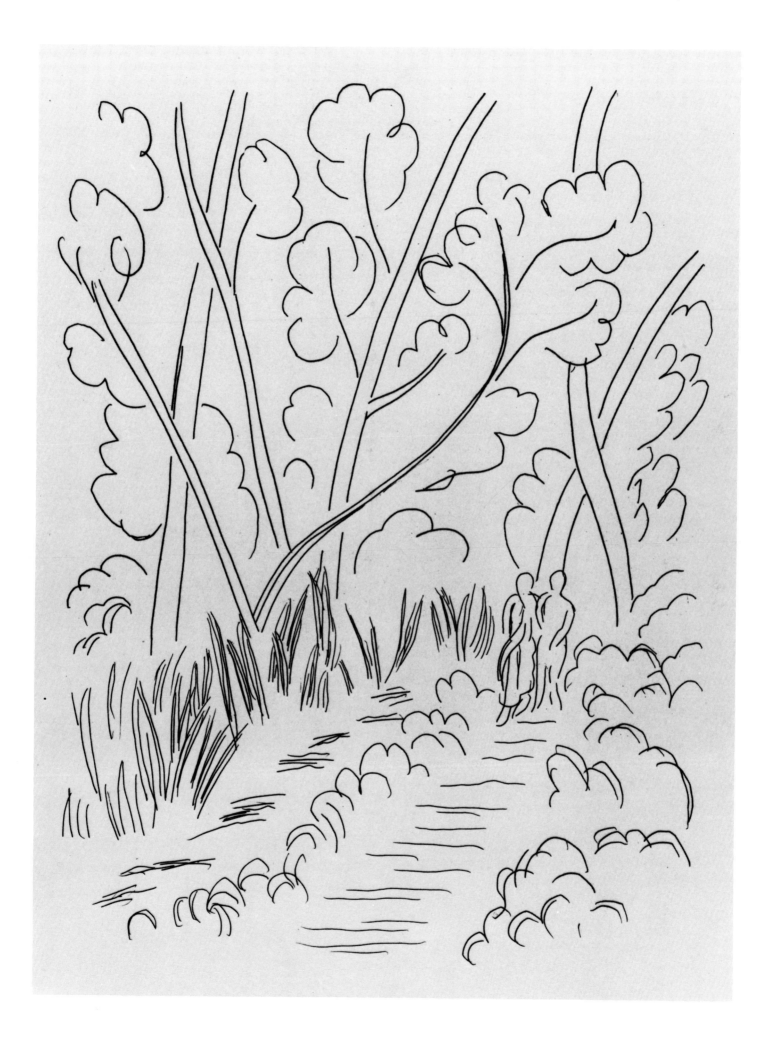

69 HAIR

(La Chevelure)

Mallarmé's words "La chevelure vole d'une flamme" ("hair flies from a flame") in *Le Faune* probably best reflect the inspiration behind this etching. The poet seemed to reawaken in Matisse memories of Tahiti, as drawings of women with wild, long hair show. Matisse found in the verse the sirens that aroused his imagination. The hair, like Medusa's, grows profusely in simple, ornamental, and rhythmical lines over the whole picture area and appears to extend into infinity, enveloping the viewer with its strands. With minimal means Matisse brought forth fullness, shapes, space, and movement that stretch beyond the frame of the picture. We are reminded of art nouveau-style female figures, of Klimt, Munch's *Sin*, but above all of the full and lustrous hair of Courbet's beautiful model from Ireland, Jo. Matisse knew these pictures well: he had also seen the Courbet exhibition in Paris's Petit Palais in 1929. Matisse owned the sensuous picture of Jo as she slept, *Red-haired Woman Sleeping* (1864, study of a detail for *The Waking*), and he had loaned it for the Paris exhibition. In it Jo's red hair plays about her head and spreads out over the couch.

It is exactly such intimate impressions that can inspire the artist to creative moments. "It is pleasing to see a good poet transport the imagination of an artist of another sort and enable him to create his own equivalent of poetry. The plastic artist, to make the best of his talents, must take care not to stick too slavishly to the text. On the contrary, he must work freely, his own sensibility becoming enriched on contact with the poet whom he is preparing to illustrate."[91] Matisse showed how he achieved this objective in 1946 in an article on book illustrating: "Etchings, done in an even, very thin line, without hatching, so that the printed page is left almost as white as it was before printing. The design fills the entire page so that the page stays light, because the design is not massed towards the centre, as usual, but bleeds over the whole page" (F. 107).

69
1931–32. Etching. Illustration for *Plusieurs sonnets,* in *Poésies* by Stéphane Mallarmé

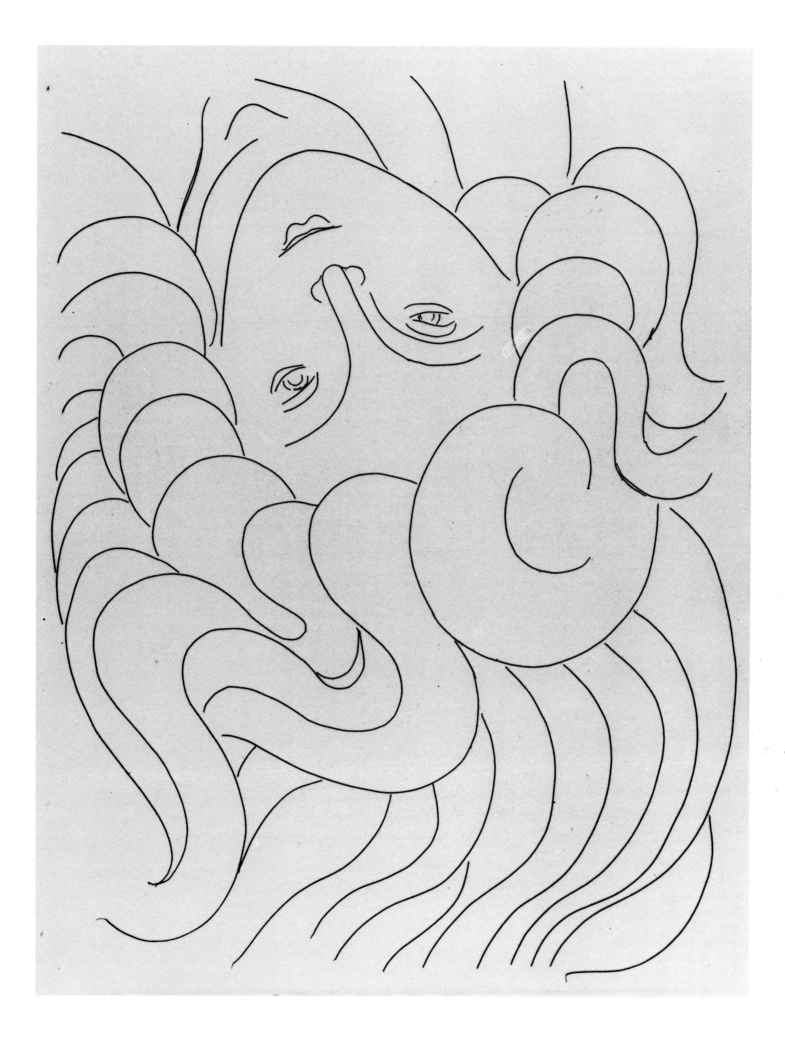

70 FLOWERS

(Les Fleurs)

"One day I was drawing lilies (for Mallarmé) and I was drawing without knowing too much what I was doing. At that moment Pierre [Matisse] rang the doorbell. I shouted out to him: Don't come in, go away, come back later. Because the slightest distraction can stop everything. And when it was finished I realized that I had done clematis, which have nothing to do with the lilies, clematis from the hedge in my garden at Issy, that I had been carrying in me for months without knowing it."[92]

Moments in which concealed, inner, superimposed pictures re-emerge and take form are rare and fleeting. Matisse was aware that these privileged moments were among his most intensively creative. He had now reached an artistic level that allowed him to create from his memory of forms without the need for a live model. This freedom gave rise to these uniform flowers, which join together to form a decorative whole yet retain their individuality. Matisse had found a kind of formula for a quite particular flower but saved it at the same time from becoming a fixed form by giving it variety and subtlety. These are "variations on a theme" running here through one print, that convinced Matisse that "in the leaves of a tree – of a fig tree particularly – the great difference of form that exists among them does not keep them from being united by a common quality. Fig leaves, whatever fantastic shapes they assume, are always unmistakeably fig leaves" (F.117). All his life Matisse searched for a common trait between things on the basis of elements that connected them and their differing external forms.

The observation of nature brought this spectacle of such connections before his eyes every day, and it was this sense of the inter-relatedness of thing that inspired him ten years later to the wall-covering paper cutouts with brightly colored forms and patterns of vegetation.

Les Glaïeuls. 1931–32. Pen and ink. Study for *Les Fleurs,* in *Poésies* by Stéphane Mallarmé. 25×32.5 cm. Baltimore Museum of Art. Cone Collection

Les Lys. 1931–32. Pen and ink. Study for *Les Fleurs,* in *Poésies* by Stéphane Mallarmé. 32.6 × 25.2 cm. Baltimore Museum of Art. Cone Collection

70
1931–32. Etching. Illustration for *Poésies* by Stéphane Mallarmé. Sixth pull of ready-for-press. Baltimore Museum of Art. Cone Collection

Bon à tier

Henri Matisse

71 THE BLINDING OF POLYPHEMUS

(Polyphème)

The major commissions for *Dance* from the Barnes Foundation and illustrations to Mallarmé's poems had hardly been completed when a new book commission was received from the American publisher George Macy. This time the subject matter was James Joyce's novel *Ulysses*. Matisse did not know the work and turned to his faithful English friends Simon and Dorothy Bussy in neighboring Roquebrune. After informing himself on the thrust of this epic novel, Matisse accepted the publisher's proposal. It was above all the opportunity to draw pictures of Homer's Odysseus that attracted him about the work. Conscientious as Matisse was, he made sure of obtaining James Joyce's permission and wrote to Bussy: "We are in full agreement on the character that I want to give the illustration; I even have his approval on the general composition of the book that I have conceived.... I am working on the Cyclops, Ulysses is putting out his eye.... I think that the person drawing should let the lead come from the literary people and the typography, which he can choose for his engravings — otherwise he would be too modest. It is a little like the role of the second violin in a quartet, except that the second violin responds to the first violin and that, in my case, I do a comparable thing to the literary people but in a rather decorative sense."[93]

For Matisse illustrating meant harmonizing, more so in this case since Joyce's text did not evoke the same intensive visual associations that Mallarmé's poems did. Matisse was transported back to thoughts of his youth, and he opted to depict the scene with the Cyclops, a scene illustrating a struggle, which was atypical of the themes in his work. The print shown here was not used for the commissioned edition. Compared with the final version it did not yet possess the dramatic violence that Matisse sensed in this incident. The Cyclops here still has a certain awkwardness, and the courageous Odysseus lacks combative strength. In the final version Matisse accentuates a dynamic element by setting the two bodies in a position of tension: Odysseus blinds the Cyclops with all his force, and the latter rears up in agony. Matisse manages to heighten the picture's dramatic power through simplifying the subject matter. By leaving off part of the giant's extremities, his feet and one hand, Matisse makes the giant's powers extend beyond the bounds of the frame. These are the kinds of brilliant inventions with which the artist knew how to capture the viewer's attention.

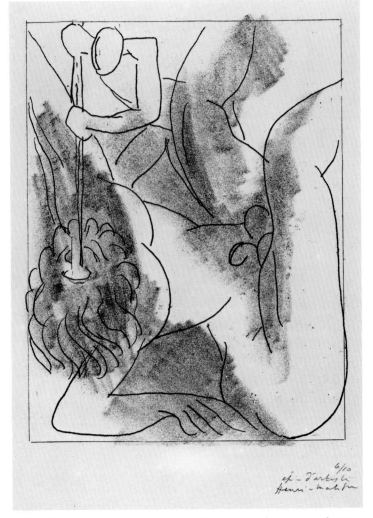

The Blinding of Polyphemus. 1934. Soft-ground etching, pl.205. 28.4 × 22.5 cm. Duthuit no.239. Bibliothèque Nationale, Paris; artist's proof

71
1934. Soft-ground etching, pl.205 *bis* (plate not used for the illustrations of *Ulysses* by James Joyce). 28.5 × 22.3 cm. 10 artist's proofs on Arches wove paper; 1 trial proof at the Bibliothèque Nationale, Paris, signed, on bleed wove paper. Duthuit, vol.1, p.184. Bibliothèque Nationale, Paris

Ulysses by James Joyce, published in New York by G. Macy in 1935, was printed in an edition of 1,500 copies for The Limited Editions Club

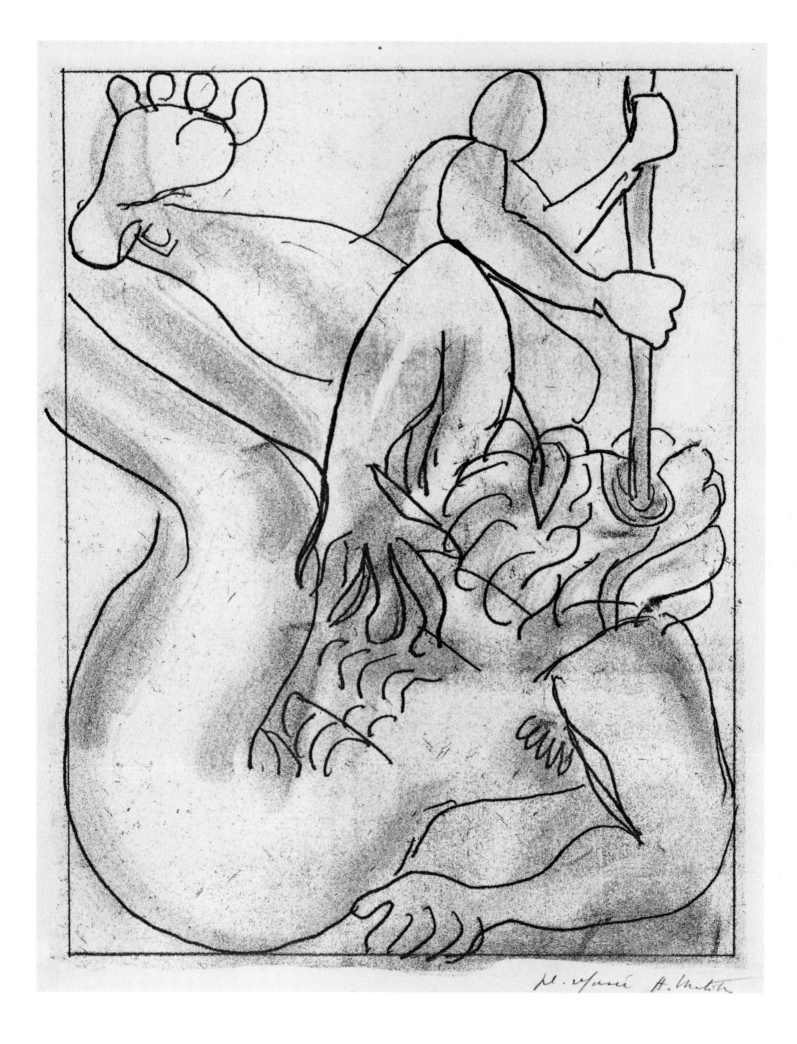

72 ITHACA

(Ithaque)

Pure landscapes are rare in Matisse's graphic work and might be seen here as symbolizing man's sense of having roots somewhere. Of the episodes the artist selected to illustrate *Ulysses,* this is the last of Homer's epic poems (following Calypso, Nausikaa, Circe, Aeolus, and Polyphemus). There are only six prints in all but Matisse heightened the illustrative aspect by adding facsimile prints for each version of the various preliminary stages, printed on alternating blue or yellow paper. The artist reinforced the picture's dramatic power and in this way managed to externalize the work's inner drama. Instead of using lithography, as was originally intended, he used the process of soft-ground etching, which was gentler and more paint-like in effect, suiting the inner mood of the text.

The printing was again laborious and Matisse paid close attention to its execution. He wrote to Bussy: "I've wasted three weeks at the imbecile lithographer's, who let me work with materials that he did not know. I've done three stones. The first insignificant, the second did not come, and the third came out all black. I got round it by making light patches with the acid and by etching into the stone to make white lines.... So I have abandoned stones for copper and I've done the etching on soft-ground... I've found the technique for me and that will do. I have something different from Mallarmé but which has another quality, full of verve."[94]

Ithaca becomes a highly stylized landscape of paths. The bright egg-shapes in the picture were originally blocks of stone, the charming landscape of bushes and trees was undergrowth and studded with tree trunks. The rather rough area in the first versions was transformed into a peaceful parkscape. The path's depth of perspective is shut off by a gate, which makes us more conscious of the proximity of civilization.

72
1934. Soft-ground etching, pl.206 (artist's proof of the last of the six illustrations for *Ulysses* by James Joyce, published in New York by G. Macy in 1935). 28.5 × 22.3 cm. 10 artist's proofs, signed and numbered, on Arches wove paper. Duthuit no.240. Bibliothèque Nationale, Paris; artist's proof

ep. d'artiste
3/10
Henri Matisse

("Fée au chapeau de clarté" – souvenir de Mallarmé)

This engraving was produced when Matisse was illustrating Mallarmé's poems. It refers to lines from *Apparition:* "Quand avec du soleil aux cheveux, dans la rue et dans le soir tu m'es en riant apparue et j'ai cru voir la fée au chapeau de clarté (When with sun in your hair, in the street and in the evening, you appeared to me laughing, and I thought I saw a fairy in a luminous hat)." Matisse engraved the iconic image into the copper plate with an astonishingly sure hand – hardly any joints are visible. The lines are wonderfully regular and result from one casting; the circles close easily, and the resistance of the material is never felt. The fine, chiseled lines are as sharp as knives, engraving their impression on the eye. The regular face is classically beautiful, permeated as it is with an infinite serenity expressed by its anonymous gaze. This unindividuated presence is one, in the words of the artist, "which best permits me to express my almost religious awe towards life.... When I see the Giotto frescoes at Padua I do not trouble myself to recognize which scene of the life of Christ I have before me, but I immediately understand the sentiment which emerges from it, for it is in the composition, the lines, the colour. The title will only serve to confirm my impression" (F.38). In the engraving shown here Matisse achieves these sentiments, uttered in 1908, in a most striking manner at the age of sixty-four, and at eighty he was again to fulfill its high demands in the chapel at Vence.

The fairy in this picture was a young Russian, Lydia Delektorskaya. She had emigrated to France as an orphan and arrived destitute in Nice in 1932 after a short-lived marriage to an exiled Russian. She was taken on by Matisse as a studio assistant to help with the large panels for the Barnes Foundation and from 1933 she cared full-time for Amélie Matisse. She stayed with Matisse for twenty-two years, until his death, and she later related this experience in a publication that appeared in 1986. As the artist's principal model beginning in 1934, her reminiscences of these years are extremely valuable, in terms of chronological detail as well as in providing insight into the artist's intimate world and working atmosphere.

During the 1940s Lydia looked after the ailing artist as his secretary, finding new models, materials, and taking care of his health. "Lydia, quite rightly, played the role of a fierce watchdog, making the best possible use of her 'boss'... this woman... was totally devoted to Matisse," the lithographer Charles Sorlier wrote in admiration.[95]

The engraving reproduced here required a detailed pencil drawing interspersed with many half tones. The artist was clearly fascinated by the model's long hair which, in his enthusiasm, he made longer still, as he once had done in works of Antoinette and Lorette. Lydia recalled: "The day before each sitting I was to braid it in the same way so that its waves were identical and in the same place around my face."[96]

73
1933 (according to Lydia Delektorskaya, 27 March 1934). Drypoint, pl.211. 36.6 × 32 cm. 5 test proofs; edition of 25, signed and numbered, on laid paper. Duthuit no.234. Bibliothèque Nationale, Paris

Henri-Matisse

24/25

74 GIRL LEANING ON THE BACK OF A CHAIR

(Jeune Fille s'appuyant sur le dossier d'une chaise)

When Lydia Delektorskaya joined the Matisse household in 1933 the artist did not seem at first to consider her as a possible model: "Henri Matisse showed little interest in me. He lived absorbed in his work; I had a 'functional' role in the house, he seemed more than anything to be a little disoriented by the presence of an example of the notorious 'Slav soul' in their very French family."[97] After a while, however, she felt "a heavy, searching gaze" fall upon her. She had realized in the meantime that she did not correspond exactly to Matisse's model type: "most of the models who had inspired him were southerners. Well I was blond, very blond." Had he suddenly discovered Mallarmé's "luminous fairy"?[99] According to Lydia's notes it was a specific pose that claimed his attention: "Don't move! And, opening his pad, he drew me, fixing upon a pose that was familiar to me: my head leaning on my crossed arms as they rested on the back of the chair."

A variation of this pose can be found in the poetic etching shown here with the expressive distortion of the position of the arm, a variant of the important poses in *Seated Pink Nude* (1936) and *Blue Eyes* (1935; Baltimore Museum of Art). Lydia, Matisse's principal model in the 1930s, inspired the artist as a blond muse to new harmonies of color and as a nude to the drawn-out and sensuous reclining poses, a successor to Titian's *Danae,* an Ingres odalisque, or a sleeping figure by Courbet. In spite of the sensuous content the pictures are thoroughly and strictly composed. They possess a rhythmic, architectural structure and a high degree of abstraction.

The few prints from this period were produced in the context of variations on pictures and are reflections of these sitting or reclining poses. They are small in size, apparently rapid and spontaneous etchings but each an individual work. It seems that Matisse drew mainly in pencil, pen, and chalk but without the intention of making prints of the works. The drawings show the artist's struggle to capture the rhythmic forms of his model Lydia and to combine these forms in consistent, vivid pictorial elements. One can discern in the etching illustrated a parallel with Picasso's graphic work, notably in the series *The Sculptor's Studio* (1930–37) – known as the Vollard Series after the art dealer Ambroise Vollard. This parallel becomes evident not only in the artist-model theme but also in the simple, static construction of the Picasso prints, while the sinuous, extended reclining poses in some of Matisse's pen-and-ink drawings can suggest the dramatic Minotaur scenes by Picasso.

74
1934–35. Etching, pl.218. 14.8 × 11.1 cm. 5 artist's proofs; edition of 25, signed and numbered, on laid paper. Duthuit no.243. Bibliothèque Nationale, Paris

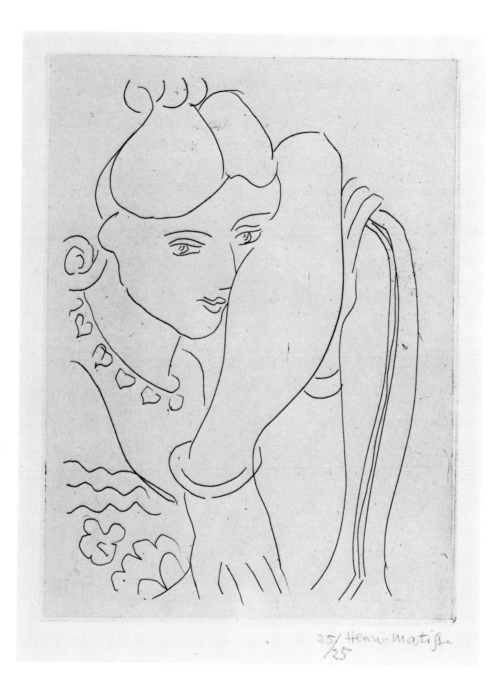

25/ Henri Matisse
/25

75 LYDIA

The artist's dependence on his model also expressed itself in his generous care of their material needs. "For my work I need to be able to count on somebody who is well," Matisse is recorded as saying, apparently also paying for delicacies and occasionally for his models' medical bills. "He would go out of his way to make the money he offered me neither extravagant nor a degrading piece of charity, but a well-merited act of thoughtfulness."[98] Matisse wanted his models to be in the best of health and a relaxed frame of mind, but demanded in return an endless amount of time. He took preventive measures to counteract occasional sluggishness or even apathy, keeping the model's interest in his work alive; he therefore gave Lydia photographs – as well as photographs of pictures in progress – of "her" pictures, had her write down thoughts on art and kept her busy assisting him in the studio. In this way he created a solid working relationship. The model watched the artist in turn: "His easel almost encroaching on his subject, he generally painted sitting down, not even two meters from it, as if to immerse himself in its atmosphere," or "if he wanted to make any corrections to the picture in the model's absence, before reworking it permanently he waited to see his subject again in real life."

The immediate relationship and proximity were determining factors in Matisse's work. The monumentality of many works derives, according to Matisse, from his closeness to the subject matter: "A cake seen through a window does not make you salivate as much as when, once inside the shop, you have your nose right up against it." These preconditions let loose a creative stream that Matisse described in the introduction to *Portraits* (1954) as "an interaction of feeling which makes each sense the warmth of the other's heart; the outcome of this can be the painted portrait, or the possibility of expressing in a series of quick drawings that which has come to me from the model" (F.152).

The artist's close-up view enabled him to interpret his subject matter in a freer and more emotional way, steering him away from cliché. This technique calls for considerable practice in decoding subject matter, however, and great concentration that obviously had on occasions to find an outlet; this prompted Lydia to comment amusingly: "During work of this kind – the cursing! He himself did not hear his own invectives; but if he did realize he would apologize to the model. This did not stop him from forgetting she was there immediately: the model became simply an element again of the problem before him." Father Marie-Alain Couturier, a Domini-

can priest who supported modern religious art, commented: "The atmosphere of an operating theatre. Lydia at his bedside, holding some instrument or other, a bottle of India ink, paper, arranging the table on wheels. And he, without a sound, drawing without a trace of agitation, but in this extremely immobile state, in an extreme state of tension."[99]

75
1947. Lithograph, pl.291. 32.4 × 22 cm. 2 trial proofs; 5 artist's proofs; edition of 25, signed and numbered, on Marais paper. Duthuit no.627. Bibliothèque Nationale, Paris; artist's proof

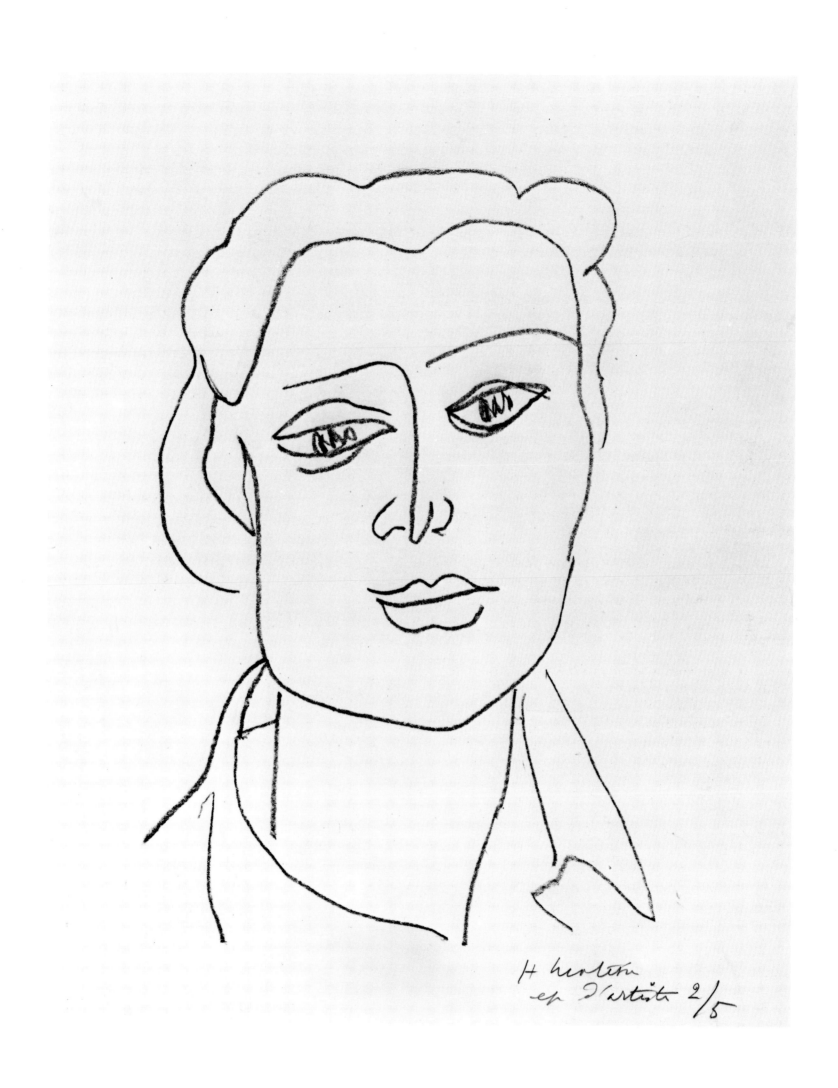

H Matisse
ep d'artiste 2/5

Paris's Notre-Dame is not depicted here head-on from Quai Saint-Michel but from the approximate height of Quai Montebello. Landscapes or city views are seldom seen in Matisse's graphic work and were usually commissioned for specific events, in this case in connection with the Exposition Internationale of 1937. Matisse worked directly into the plate, which was what he looked at, worrying little about the counterproof image in the print. The freedom that he had acquired through ten years of etching, both in the drawing of the lines and the conception, becomes clear when compared with the etchings of the *Pont Saint-Michel* from 1927 (Duthuit nos. 107 and 108). The two-dimensional quality of the section of the picture, the close-up shot as if seen through a zoom lens, and the imaginative decorative combination of trees and architectural components reveal the same principles of composition in the renditions of landscapes as in his still lifes and interiors.

Matisse's fame – like Picasso's – was confirmed in the 1930s, not least thanks to the busy exhibition scene. In the summer of 1931 the Parisian public was able to see a major retrospective on the master for the first time at the Galerie Georges Petit. There were also retrospectives in Berlin, Basel, and New York. Exhibitions followed in 1936 and 1937 at Paul Rosenberg's gallery in Paris, and a large exhibition of drawings and prints appeared in London at the Leicester Galleries in 1936, in Lucerne in 1937 at the Galerie Rosengart and in 1938 again in New York, staged by the artist's son, Pierre Matisse, who had been running his own gallery since 1931, introducing many young European artists to the United States. New art magazines awakened public interest, which even the international economic crisis of the 1930s could not curb. Nevertheless, the younger generation of artists felt the effects of the low dollar: "The painter was no longer a desirable or welcomed guest, and people gave up visiting studios from fear of being obliged to buy a canvas or a drawing."[100]

Nearly seventy, Matisse was able to work without financial worry. But his concern for artistic renewal, expressed in tireless creativity, continued to absorb him. The gifted English critic Roger Fry said, in 1931, "I don't believe that Matisse ever bothered to take pleasure in adopting the all too easy role of mystifier. He is much too honest for that. He has given proof of this honesty many times by his clearly expressed desire not to exploit his own success. Matisse has always shown himself to be willing to judge himself. At any moment he is capable of turning his back on what he has done and refusing to take the line of least resistance."[101]

76
1937. Etching, pl.219. 36.7 × 28.8 cm. 5 trial proofs on laid or wove paper, signed on the plate. Duthuit no.248. Bibliothèque Nationale, Paris

This engraving was printed by Daragnès in an edition of 500 for the city of Paris on the occasion of the Exposition Internationale of 1937

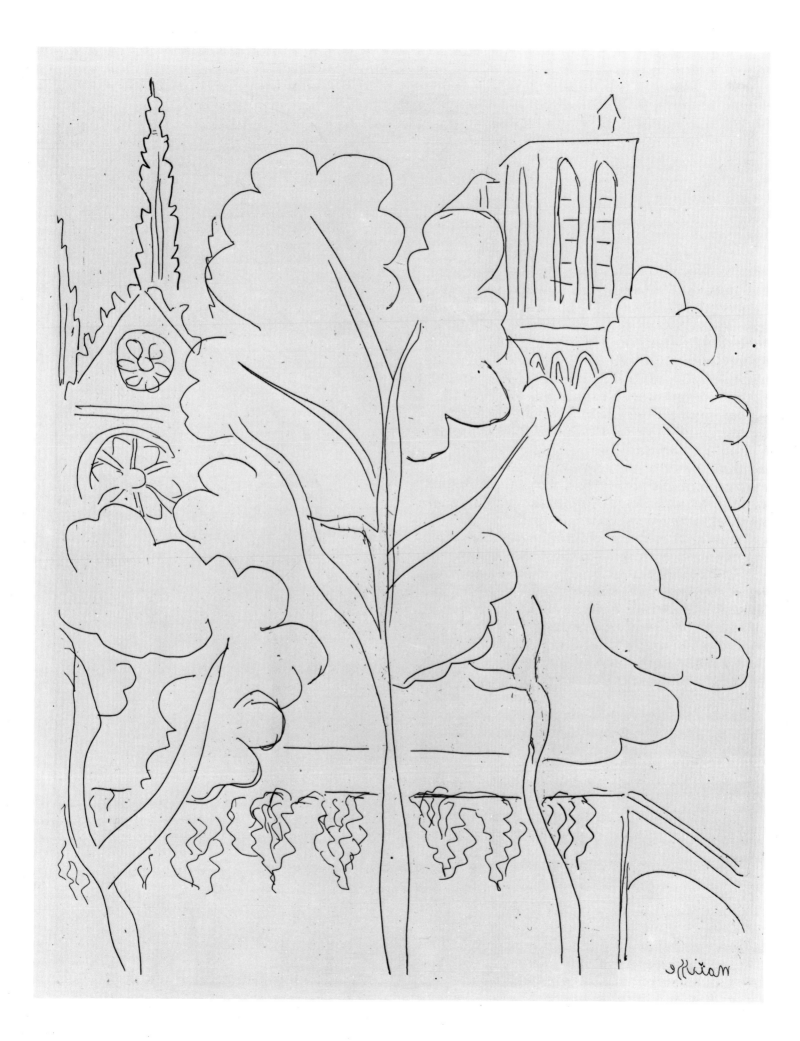

77 THE BEAUTIFUL TAHITIAN WOMAN

(La Belle Tahitienne)

During 1938 a series of black linocut portraits of women were produced, the prints of which radiate a certain hardness and aggression stemming from the powerful white lines. They bear very different titles and names but are in part variations on the same female type with distinct facial features and loosely falling locks. Like free renditions drawn from memory, these portrait types are decorated with embellishments, as this beautiful Tahitian woman illustrates. The title is probably based on the garland round the model's neck, a motif drawn from memories of Tahiti: "The Tahitian girls retain their wild and uncultivated nature despite the delicate Paris styles they wear," Matisse commented (F.61).

What is special about this portrait is the two-dimensional pattern that extends over the whole print: stars, stripes, flowers, geometrical shapes, and the features of the face itself, the eyes, mouth, and waves of the hair, all become decorative components. There is no hierarchy of motifs any more, their interrelationship alone determines their pictorial value, as Matisse explained to Tériade in 1936: "You can change the relationships by modifying the quantity of the components without changing their nature" (F.74). Although this observation refers to the chromatic scale, it is applicable here in a pure and sensitive manner. No painterly gradations could contribute to this composition, made up as it is of engraved lines set off by blank spaces. Matisse attributes the same role to these elements that we saw in the illustrations for Mallarmé's poems (see Pls. 65–69), but here the black and white values are reversed. The lines and their intersections form zones of distinct patterns that are built up of varying degrees of thickness and density and which, taken in combination, animate the picture. The constitutive elements of the picture's structure become more apparent than might perhaps be expected at first sight: "Making a picture would seem as logical as building a house, if one worked on sound principles. One should not bother about the human side. Either one has it or one hasn't. If one has, it colours the work in spite of everything" (F.82).

77
1938. Linocut, pl.255. 28 × 19.8 cm. 1 trial proof on Rives paper, 5 artist's proofs; edition of 25, signed and numbered, on G. Maillol wove paper. Duthuit no.717. Bibliothèque Nationale, Paris

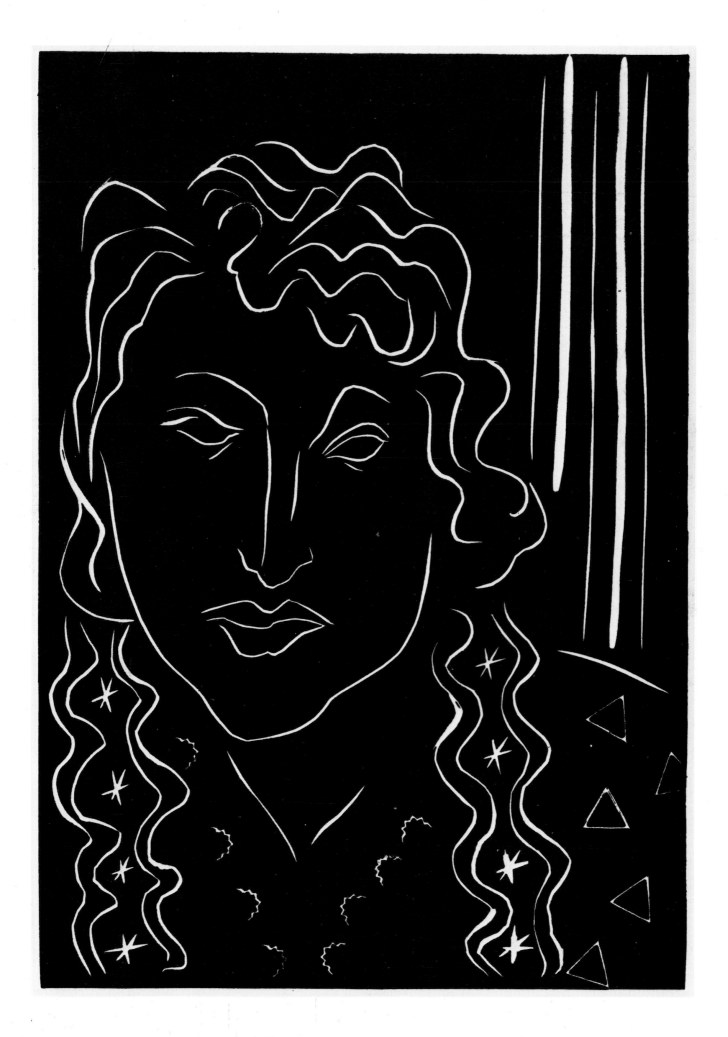

78 THE SIESTA

(La Sieste)

The intense period of drawing between 1938 and 1943 was marked by an astonishing process of abstraction and reduction. Matisse wrote to Bonnard on January 13, 1940: "I am paralyzed by something conventional that prevents me from expressing myself in the manner in which I would like in paint. My drawing and painting are moving apart. Drawing suits me because it conveys exactly what I am feeling. But my painting is inhibited by the conventions of new surface painting through which I must express myself entirely, painting using only local tones without shadows, without models, that have to react one against the other to suggest light, the concept of space. That hardly goes well with my spontaneity, which makes me discard in an instant a work I have spent a long time on, because I rethink my picture several times as I do it without really knowing where I am going, relying on my instincts. After preliminary works I have found a way of drawing that has a spontaneity that frees me completely from what I feel, but this only works for me, as artist and observer. But a colorist's drawing is not a painting. You would have to do an equivalent work in color. This is what I cannot manage to do."[102]

A minimal technique had already been of great benefit to the artist; he seemed to have found simple, effective solutions in drawing that he was still searching for in painting. At the end of the 1930s Matisse was coming up with breathtaking pictures of luminous figures, ciphers of objects, executed mainly in linocuts. These are expressive, monumental, anonymous pictures of great simplicity and conciseness. The luminosity of the lines, which are like shimmering neon tubing, is increased in the example illustrated to the radiant level of the setting sun. The extremities of the nude or individual features such as the eyes, nose, and mouth are left off: they would only disturb the overall flow of the linear pattern and distract the observer unnecessarily. The composition radiates ease, quiescence, and repose, another paradisiacal reflection on the Golden Age: "In Tahiti.... There are no worries in that land.... There the weather is beautiful at sunrise and it does not change until night. Such immutable happiness is tiring" (F.135).

Matisse knew about the seduction and magic of this world of pictures and was therefore able to portray it with such charm because he himself was subject to earthly trials and limitations, and carried dreams within him. He had found the lassitude of tropical Tahiti stultifying: a "paradise" where dreams, desires, longings were forgotten. "You cannot work without worries. That is the great lesson I brought back from the Pacific."[103] Matisse here became not only a magician but also a prophet. For him it was not a question of morality: the only thing that counted was energy, which could also be liberated by tribulations and worries and which led to creativity.

78

1938. Linocut in black and red chalk, pl.247. 25.8 × 30.5 cm. 1 trial proof; 5 artist's proofs; edition of 25, signed and numbered, on G. Maillol wove paper. Duthuit no.706. Bibliothèque Nationale, Paris

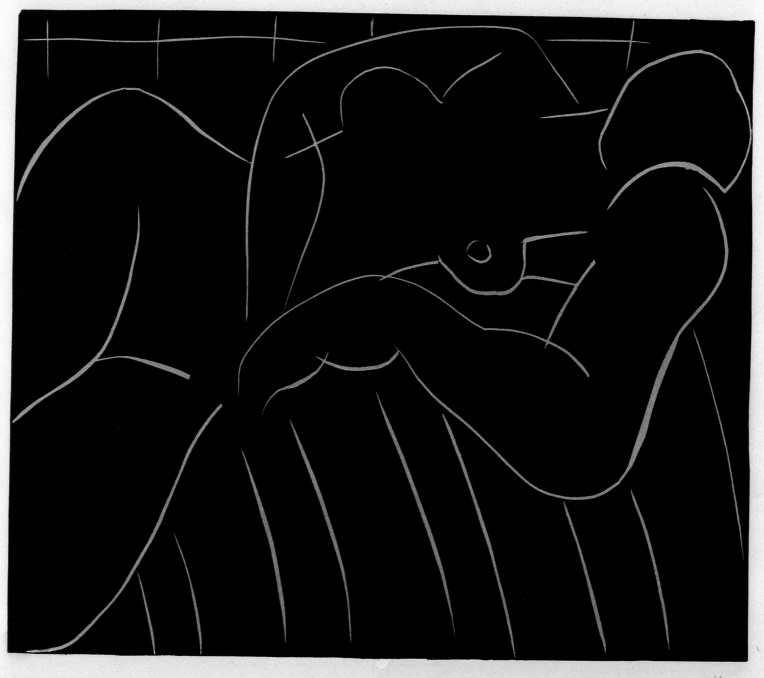

Henri Matisse

15/29

79 BOWL OF BEGONIAS I

(Corbeille de bégonias I)

Whether it was flowerpots, plants, or female heads, Matisse attempted to give his subject matter presence and energy by using the simplest means. The still life lay at the root of his art. Even when first copying old masters, his bottles, glasses, and jars had a special sensuous gleam and a perceptible volume. According to Louis Aragon, Matisse once made the following comment while a pupil of Gustave Moreau: "I thought I would never do figures, but then I put figures into my still lifes. My figures live for the same reasons that made my still lifes come alive... a loving group, an emotion in my objects that gives them their quality. It was after showing still-life objects that I was able to show the human figure."[104]

Growing up in northern France, Matisse clearly received his first artistic impulses from Dutch works, which dazzled him with their overwhelming materiality – luminous, glossy interiors filled with sumptuous objects. Matisse later advised his pupils: "To copy the objects in a still life is nothing; one must render the emotion they awake in him. The emotion of the ensemble, the interrelation of the objects, the specific character of every object – modified by its relation to the others – all interlaced like a cord or a serpent.... A still life is as difficult as an antique and the proportions of the various parts as important as the proportions of the head or the hands, for instance, of the antique" (F.45).

In the example shown here we can see just how important the proportions, the mutual relationship of form and tonal value are in the artist's work, since the smallest change affects the nature and space taken up by the pot of begonias. A second version, only slightly altered, produces a more compact and stable grouping (Duthuit no.719). The small, subtly distributed flowers punctuating the latticework background in this version soften the spatial dimension, fill in the volume, and make the drawing vibrant.

Foliage was very important to the aging artist; his studios in Nice and in Vence were filled with large-leaved plants and potted plants of all kinds. They show the inexhaustible wealth of variations in form found in nature and the resulting decorative possibilities as subject matter for pictures.

79
1938. Linocut, pl.257. 20.1 × 23 cm. 7 trial proofs; 5 artist's proofs; edition of 25, signed and numbered, on G. Maillol wove paper. Duthuit no.718. Bibliothèque Nationale, Paris

80 EMBRACE

(Etreinte)

Could an embrace be represented in a more concise, abstract, yet tender way?

Matisse made Henri de Montherlant's acquaintance in Nice and composed a portrait of the writer. The idea of working together led to illustrations to *Pasiphaé, Chant de Minos (Les Crétois)*, which were published by Martin Fabiani and printed by Fequet and Baudier in 1944. Matisse, who was now forced to rest frequently following an operation, drew more than ever. He viewed this commission as "his" second book, for he had not regarded either *Ulysses* or the book editions with a frontispiece or reproductions as authentic examples of book illustration. The new work engrossed him: "A simple white line on an absolutely black background. A simple line, without shading" (F. 107). There are no secondary lines to divert the observer's attention, to compete with, interrupt, or detract from the natural flow of the contours, which always act as the agents of form, volume, movement, and light, as the print shown here demonstrates.

Matisse fussed greatly over his prints and rejected many tests and studies. What mattered was the fragility and complexity of the line, together with the constant awareness of the format and the need to integrate the text harmoniously. He asked himself, in fact, "How can I balance the black illustrating page against the comparatively white page of type? By composing with the arabesque of my drawing, but also by bringing the engraved page and the facing page together so that they form a unit." Matisse added red designs to the text as accents in order "to break up the slightly sinister character of the black and white book" (F. 108).

The artist worked intensively on these illustrations for ten months and tried out the hitherto little-used technique of linocuts. He compared it to "the violin with its bow: a surface, a gouge — four taut strings and a swatch of hair. The gouge, like the violin bow, is in direct rapport with the feelings of the engraver. And it is so true that the slightest distraction in the tracing of a line causes a slight involontary pressure of the fingers on the gouge and has an adverse effect on the line. Likewise, a change in the pressure of the fingers which hold the bow of the violin is sufficient to change the character of the sound from soft to loud" (F. 109). Matisse summed up the objective of any illustrated edition in musical terms again: "The drawing must be the plastic equivalent of the poem. I would describe them not as first and second violins, but as an ensemble playing together" (F. 109).

80
1941 and 1943, Nice. Linocut, pl.355. 24.2 × 17.2 cm. 1 artist's proof at the Bibliothèque Nationale, Paris, on wove paper (Arches?). Bibliothèque Nationale, Paris

Illustration for *Pasiphaé* by Henri de Montherlant, published by Martin Fabiani in Paris in 1944 in an edition of 250 copies, containing 18 inset linocuts

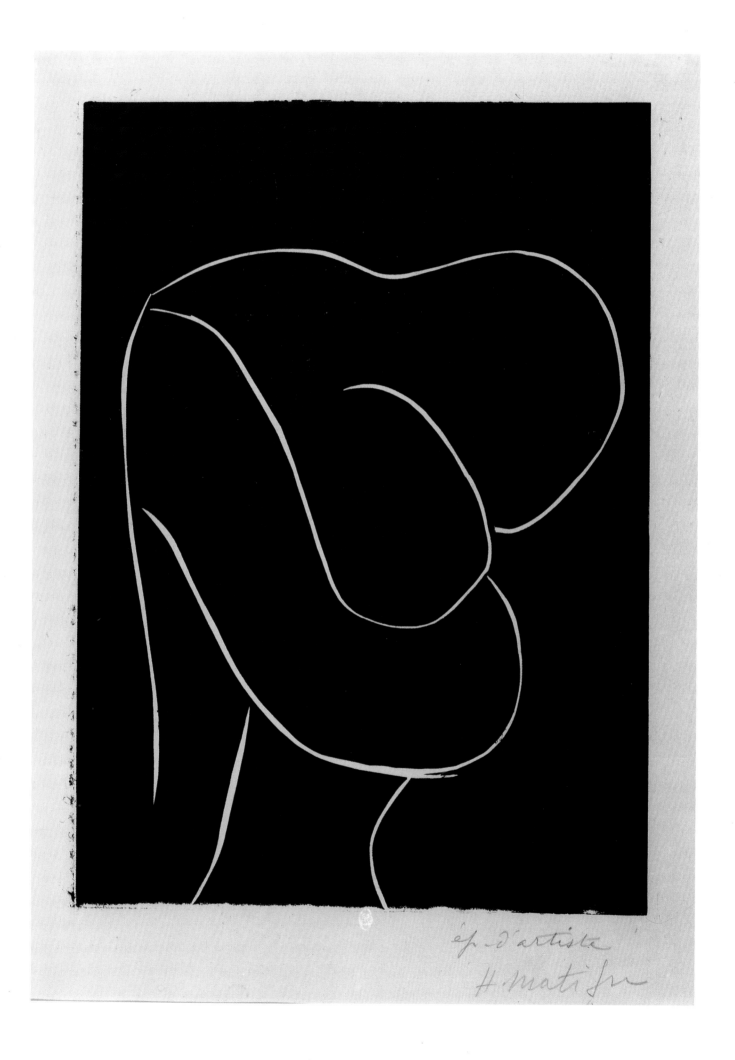

ép. d'artiste

H. Matisse

81 LARGE MASK (1944) *(Grand Masque)*
SELF-PORTRAIT (1944) *(Autoportrait)*
SELF-PORTRAIT (1946) *(Autoportrait)*
SELF-PORTRAIT (1951) *(Autoportrait)*

Between 1944 and 1951 eight self-portraits were produced in simple outlined lithographs. They looked a little like caricatures. It is easy to imagine the artist in front of the mirror, scrutinizing his head, tensing and moving his features in order better to read and interpret them. Matisse would, according to Pierre Courthion, have been faced with a seventy-five year-old man who was "still very young all in all and very French."[105] The photographer Jules Brassaï remembered how Matisse was always impatient when waiting for his portrait to be taken, visibly concerned as to the way he looked: "I am a cheerful man – joyful, even.... Anyway, I have a forbidding face. People always take me for a grumpy professor.... I look like an old fogey." Brassaï confirmed this: "And it was true. Matisse was jovial. But laughing did not suit him. It distorted him. He searched for himself in his portraits and had difficulty finding himself – if he appeared austere, he was belying his nature; if shown laughing, it looked like caricature. The hint of a smile would lighten his face..."[106]

The search for an identity to his face was no easy undertaking for the artist, as the different versions testify. He decided on the slightly smiling variant when dedicating one version to his son Jean. The genuineness of his artistic purpose is also reflected here, however, and it may be a consolation that even a great artist had to take pains over his appearance. Poor Matisse suffered even more when he had to see himself on film: "I was shocked by the slow motion...really strange! Suddenly you see the hand working completely from instinct, caught by the camera and dissected.... I kept wondering: 'Is that you doing that? What the devil am I supposed to do meanwhile?' I felt absolutely lost.... I didn't recognize my hand or my canvas.... I was asking myself worriedly: 'Is it going to stop? to continue? What direction is it going to go in?' I was amazed to see my hand carrying on further and further to a final point.... Usually, when I start on a drawing, I am scared, even distressed. But I've never been as petrified as when I saw my poor hand in slow motion going this way and that, as if I was drawing with my eyes shut."[107] Brassaï noted down this comment in December 1946, remarks occasioned by a documentary film made in the same year by the film-maker François Campaux with commentary by Jean Cassou. Unlike Picasso, Matisse was said to have been very helpful and most fascinated.

Matisse. c.1940–41. Photograph by Hubert de Segonzac. Musée Matisse, Nice

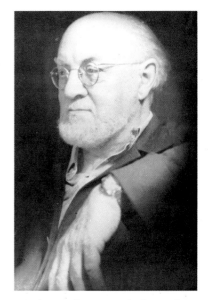

Matisse. Photograph by Rémy Duval. Musée Matisse, Nice

81 I
1944. Lithograph, pl.336. 35.2 × 25 cm. 2 trial proofs; 15 artist's proofs; edition of 50, signed and numbered, on laid Annam paper. Duthuit no.562. Bibliothèque Nationale, Paris; artist's proof

81 II
1944. Lithograph, pl.379. 38.5 × 24 cm. 2 trial proofs; 6 artist's proofs; edition of 25, signed and numbered, on Arches wove paper. Duthuit no.563. Bibliothèque Nationale, Paris

81 III
1946. Lithograph, pl.286 bis. 24.4 × 10.7 cm. 5 artist's proofs; edition of 12, signed and numbered, on laid paper. Duthuit no.579. Bibliothèque Nationale, Paris; artist's proof

81 IV
1951. Lithograph, pl.343. 31 × 21.2 cm. 1 trial proof; 10 artist's proofs; edition of 50, signed and numbered, on laid Annam paper. Duthuit no.635. Bibliothèque Nationale, Paris

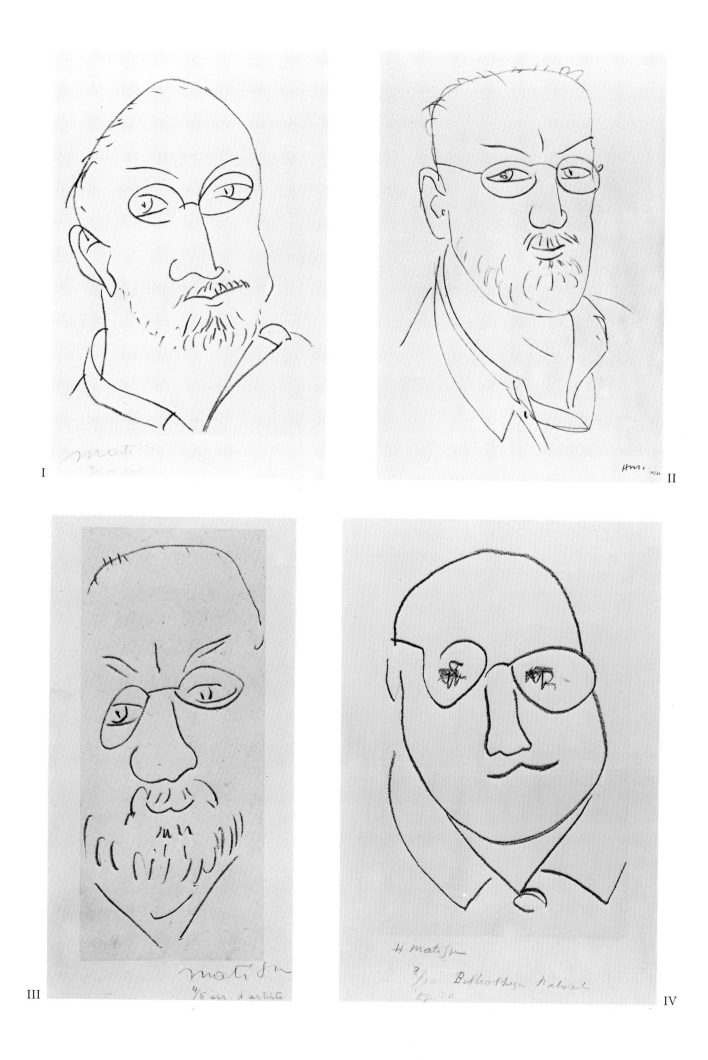

I

II

III

IV

82 HENRI MATISSE, MASK (1945)

(Henri Matisse, masque)

Matisse's graphic work takes us from the first questioning self-por-trait at the beginning of his career as an artist to the roguishly smil-ing portrait at the end of his life. Matisse did not act like an old man and his work clearly kept him fresh. He nevertheless retained his professorial appearence. Pierre Courthion described the way he looked in 1942: "It is his eyes that I remember above all – their clarity. His blue gaze looks at you and dissects you through the lenses of his glasses and, if no connection is made, returns into him-self like the proboscis of an insect who has sucked in sap. His nose, quite thick at the end, with fleshy, puffy sides, is not completely in line with his ears, the lobes of which hang pinkly, curiously com-pact, towards the start of his beard. A light down blurs the contour of the skull. Matisse would suggest one of those Greek philosophers whom we copied from casts at the Ecole des Beaux-Arts, if his keen-ness did not contrast so strongly with the bloodless immobility of the plaster. I can also still see very distinctly his lower lip when a smile softened it; or when, thickly and rapidly, it threw out the phrase in a single breath, suddenly expressing a thought that was unique."[108]

Matisse was always well-groomed in appearance, in contrast to Bonnard's unironed and ill-fitting clothes, or Picasso's shorts and open shirts. The artist lived apart from his family and during the war until 1949 he lived in the villa "Le Rêve," surrounded by dense, southern fauna. His daily life had been restricted after a seri-ous operation in 1941, followed by pulmonary embolism; but his creative energy was intact. He had been given a second life and his dreams of paradise continued, reflected above all in his many book illustrations. He worked on his beloved *Florilège des Amours de Ron-sard,* published in 1948, the poems of Charles d'Orléans in 1950, and *Les Fleurs du mal* by Charles Baudelaire in 1947. He also imm-ersed himself in the new technique of paper cutouts and designed illustrations for his own *Jazz* in 1947. Plagued by insomnia, he frequently drew at night. He said to André Rouveyre in 1947: "Life is short... it is not always amusing... my insomnia which saps much of my energy; at the moment I am quite profoundly disheartened. And yet since my return to the four canvases I've been working on, two are excellent, I think, and I have a few good drawings."[109] Work always revived the artist yet never conveyed traces of physical pain, loneliness, worries about the war, or the extent of commit-ment that it took from him. Art imposed limitations, and his daughter Marguerite Duthuit remembers his comment: "In life you have to choose: paint or socialize. You cannot do both."[110]

82
1945. Lithograph, pl.276. 22.2 × 15.7 cm. 3 trial proofs; 4 artist's proofs; edition of 12, signed and numbered, on Arches wove paper. Duthuit no.564. Bibliothèque Nationale, Paris; copy with dedication to Jean Matisse

3/12

H Matisse

à Jean Mactrisu

The catalogue of Matisse's work shows that he produced six versions of Marguerite Duthuit's face. She had not appeared as a model in her father's work since her marriage in 1923 to the Byzantine expert and art critic Georges Duthuit. She is presented here as a self-assured and beautiful woman who, rendered without shading, seems to have no age. We know her face from earlier pictures (see Pl. 29) and it is astonishing how with such apparent ease and precision Matisse fixes these features – the striking shape of the chin and cheek – in only a few outlines and brings out Marguerite's personality unmistakeably. One might have assumed that he conjured up her image from memory. Correspondence with his friend Camoin and with Louis Aragon gives us the background to this portrait, however, and proves that the father had worked with his daughter in front of him.

During the war Matisse was extremely concerned about Marguerite. She was an active member of the Resistance and became a German prisoner of war. Matisse wrote to his friend Camoin on May 5, 1944: "As for me, I have just received the biggest shock of my life, but I think I will get over it by working: My wife and daughter have been arrested separately and in different places. I found out, two days later, without any other details, and no more news since.... I have just had to hope the situation will improve, not wanting to let my imagination run away. I have worked a lot to dampen it."[111] On July 23, he told Camoin: "For my part, I thought I had experienced everything, physical and mental suffering. But no! I have had to go through this last trial. I don't dare think about Marguerite, about whom nothing is known. It is not even known where she is."[112] We know now that she was tortured and deported but was able to escape. Pierre Schneider tells how she hid for several weeks in the Vosges forests. According to the exchange of letters she returned to Paris in November 1944. On February 7, 1945 Matisse wrote to Aragon: "I have been most moved by my daughter's visit – talking together for almost two weeks made me experience life in prison, everything that she suffered and the horrors that surrounded her – what a book for a Dostoyevsky!"[113] This trying moment for a father was reason enough for the portrait drawings. He donated two of them to the cause for which Marguerite had worked, the Francs-Tireurs et Partisans. Louis Aragon, who witnessed this sitting, wrote "The years have passed and those eyes have seen prison, horror. She is a quiet, calm woman. She no longer has the frightened eyes of Margot, in a pinafore dress with a pendant on the end of a chain."[114]

Today the pictures of Marguerite provide a unique record. They run through the artist's oeuvre like a fixed artistic point from which different periods can be seen and intermediate stages measured; at the same time they demonstrate the artist's constantly changing outlook. Here it is completely in keeping with the pictorial language of his late work.

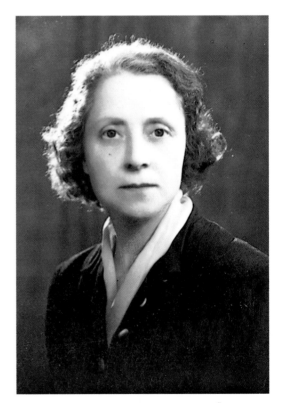

Marguerite. c.1945. Photograph. Henry Matisse Archives. Claude Duthuit Collection

83
1945, printed in 1969. Lithograph, pl.434. 30 × 22.8 cm. A few trials pulled in 1945; edition of 25, numbered and bearing the seal "HM," on wove paper. Duthuit no.571. Bibliothèque Nationale, Paris

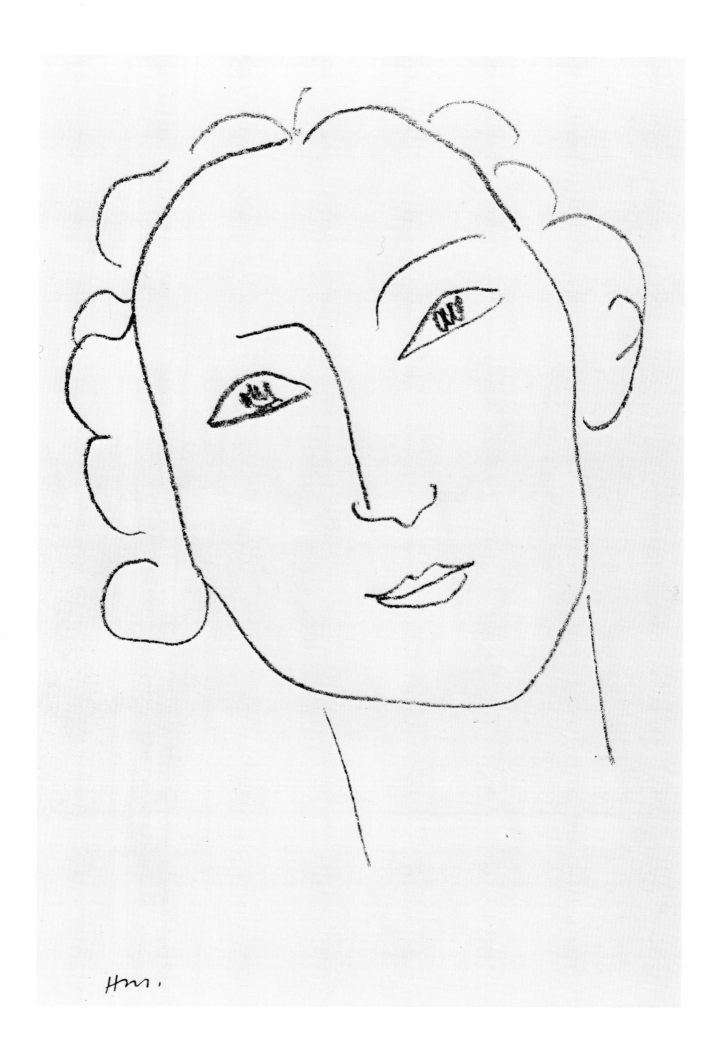

84 CLAUDE, MASK

(Claude, Masque)

Claude Duthuit, the artist's grandson, was fifteen years old when Matisse drew this portrait. It was, he remembered, very hot and he had to sit still for at least an hour, and, what was more, the atmosphere in the studio was said to have been very serious. Matisse demanded very great discipline and receptivity from his models, which a boy of that age was presumably less prepared to provide. His second grandson, Gérard, the son of Jean Matisse, also had his portrait done in the same year (Duthuit no. 577).

It seems that Matisse produced more portraits and lithographs of friends and acquaintances after the Second World War. This example of the portrait of Claude shows once again the artist's way of working, which had not changed even in his old age. Matisse returned occasionally to pencil or chalk drawings of models in order to model or add nuances to a face or find new interpretations. Claude became a young man, but his features imprinted in his father's spirit permitted Matisse to improvise freely while remaining conscious of the need to retain the essence of the face. Several of these versions of Claude survive (Duthuit nos. 583–87). They served as a basis for the fontispiece of Tristan Tzara's book *Le Signe de Vie* (1946).

The portraits are among the most fascinating of Matisse's works. They document the artist's tightrope walk between the demands of portraiture and the urge to produce generalized features, between fidelity to the model and free interpretation. "I ended up discovering that the likeness of a portrait comes from the contrast which exists between the face of the model and other faces, in a word from its particular asymmetry. Each figure has its own rhythm and it is this rhythm which creates the likeness. In the West the most characteristic portraits are found in Germany: Holbein, Dürer, and Lucas Cranach. They play with asymmetry, the dissimilarities of faces, as opposed to the Southerners who usually tend to consolidate everything into a regular type, a symmetrical structure. I believe, however, that the essential expression of a work depends almost entirely on the projection of the feeling of the artist in relation to his model rather than the organic accuracy of the model"(F.151).

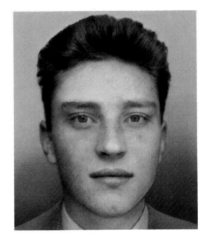

Claude Duthuit. c.1945. Photograph. Henri Matisse Archives. Claude Duthuit Collection

84
1946. Lithograph, pl.323. 23.9 × 17.8 cm. 3 trial proofs; 5 artist's proofs; edition of 10, signed and numbered, on Arches wove paper. Duthuit no.578. Bibliothèque Nationale, Paris; trial proof with dedication to the Bibliothèque Nationale

Essai

H Matisse

P. la Bibliothèque Nationale

85 PORTRAITS OF PAUL LEAUTAUD

(Portraits de Paul Léautaud)

It is a fascinating experience to follow how far Matisse can exploit the asymmetry of a face and distort it while remaining true to the constraints of producing a likeness in a portrait. The writer Paul Léautaud (1872–1956), a contemporary of Matisse, made notes on such an attempt. Léautaud was seventy-four in this photograph by Henri Cartier-Bresson, which shows him small and thin, with a bony, wrinkled face and sunken cheeks and lips. The small round glasses conceal a sly expression.

André Rouveyre introduced Léautaud to Matisse. A portrait was planned for the frontispiece of the book *Choix de pages de Paul Léautaud* published in 1946. Léautaud had great trouble understanding Matisse's drawing style and expressed this difficulty in his *Journal*.[115] His negative criticism is a valuable document today and reminds us that at that time Matisse's art was far from achieving general acceptance. "The talent for illusion, blindness, abnormality that Matisse must have in order to have ended up with this portrait made up of three or four plain lines, without life, expression, or the slightest detail of a likeness, and for him then to look at it with the indulgence and satisfaction that he showed and expressed.... Matisse, for me, is a little silly as a painter and as a writer."

When Matisse finished and gave Léautaud the portrait drawing, the latter sold it at the first opportunity: "There is nothing there of my face.... A portrait that could equally well be of an imaginary person, born from Matisse's meditations." It is a fact of art history in the twentieth century that portrait commissions have rarely turned out to satisfy the client; it is astonishing nevertheless that Léautaud reacted with such a lack of understanding to this amusing cinematography. The portraits were too snappy, too cursory, too "absurd." He could not see the pains that Matisse took. The result was not him, it was a "Matisse." The artist apparently destroyed some four hundred sketches that he had made of Léautaud and saved the few with which he was not dissatisfied. He hung about twelve of them in his room, and Léautaud himself described in his *Journal* their effect on the artist: "Tomorrow, after sleeping, the mind's nightly labors, he will look at them, they will act upon him, and without his knowing it, the final drawing will form in his head. He will then do the portrait." It therefore comes as no surprise that at the end of his life Matisse frequently felt obliged to record in writing his ideas on his art as a portraitist, because – as he himself often stressed – his works were all portraits, pictures drawn from life.

Paul Léautaud. Photograph by Henri Cartier-Bresson

85 I–XII
1946. Lithograph, pl.288, 296–306. Approx. 20 × 14 cm. A few artist's proofs; edition of 5, signed and numbered, on wove paper. Duthuit vol. 2, p.174, nos.593–603. Bibliothèque Nationale, Paris

The eleven portraits of Paul Léautaud, executed in 1946, are preliminary drawings for the frontispiece (pl.288) of *Choix de pages de Paul Léautaud*, edited by André Rouveyre for Bélier Editions in 1946.

pl. 288

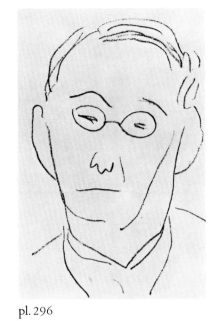

pl. 296

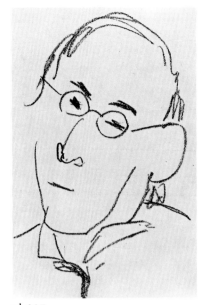

pl. 297

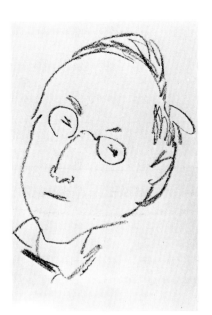

pl. 298

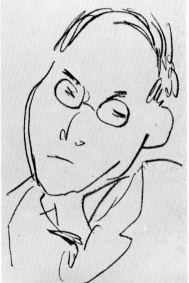

pl. 299

pl. 300

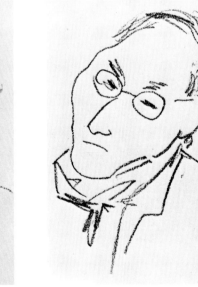

pl. 301

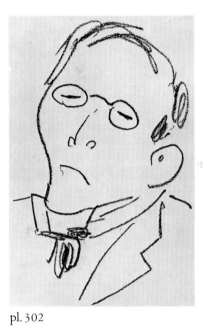

pl. 302

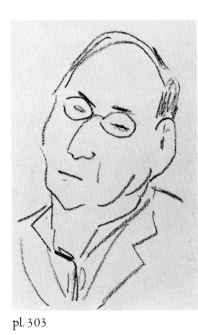

pl. 303

pl. 304

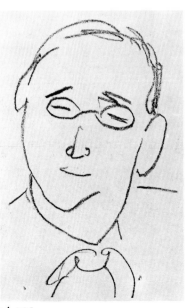

pl. 305

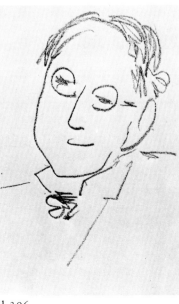

pl. 306

86 FACE, THREE-QUARTER VIEW (I) *(Visage de trois quarts)*
SCULPTURAL FACE (II) *(Visage sculptural)*
SMILING FACE (III) *(Visage souriant)*
FACE STARING INTO THE DISTANCE (IV) *(Visage au regard lointain)*

Matisse decorated his walls with the faces of his models. He wanted to see the different versions and let them work on him, an effect that was almost cinematic. He commented to Paul Léautaud that the likeness of a portrait carried less weight than "what results from these tests, these drawings as a whole, in the painter's mind, what is gained in examining and making discoveries, and a certain familiarity with the model, in a word, the result of everything that forms the basis for the final portrait.... I could make another portrait from all of them in a half hour that would bear a likeness. That is not what I am doing. That does not interest me. I am searching, I want something else."[116]

Matisse was able to inspect differences in the faces on the wall from his bed and assess possible interpretations. The four examples illustrated here of portraits of Lucienne Bernard, wife of a poet friend, give an impression of this technique, what Matisse called "the cinema of my sensitivity." "My instant drawing is not my main number. It is simply a film technique involving a sequence of images that I produce constantly during background work, for a picture is nothing more than the result of a sequence of precise preconceptions which come to life in tranquility, one supporting the other."[117] It was the artist's role to reproduce sense impressions received from the model. This is reflected in a series of drawings in the concentration and summation of these impressions, which in Matisse's case always means a reduction in the means of expression without, however, falling prey to a system, a formula.

86 I
1946. Etching, pl.318. 14.9 × 11 cm. 5 artist's proofs; edition of 25, signed and numbered, on laid paper. Duthuit no.297. Bibliothèque Nationale, Paris

86 II
1946. Etching, pl.317. 15 × 11 cm. 5 artist's proofs; edition of 25, signed and numbered, on laid paper. Duthuit no.295, Bibliothèque Nationale, Paris

86 III
1946. Etching, pl.319. 14.9 × 11 cm. 5 artist's proofs; edition of 25, signed and numbered, on laid paper. Duthuit no.298. Bibliothèque Nationale, Paris

86 IV
1946. Etching, pl.315. 14.8 × 11 cm. 5 artist's proofs; edition of 25, signed and numbered, on laid paper. Duthuit no.294. Bibliothèque Nationale, Paris

I

II

III

IV

87 MARTINICAN WOMAN
(Martiniquaise)

The late graphic work consists almost exclusively of faces, evoked with the minimum number of strokes. It looks like an obsession on the part of the artist and only becomes comprehensible when the faces are seen in conjunction, since the observer must also examine the works in a series in order to understand Matisse's aims and way of working. Only then does one begin to understand the complexity of these apparently simple line sketches, seeing the infinite creative imagination that lies behind them.

These examples of a woman from Martinique, printed in 1946, were preliminary drawings for the frontispiece of Baudelaire's *Les Fleurs du mal*.

87
1946–47. Etching, pl.305. 25.2 × 19.1 cm. 1 trial proof; 5 artist's proofs; edition of 25, signed and numbered, on laid Annam paper. Duthuit no.285. Bibliothèque Nationale, Paris

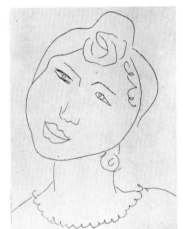

pl. 303

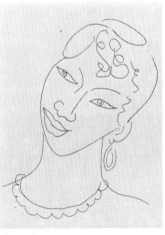

pl. 306

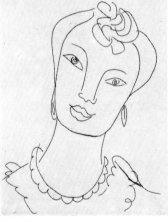

pl. 307

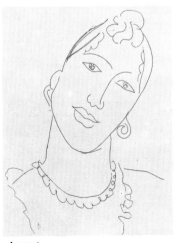

pl. 304

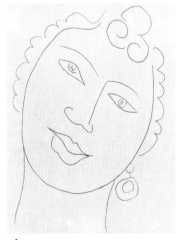

pl. 301

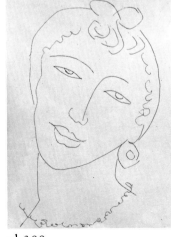

pl. 300

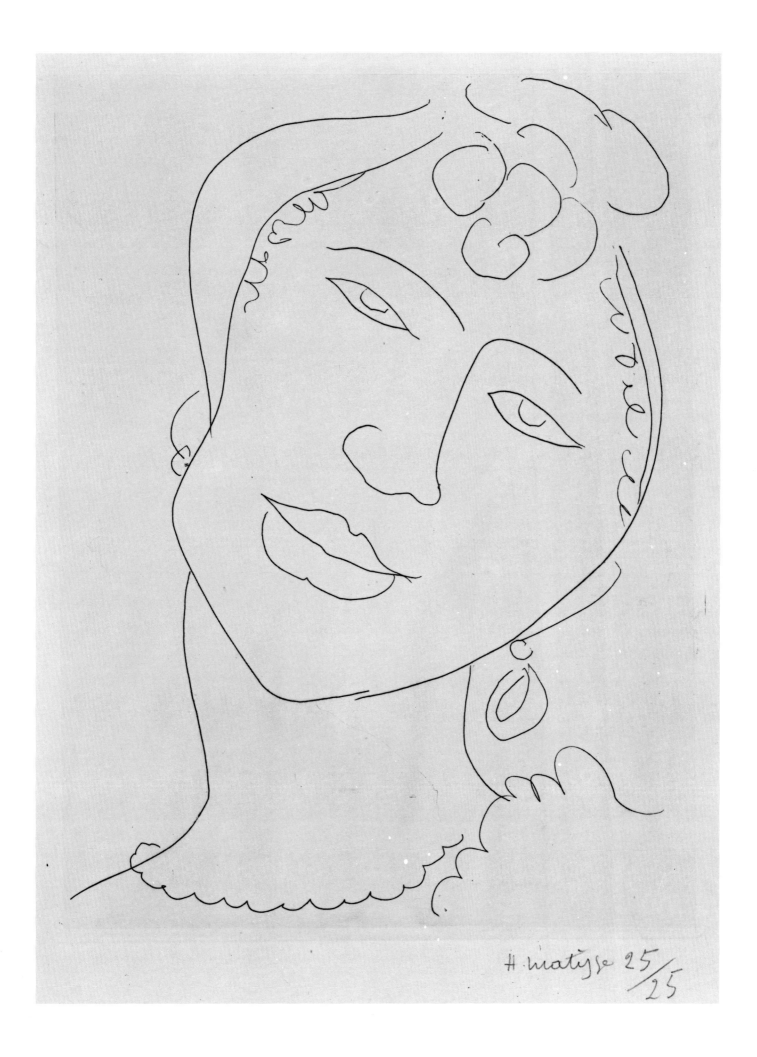

H. matisse 25/25

MARTINICAN WOMAN

(Martiniquaise)

"A model acts like a bolt of lightning. There was an encounter in Martinique during a stop-off of a few hours. The painter had jumped into a taxi to have a trip round Mont Pelé. On his return the driver asked permission to stop at a house. A negress came out, bringing him a bunch of bananas. This woman was perfection. Perfection. Not beauty."[118]

During this period Matisse often worked from dark-skinned models, described as coming from the Congo, Madagascar, Haiti, or Martinique. The 1946 film on Matisse by François Campaux included a Martinican model. Dina Vierny, a former model of Maillol, called Matisse's model Carmen. It was her face that Matisse chose for the frontispiece of Baudelaire's *Les Fleurs du mal*. All the etchings of her demonstrate great artistic freedom. The model's exotic features distanced the artist from the start and enriched his repertoire of forms. In these faces he experienced a kind of natural divergence from the norm, a naturally ordained distortion that must have claimed his attention and stimulated his creative imagination. He wrote to Camoin on the book project: "I've done the illustrations for your good buddy Baudelaire. I've done thirty-five lithographs of expressive heads to match the pieces chosen. It is not what is usually expected of illustrations for this poet. It would be easy to imagine a series of legs writhing in the air in some degree of agony. I hope that the middle classes will not be so demanding and that they will make allowances for the unexpected in my work."[119]

Accidents during the printing at Daragnès's studio made the planned edition impossible, but it was published later in 1947 with the *Martinican Woman* as a frontispiece and photolithographs.

Martinican Woman. 1946. Photograph by Hélène Adant. Pierre Matisse Collection

88

1946–47. Etching, pl.309. 14.8 × 11 cm. 2 trial proofs; 5 artist's proofs; edition of 25, signed and numbered, on laid paper. Duthuit no.289. Bibliothèque Nationale, Paris

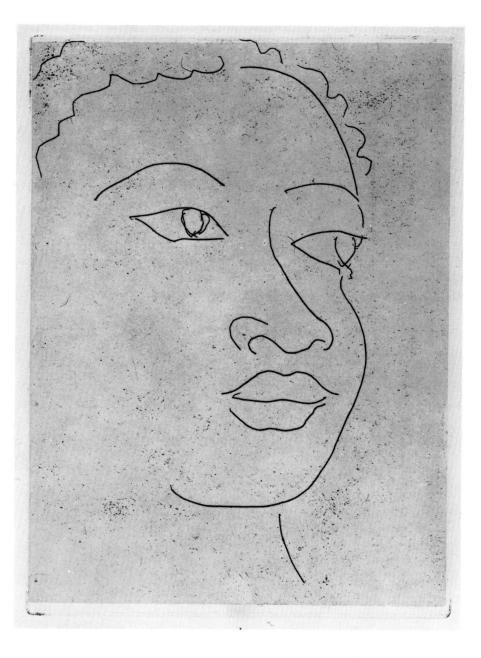

89 HAITIAN WOMAN

(Haïtienne)

The printer Fernand Mourlot has passed on vivid recollections of Matisse's involvement with printing techniques, materials, and people. Mourlot, the artist's preferred lithographer from 1937 on, had clearly won the confidence of most of the artists of the time and provided them with high quality work. "He was not like Derain or Picasso, who you could joke with. He gave instructions," the lithographer said of Matisse.[120] "In fact those sessions with Matisse were very hard. He knew what he wanted and there was no point in arguing. When I was sure of something, of a technical detail, I had to spend hours persuading him that I was right. After two and a half, three hours, this was rather tiring."[121]

One day Matisse apparently brought the printer line drawings for reproduction in an edition of *Verve*: "Matisse had put a dot in each corner of the page of the drawing. 'I want the first proofs to show these marks and you will remove them for the print run; in that way I will be certain that my drawing is properly framed on the page.'"[122] For Matisse such invisible components were of the greatest importance – after all, he even worked with a plumb rule when necessary! "The vertical is in my mind. It helps me give my line a precise direction and in my quick drawings I never indicate a curve – for example that of a branch in a landscape – without a consciousness of its relationship to the vertical. My curves are not mad"(F.112).

The printer was expected to follow the artist's instructions to the letter, with care and precision, and furthermore, to be extremely circumspect about making any artistic interventions of his own. Matisse's standards called for a highly skilled lithographer: "I would be very pleased, my dear Mourlot, if you would agree to work for me and to advise me a little. I have a lot to do and I am no great technician."[123] Matisse, as already mentioned, was greatly confined after major surgery in 1941 and could not, like Picasso, spend hours at the printer's directly supervising production from numerous printing proofs. He therefore relied all the more on a good man, even when his work did not cause any particular technical problems.

89
1945. Lithograph, pl.273. 36.6 × 27.5 cm. 5 trial proofs; 10 artist's proofs; edition of 200, signed and numbered, on wove paper. Duthuit no.567. Bibliothèque littéraire Jacques Doucet, Paris; artist's proof with dedication to the present owner

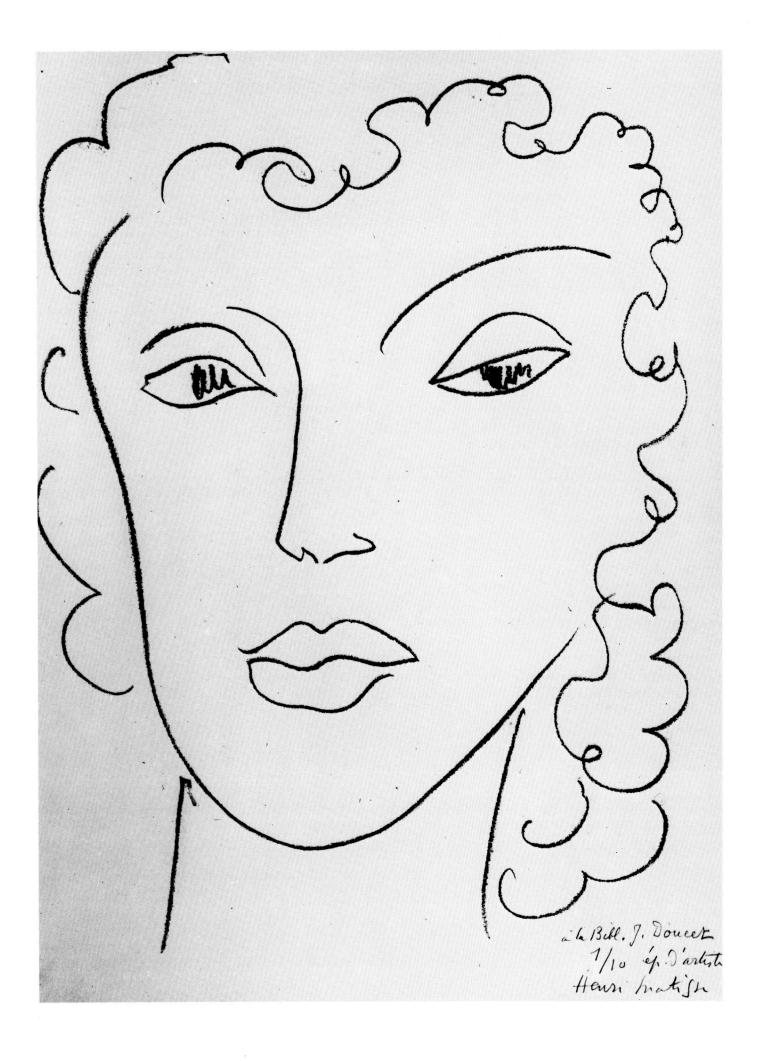

à la Bibl. J. Doucet
1/10 ép. d'artiste
Henri Matisse

90 NUN WITH CANDID EXPRESSION

(Une religieuse a l'expression candide)

The three versions of the nun (Duthuit nos. 276–78) were produced for a project to illustrate *Lettres Portugaises* by Marianna Alcaforado, published in 1946. The model was captured in a large, impressive chalk drawing done in June 1945. According to Christian Arthaud she was a fourteen-year-old Russian, Doucia Retinsky. Lydia Delektorskaya, who had often provided the artist with suitable models, probably found her for this role. For these illustrations Matisse was looking for a face that would reflect the inner power of a religious passion and in so doing capture the essence of Marianna Alcaforado. "That is surprising," remarked Louis Aragon, "because how could this girl provide the archetype for the inner struggle of the Portuguese nun, the passionate conflicts of ungratified sensuality?"[124]

Whether she be Chinese, Haitian, or a fourteen-year-old girl, what mattered for Matisse was a new face that, in its still streamlined contours, in the soft curves of the young Slavic head, and the expectant, uncertain expression, reflected both awareness and ignorance, suggested unused energies that must have been reined in. The formal attraction of the composition lay in the correspondence of the face and the nun's veil. The young girl returned to Matisse six years later and asked to be drawn again. The result was a powerful portrait showing a self-confident expression and rounded contours of the head resting on a solid neck.

As Matisse grew older, his models became younger. They were twenty-year-old women, reflections of their era. The series of portraits inspired by these models bore witness both to the changing times and to the constancy of the artist's hand, which acquired greater creative freedom and mastery as the age difference between him and the subject matter increased. He succeeded in unlocking the secret of a thing and deciphering its character more easily and quickly: *"The character of a face* in a drawing depends not upon its various proportions but upon a spiritual light that it reflects — so much so that two drawings of the same face may represent the same character though drawn in different proportions. No leaf of a fig tree is identical to any other, each has a form of its own, but each one cries out: Fig tree!"(F.112)

90
1945. Etching, pl.324. 15.8 × 11.9 cm. 1 trial proof; 5 artist's proofs; edition of 25, signed and numbered, on laid paper. Duthuit no.277. Bibliothèque Nationale, Paris

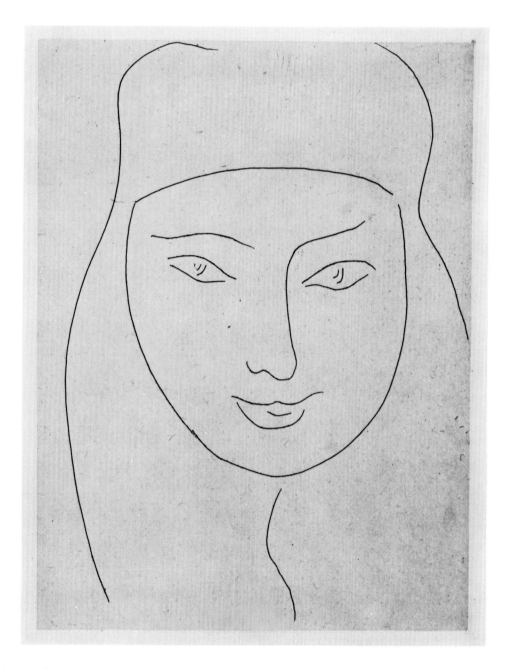

91 BEDOUIN, FIGURE WITH HEADBANDS

(Bédouin, figure aux bandeaux)

The aquatint technique did not, as one might assume, lead Matisse toward a new method of painterly reproduction with a fine, graduated scale of tones – as was the case with Picasso or Goya. Instead he again concentrated on line and, in this example, on dark brushstrokes. Matisse did not start working with this technique until 1930, broadening the range of his experience of etching and monotype and experiencing the excitement of a printed brushstroke. This solid, heiroglyphic style, which also managed to impress itself clearly on the eye from a distance, led to a still greater reduction in the descriptive elements. The aim was to bring out the specific quality of a face – in this case that of a Bedouin – more clearly and simply, to take the stylization even further so that eyes, nose, and mouth are reduced to mere lines and the head to an oval, mask-line shape. In spite of all these features the face still seems to breathe, retains its radiance, and does not become fixed in a stiff or geometrical form. This is the consequence above all of the liveliness of the lines, the flow of the brushstroke, and the irregular thickness of the strokes.

The line seems to be moving. "Lines are forces," the old master declared as he decorated the chapel at Vence, his last great work. These lines of energy are the secret behind his mask-like faces, which are impossible to imitate. They rely as ever on the direct pressure and direction of the artist's hand – which Matisse discusses in *Jazz*: "*If I have confidence in my hand* that draws, it is because as I was training it to serve me, I never allowed it to dominate my feeling. I very quickly sense, when it is paraphrasing something, if there is any disaccord between us: between my hand and the 'je ne sais quoi' in myself which seems submissive to it. The hand is only an extension of sensibility and intelligence. The more supple it is, the more obedient. The servant must not become the mistress"(F.112).

The result of this fervently controlled brushwork is that minute variations can be produced that give each face a slightly different expression.

91
1947. Aquatint, pl.330. 31.7 × 25.2 cm. 8 trial proofs; 5 artist's proofs; edition of 25, signed and numbered, on laid Annam paper. Duthuit no.777. Bibliothèque Nationale, Paris

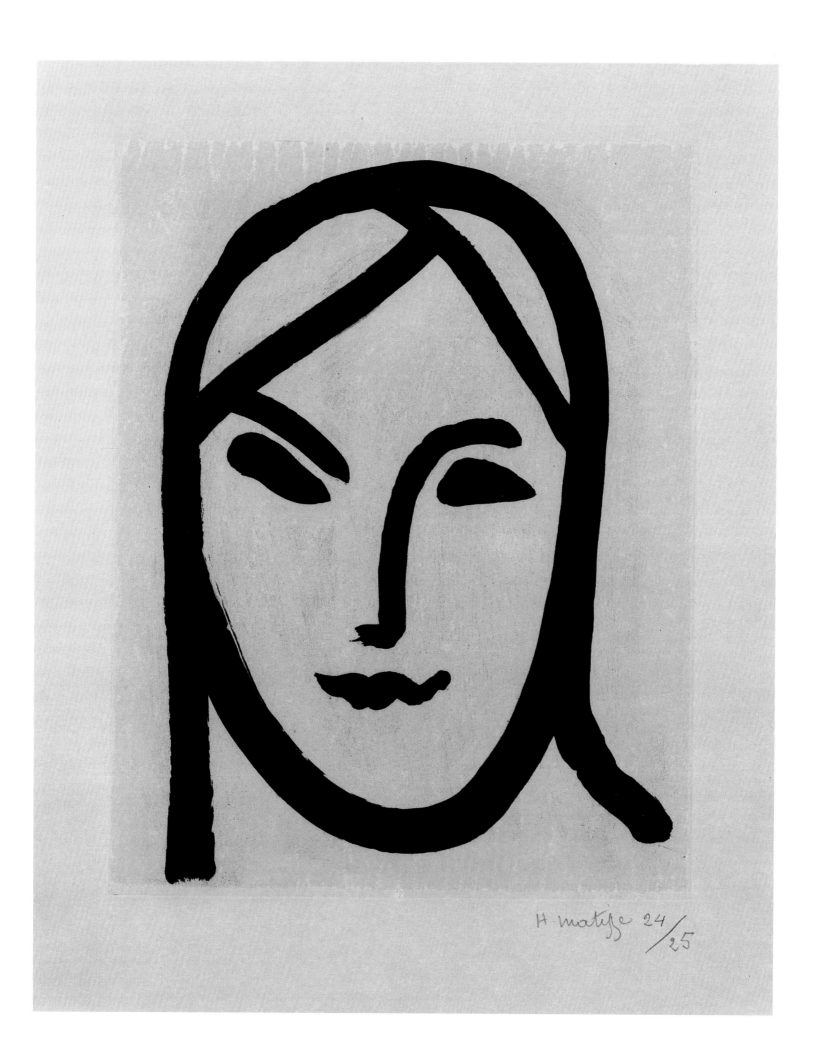

H. matisse 24/25

92 THE TOBOGGAN

(Le Toboggan)

Matisse had been working since 1943 on the paper cutouts from circus and theater motifs for a book for which he also wrote the text. "Drawing with scissors," cutting out shapes from paper colored by himself – this became the old master's great passion. "Paper cutouts allow me to draw in color. I see it as a simplification. Instead of drawing the contour and putting color into it – one modifying the other – I draw directly in color, which is all the more measured because it has not been transposed. This simplification ensures a precision in the meeting of the two methods, which become one."[125]

Although the stencil technique used in the book *Jazz* is not actually an original printing process and allows gouache paintings to be produced in series, the example here – the original of which is in color – provides the link that was so important for Matisse between color and the sheared edges produced by scissors. What is more, the reproductions were carried out by hand. Matisse had finally found a way of creating a new synthesis of color and shape. After some hesitation he called the book *Jazz* rather than *Cirque*, thus making the connection with music again. "Jazz is rhythm and meaning," Matisse declared (F.147). He wanted to move away here from the purely thematic and draw attention to the internal structure of the book, to rhythms, syncopations, staccati, shrill and delicate intonation, and improvisation.

"By drawing with scissors on sheets of paper coloured in advance, one movement linking line with colour, contour with surface. It simply occurred to me to unite them.... Sometimes a difficulty arose: lines volumes, colours and when I united them everything melted, one thing destroying another. I had to start over again, to look to music and dance, to find equilibrium and avoid the conventional"(F.147). What appears to be a child's game requires a brilliantly creative mind assembling all its energies.

The Toboggan, the wonderfully tottering figure in an endlessly deep space, surrounded by sparkling stars and flowing waves, embodies the unlimited possibilities of space that an artist confronts and which he harnesses through his creative power into pictures and signs. Matisse had already used the motif of the weightless figure in 1945 for a cover for the magazine *Verve*. The present picture, however, is rooted in the theme of dance and goes back to the work Matisse did for the Ballets Russes *Rouge et Noir* based on Shostakovich's First Symphony in 1939, and ultimately to the great dance compositions for the Barnes Foundation. *Jazz* becomes the artistic flight of a tirelessly productive and restlessly creative mind – "the artist is an explorer" evoking cosmic images.

92
1947. Color stencil. E.W.K. Collection, Bern

Plate XX of *Jazz*, published in Paris by Tériade in 1947. Boxed set of large inset plates, containing 20 color stencils taken from the artist's paper cutouts and with text in the artist's handwriting reproduced in facsimile. 270 copies, signed; 100 albums containing the plates in the book exclusively

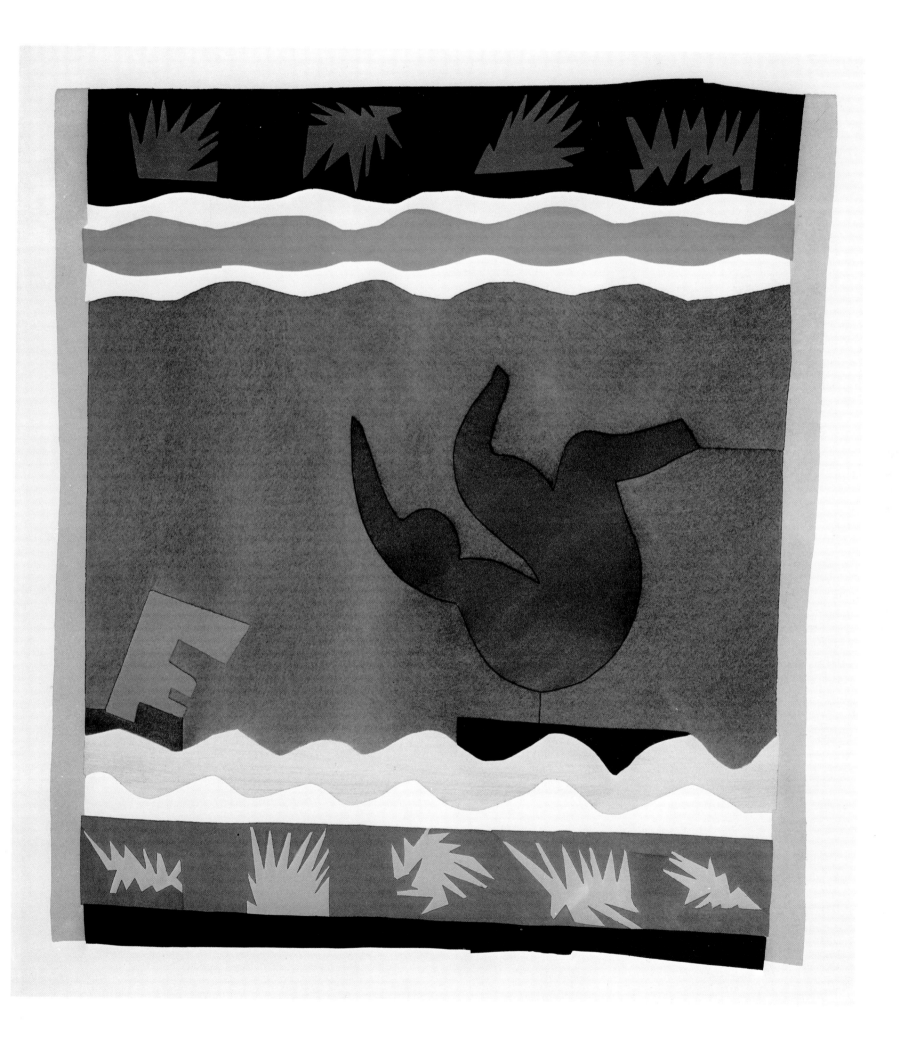

93 MARIE-JOSE IN YELLOW DRESS

(Marie-José en robe jaune)

Between 1946 and 1948 the artist surprisingly produced a whole series of large drawings in India ink using broad brushstrokes. They are still lifes and interiors with or without a model, all in wonderful, thick black and white contrasts without intermediate tones. The themes of the pictures are directly related to painting. The only example of this creative period in prints is the aquatint shown here, a composition that fills the whole sheet and looks like a slice of a larger interior.

The depiction of the subject matter in simple black outlines and brushmarks leads to a completely flat composition, recalling the lithographs of 1928, which evoked in fine chalk strokes the light and color of the studio. Even here, Matisse was thinking in colors as he drew with his brush: "The special quality of brush drawing, which, though a restricted medium, has all the qualities of a painting or a painted mural. It is always colour that is put into play, even when the drawing consists of merely one continuous stroke. Black brush drawings contain, in small, the same elements as coloured paintings... that is to say, differentiations in the quality of the surfaces unified by light."[126]

The concepts that prompted the artist for this work were not new, but the color black carries more weight here than in earlier lithographs because of the broadness of the strokes. This makes the drawing appear more primitive, bringing to mind his first fauve woodcuts (see Pls. 6 and 7), and the dazzling effect is stronger, heightened by the generally broken outlines that generate volume and vibrations. This shimmering light effect was already conveyed by breaks in the lines with similar intensity in the monotypes of 1914–16 (see Pl. 24, *Gourds*). What can be seen there in the pumpkins in close-up, however, is created here at a distance. It is perhaps too seldom pointed out that Matisse, who had been ailing since 1941, had to develop a different visual approach. He discovered that if he wanted to judge works conceived on a large scale, they had to be seen from farther away – usually on the walls around him. He was not able as before to change his angle of view by stepping back or to the side. "My passion for work has forced me to stop a little, and I am suffering from extreme eye sensitivity. So I have to see objects in my memory for me to continue to think," he complained in old age.[127]

93
1950. Aquatint in black. 53.5–41.8 cm. Several trial proofs in black or in color, on Arches wove paper. Bibliothèque Nationale, Paris

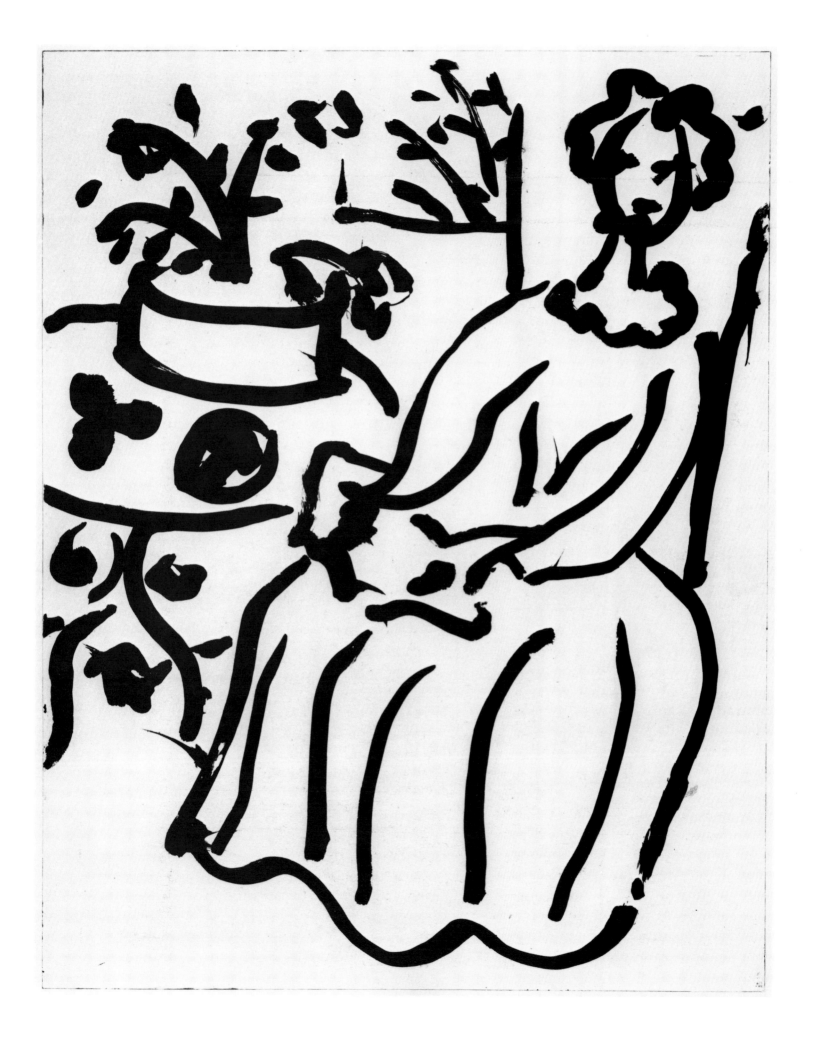

94 MARIE-JOSE IN YELLOW DRESS (IN COLOR)

(Marie-José en robe jaune)

The print seen here is strictly speaking the only original color print in the traditional sense, apart from *Dance* (see Pl. 63). Matisse, who was first and foremost a painter, kept color out of his graphic works, as if to tease his artistic temperament's obsession with color, for he thought in color even when drawing in pencil or brush. He now incorporated these colors into three variations of the same aquatint – that which immediately precedes the work opposite – with the same red, blue, green, and yellow. The example illustrated is a proof for a large edition of a hundred copies.

Matisse had experience with color printing from occasional color posters of his pictures, as the printer Fernand Mourlot testified when in 1937 he had to make a reproduction of *The Dream:* "The colorist started to work again: it should be said that before the war color photography had not attained its current perfection. Carried out by experts, work done by hand was superior to photomechanical processes. Matisse was very alive to the care that we took assisting him; he was scrupulous in following every stage of the printing, and it is quite difficult, even for an artist, to follow a lithograph in color or a four-color print if he is not a technician."[128]

The printed colors were obviously too dull and failed to give the impression of depth and expansive power that characterize Matisse's canvases. Colors did not have merely a decorative function in his work – they were the leading components, actors whose descriptive power was essential for the painter. He was unwilling to restrict himself in their application through a technical process or to leave the physical act of inking to an intermediary. At first he was disappointed with the color prints in *Jazz,* as he told his friend André Rouveyre: "I believe that what spoils them absolutely is the transposition – it removes the sensitivity from them, without which what I do is meaningless... But I know that these things must stay the way they are, originals of gouaches quite simply."[129]

Matisse was an inventor at heart, a brilliant craftsman, a researcher, and he needed direct contact both with his subject matter and his materials. His physical disability also presumably played a role and a halt was called to further color prints. He was too occupied by his paper cutouts, a field which had yet to be developed. "I am always short of time and I have the constant feeling that it will not be possible to finish the efforts of a lifetime, through lack of time," he wrote to Rouveyre in 1944.[130]

94
1950. Color aquatint (black, red, yellow, blue, green), pl.362. 53.6 × 41.7 cm. A few trial proofs; edition of 100, signed and numbered, on Arches wove paper. Duthuit no.817. E.W.K. Collection, Bern

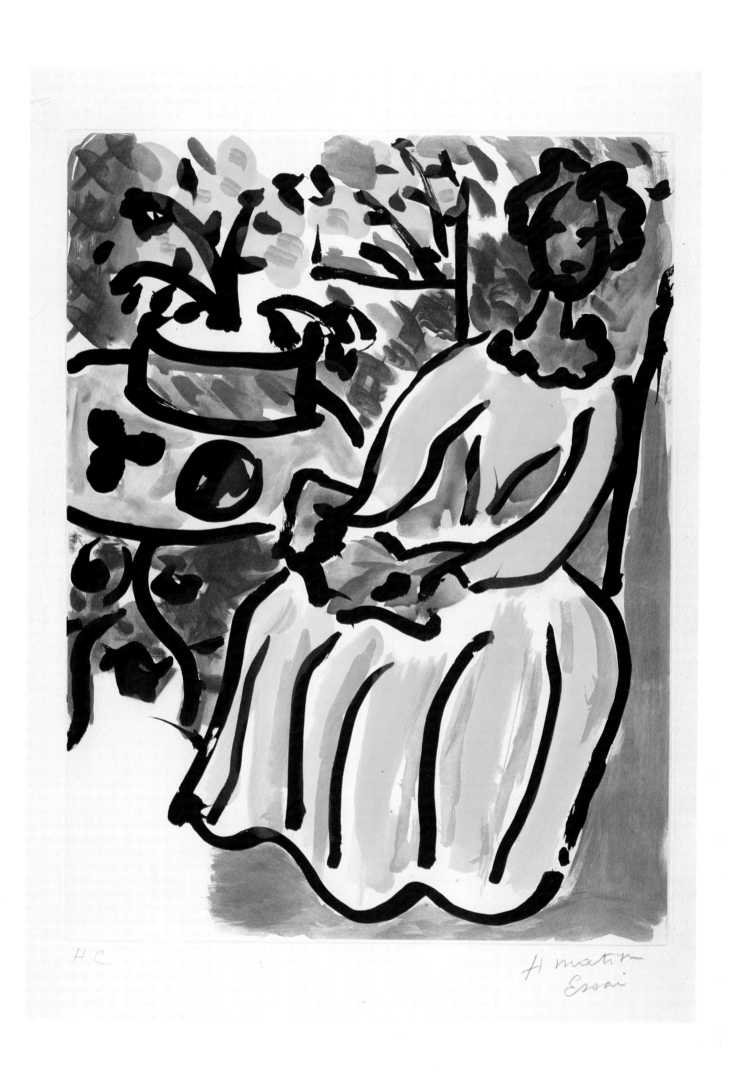

H matisse
Essai

95 WHITE MASK ON BLACK BACKGROUND

(Masque blanc sur fond noir)

This work appears like a floating mask-head, more like a symbol for a face, similar in its luminosity to the moon sailing through the deep black night. Here Matisse exploits the painterly qualities of the aquatint technique, avoiding hard contrasts of black and white by mixing gray tones into the white and setting fine white stripes into the black. The head has contours, as if the artist had worked with scissors, and the black background has the irregularity of hand drawn brushstrokes. The eyes and eyebrows are arranged asymmetrically, as are the lips.

One might interpret this mask as an apparition, a clown, a self-portrait, or as an icon. It is an ageless face with great vision, suggested in the alert, open eyes, and with an individual physical presence; there is also movement, implied in the slightly angled position. "When I paint a portrait, I come back again and again to my sketch, and every time it is a new portrait that I am painting... the final portrait may show that person younger or under a different aspect from that which he or she represents at the time of sitting, and the reason is that that is the aspect which seemed to me the truest, the one which revealed most of the sitter's real personality. Thus a work of art is the climax of long work of preparation. The artist takes from his surroundings everything that can nourish his internal vision, either directly, when the object he is drawing is to appear in his composition, or by analogy" (F.149).

The masks could in these terms be interpreted as a summation of portraits, the result of assimilations and reductions of accummulated impressions. Matisse had already experienced the anonymity and expressivity of a mask's face in 1906 when he had seen the Fang masks from Gabon in Derain's studio on Rue Touralque. This image lingered in his late work and mingled with other impressions of primitive and non-European art. His extensive experience with theater also provided him with mask faces, however. Matisse used this motif for the first time on the stage curtain for *Le Chant du Rossignol* in 1920. In the course of his portrait work, he had also repeatedly reduced the images of his friends to a few strokes and given them mask-like features. In 1948 he produced a series of aquatint prints of mask faces with black outlines against a bright background, a theme taken up again in 1952 for his program for the International Festival of Dramatic Art in Nice and in 1953 in his large decoration. It is the most concise form for conveying the universal features of a human face while maintaining individual traits.

95
1949–50, printed in 1966. Aquatint. pl.387. 31.7 × 24,9 cm. 3 trial proofs; 6 artist's proofs; edition of 25, numbered and bearing the seal "HM.," on Rives paper. Duthuit no.811. Bibliothèque Nationale, Paris

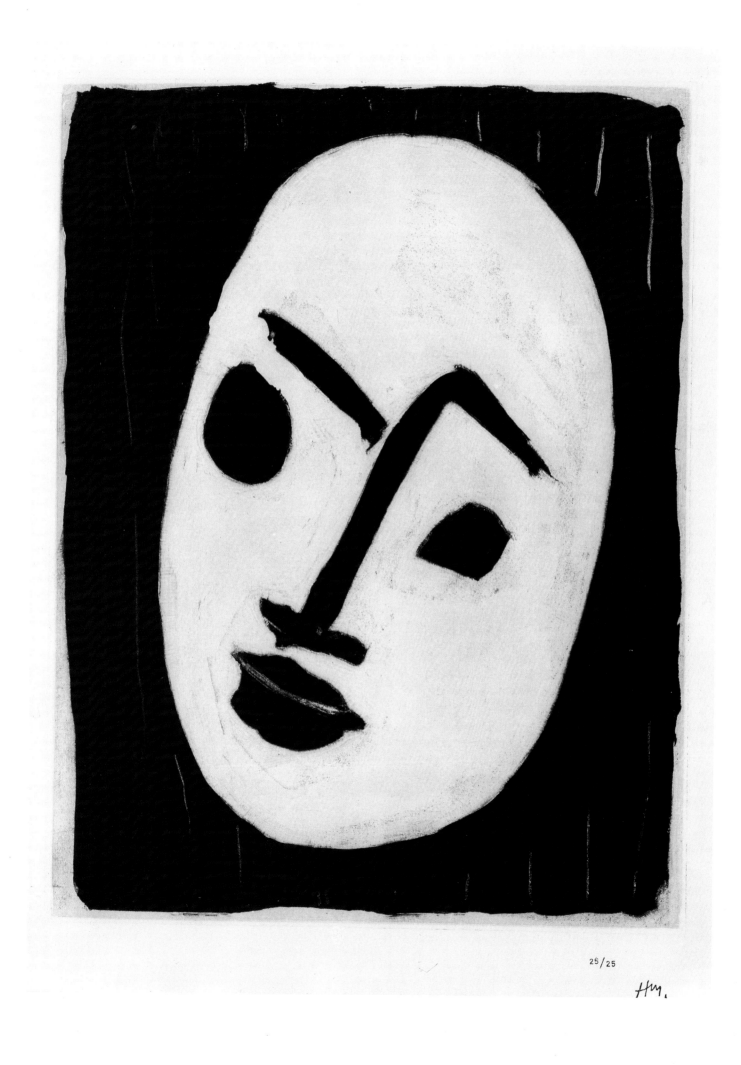

25/25

H.M.

(Vierge et enfant sur fond étoilé)

When asked if he believed in God, Matisse replied, "Yes, when I work. When I am submissive and modest, I sense myself helped immensely by someone who makes me do things by which I surpass myself. Still, I feel no gratitude toward Him because it is as if I were watching a conjurer whose tricks I cannot see through. I find myself thwarted of the profit of the experience that should be the reward for my effort. I am ungrateful without remorse"(F.112).

Matisse, who had not previously manifested interest in sacred art, had neither given it his support nor been a churchgoer, ventured in 1947 to decorate a chapel for Dominican nuns. With the thoroughness characteristic of an artist, Matisse undertook the decoration of La Chapelle du Rosaire at Vence, making it his total work of art, and left his imprint on every aspect: garden, walls, tiles, windows, liturgical utensils, and vestments. The chapel was consecrated in June 1951. The eighty-year-old artist expended a great deal of energy on the work and charged nothing. His contemporaries were speechless, especially those with Communist sympathies such as Aragon, Picasso, and Léger. Picasso is reputed to have reproached him: "Why don't you make a market there? You could paint fruit, vegetables."

Matisse was caught in the crossfire of polemics. Attacks also came from the Catholic Church, when, in discussions over the differences between Christian art and modern art, the chapel at Vence became a focus of controversy. He had a zealous champion in Father Marie-Alain Couturier, who argued for creative artistic freedom without dogma: "Genius is, in effect, an expression of the spirit, and this emanates from God. Everything that is beautiful, that has artistic vitality, is therefore religious. And that is why: 'I believe that artists have a god and that he catches up with them at the end of that road taken by all prodigal children...'"[131] Couturier therefore understood the feelings and convictions of Matisse, who had already declared in 1908 his religious feeling for life.

Matisse had probably intended to create an ideal work of art by applying all the energy at his disposal. He never undertook anything, however, in order to clarify his position in the light of polemics. He allegedly answered Picasso: "Yes, I say my prayers, and so do you, as you well know: when everything goes badly we throw ourselves into prayer, to find the climate of our First Communion again. And you do it too."[132] He replied to Couturier in 1951: "I have created a religious space,"[133] and to André Verdet in 1952: "I did the Chapel with the sole intention of expressing myself *profoundly*. It gave me the opportunity to express myself in a totality of form and colour. The work was a learning process for me"(F.144).

This education over a number of years and the overwhelming sincerity of his concern are reflected in numerous designs for the chapel.

96
1950–51, printed in Nice for the inauguration of the La Chapelle du Rosaire, Vence. Lithograph, pl.346. 30.8 × 24.5 cm. 2 trial proofs; 8 artist's proofs; edition of 100, signed and numbered, on laid paper. Duthuit no.647. Bibliothèque Nationale, Paris; artist's proof

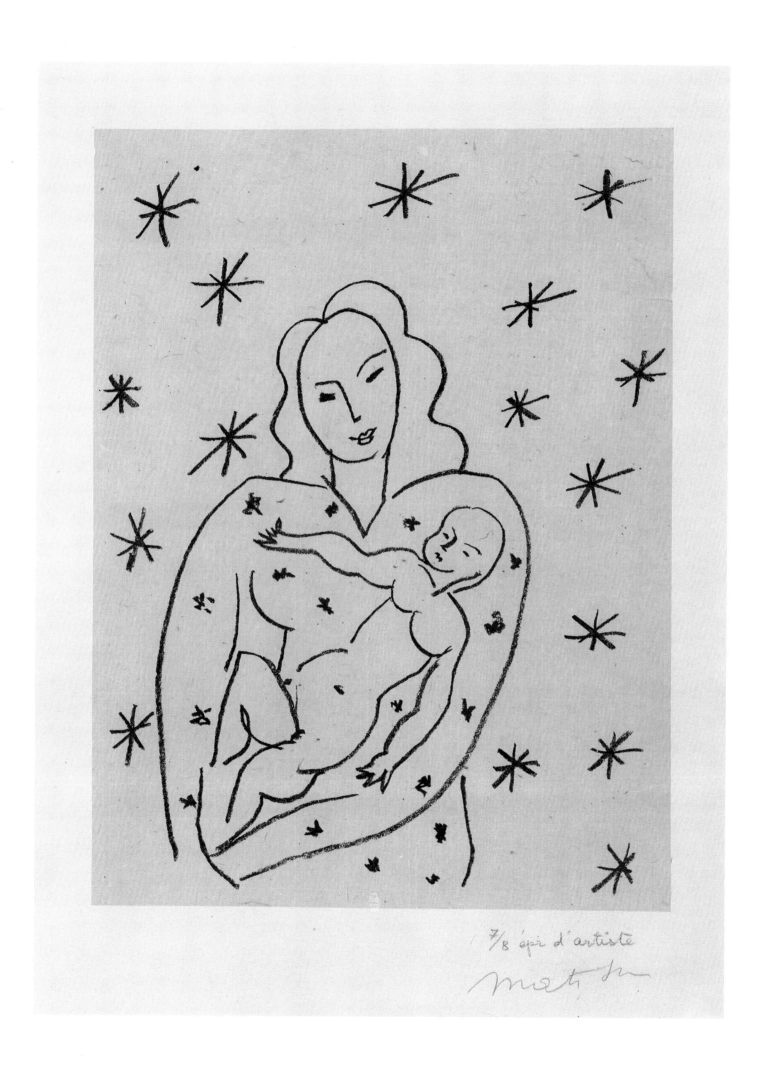

7/8 épr d'artiste

Matisse

97 MADELEINE – STUDY
(Madeleine – étude)

The face of Madeleine and the lithograph shown here are linked to the large ceramic wall in the chapel at Vence. As we would expect, the numerous studies show the artist's movement from multiplicity to economy, from complexity to simplicity, from mobility to rest, toward the maximum expression in the most concise form, the symbolic rendition of an infinitely polyvalent world.

A woman, Monique Bourgeois, was behind the project to decorate the chapel, "a beautiful girl, lively and intelligent," as Lydia Delektorskaya described her.[134] Mademoiselle Bourgeois was acting as a nurse to the convalescing artist in Nice after his operation in 1941. She was also his model for a time, and Lydia was able to perceive the nature of their relationship: "She had lost her father. Matisse's children and grandchildren were far away. A deep affection grew up between them, as between a girl and her grandfather, that of a man confined to his bed by infirmity and a girl in full bloom who was morally, seriously shocked by the idea of physical deficiency."[135] Matisse was affected deeply when the young woman told him of her decision to take the veil. Contact with the artist was maintained, however, as Pierre Schneider confirms from correspondence. After her novitiate in 1946, Monique came to visit Matisse, but now she bore the religious name Sister Jacques-Marie. Her artistic intuition, which may have been sparked by the atmosphere around Matisse, gave her the idea of designing a window. She had also witnessed the genesis of *Jazz*. Matisse amended her designs and gave advice until he was gradually tempted to take on the work himself.

It was ultimately friendship with this unusual woman that kindled his desire to work on the chapel. A letter to André Rouveyre in 1947 describes the emotional ties between them: "I have just had a visit from my nun, the one who posed for the canvas called *The Idol*. She's a Dominican, and a magnificent person. We speak of one thing and another in a certain tone – a kind of gentle teasing.... It's a little as if we tossed flowers at each other – petals of roses, and why not, there is no harm in the tenderness which doesn't need words, goes beyond words."[136] The mood of these words carried forward into his drawings, to the Madonna bespangled with stars (see Pl.96) and, in some versions, also strewn with flowers. The connection between flowers and model is an image rooted deeply in the artist's memory. The path he traveled in order to present it again in its full splendor becomes clear when this etching is compared with the small etching of Yvonne Landsberg (see Pl.26).

97
1950–51. Lithograph, pl.348. 20.4 × 17.9 cm. 1 trial proof; 15 artist's proofs; edition of 200, signed and numbered, on laid paper. Duthuit no.645. Bibliothèque Nationale, Paris

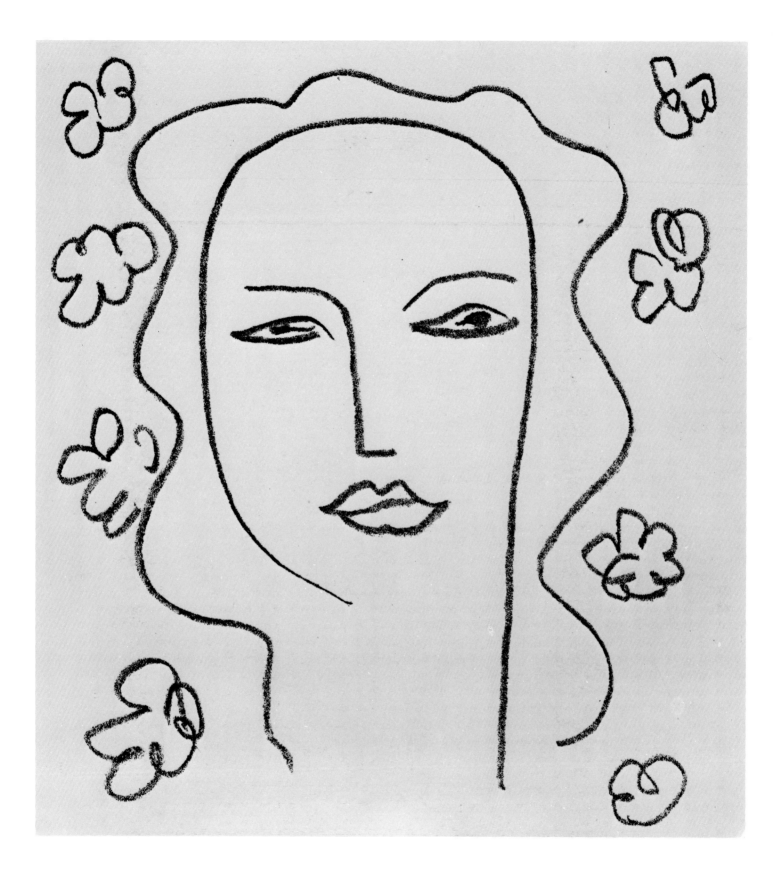

98 STUDY FOR SAINT DOMINIC

(Etude pour saint Dominique)

The skriking anonymity of this print stems from the absence of the facial features. An identical version (Duthuit no. 656) with eyes, mouth, and nose, although in stencil-like form, reveals the enormous transformation in the picture and increases the mystical and magical effect of this figure, which in spite of everything is human. The portrait of Saint Dominic, which covers the wall in the chapel at Vence, appears to have no face, like that of the Madonna and Child. Matisse explained: "The panel of Saint Dominic and that of the Virgin and the Christ Child are on the same level of the decorative spirit, and their serenity has a character of tranquil contemplation which is proper to them"(F.130). The static presence and complete peace that these figures radiate seemed essential to the artist. "In sum, the ceramic tiles are the spiritual essential and explain the meaning of the monument. Thus they become, despite their apparent simplicity, the focal point which should underline the peaceful contemplation that we should experience; and I believe this is a point that should be stressed"(F.130).

Matisse only arrived at these final versions slowly and painfully. He generally worked while sitting down and with a long stick to which chalk was attached. This way of working required extraordinary concentration on hand, implement, and sheet size. The huge dimensions under these conditions were a nightmare for the artist, although he had experience of such perspectives from the Barnes decorations.

These portraits rendered by only a few lines proved difficult to understand for visitors, who expected frescoes in the traditional sense. The faceless being made a surrealistic and completely incomprehensible impression. Matisse had to explain himself: "that's because the face is anonymous. Because the expression is carried by the whole picture. Arms, legs, all the lines act like parts of an orchestra, a register, movements, different pitches. If you put in eyes, nose, mouth, it doesn't serve for much; on the contrary, doing so paralyses the imagination of the spectator and obliges him to see a specific person, a certain resemblance, and so on, whereas if you paint lines, values, forces, the spectator's soul becomes involved in the maze of these multiple elements... and so, his imagination is freed from all limits"(F.141).

In his pictures Matisse also wanted to liberate the observer from fixed ideas, to activate the visitor's imagination and steer him away from snap interpretations. "It only needs a sign to evoke a face, there is no need to impose eyes or a mouth on people... you should leave the onlooker to his reverie."[136]

98
1950. Lithograph, pl.378. 18.9 × 16.3 cm. 15 artist's proofs; edition of 200, signed and numbered, on laid paper. Duthuit no.658. Museum of Modern Art, New York

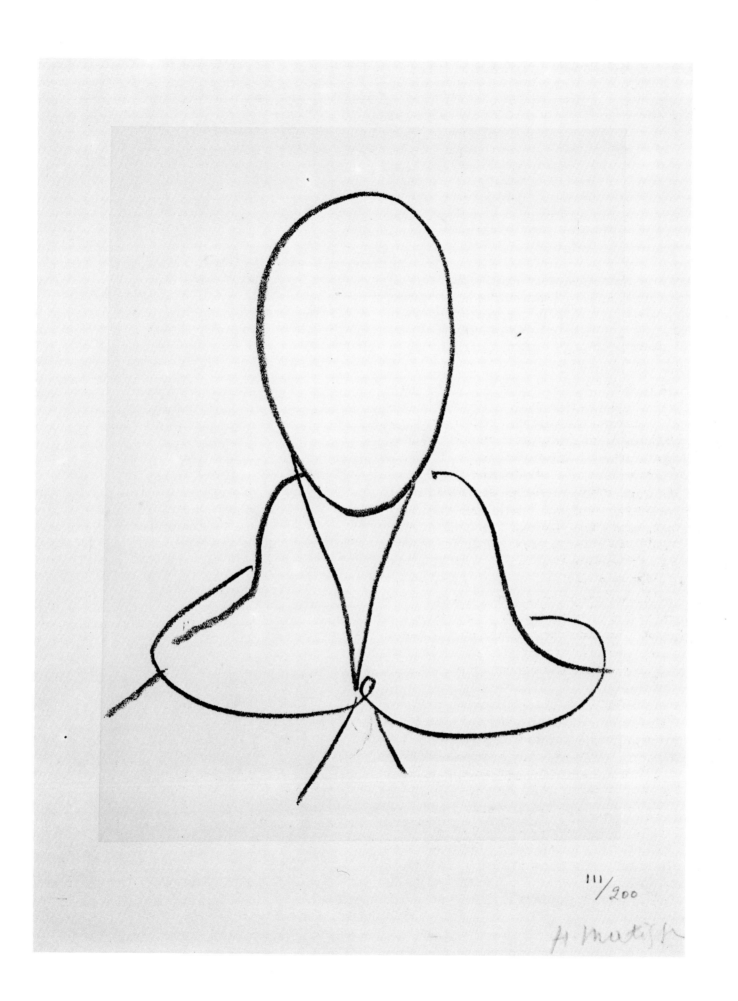

III/200

H. Matisse

99 STUDY FOR THE ALTAR CLOTH FOR THE CHAPEL AT VENCE II

(Etude pour la nappe liturgique de la chapelle de Vence II)

Matisse chose the fish to decorate the altar cloth in the chapel at Vence which is the symbol of Christ. Their flowing shapes harmonize with the overall pattern of flora in the interior, with the leaves of plants on the window, and the stylized flowers on the ceramic wall. The ancient symbol of life and fertility points to the artist's tireless and unbroken creative spirit.

Animal motifs appear rarely in Matisse's work. They invariably have a purely decorative function, whether they are snakes, birds, or fish. The artist was interested in forms, not animals. The rich formal language of sea creatures and algae recalled his visit to Tahiti. These motifs were first seen in the large paper cutouts *Polynésie la mer* of 1946 and *Océanie la mer* of 1946. In late 1946 Matisse explained to the photographer Brassaï: "Memories of my voyage to Tahiti are only coming back to me now, fifteen years later, in the form of obsessive images: madrepores, corals, fish, birds, jellyfish, sponges.... It is curious, isn't it, that all these delights from the sky and sea did not stimulate me straight away.... I came back from those islands with absolutely nothing in my hands.... I did not even bring back any photographs.... 'If I take photos,' I told myself, 'of everything I see in the South Seas, I will no longer see anything but those poor images. And photos may perhaps prevent my impressions from having a deep-seated effect....' I believe I was right. It is more important to become saturated with things than to want to snatch at them."[137]

The artist never lost his ability to draw on his deeply ingrained visual impressions. The decorations for the chapel represent a hymn to life in the same way as the aquatint shown here does. The fish are all swimming in the same direction, driven by the same current, symbolizing the dynamic energy that is inherent in all living creatures and which is also an intrinsic part of the artist's work. "Creating a stroke, a line, conjuring a shape into existence – that does not happen in conventional academies, it happens outside, in nature, through the close observation of the things that surround us. A tiny detail may reveal to us a grand mechanism, an essential component of life."[138] Throughout his life Matisse traced these mechanisms and drives, discovering a whole world in a state of agitation and potency.

99
1949. Aquatint, pl.348. 34.5 × 27.8 cm. 2 trial proofs; 5 artist's proofs; edition of 25, signed and numbered, on Marais paper. Duthuit no.813. Bibliothèque Nationale, Paris

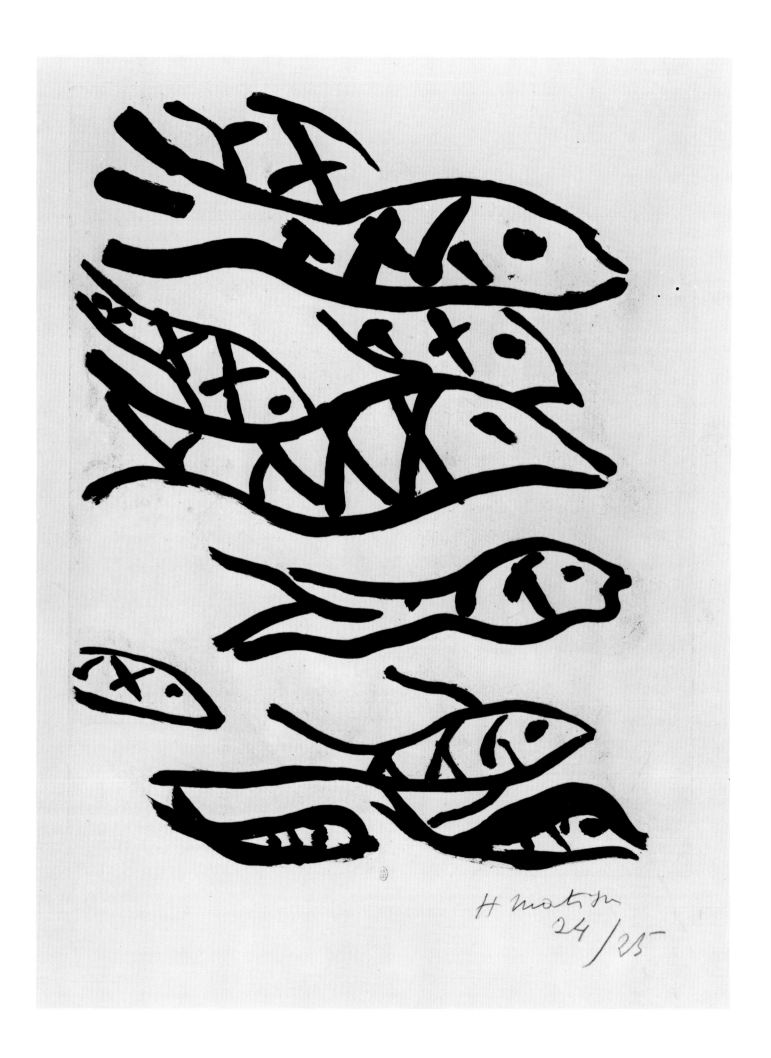

H matisse
24/215

100 THREE MASKS, FRIENDSHIP

(Trois Têtes, à l'amitié)

Matisse died in Nice on November 3, 1954 from a heart attack shortly before his eighty-fifth birthday. He worked to the end: "You know as I do that work is the indispensable complement to life," he wrote in the fall of 1952 to his friend André Rouveyres.

The three masks – a magic number – bear the features of Apollinaire, Rouveyre, and Matisse himself. The print was a design for the frontispiece of André Rouveyre's book on Apollinaire published in 1952, and the print was intended as a symbol of the friendship that united these men and as a homage to Apollinaire, an ardent champion of modern art who died prematurely in 1918. Rouveyre and Matisse knew each other since studying in Gustave Moreau's studio. The real bonds of friendship were formed during their stay in Nice. Their correspondence provides powerful witness to the lonely, aging man and the eternally young artist, who worked hard for his art and was filled with the contradictory feelings of joy and doubts: "What a life of torture it is if one depends, with my acute sensitivity, on a method, or rather when acute sensitivity prevents you from falling back on a supporting method. I am completely shattered by it – and it comes back to me that all my life has been spent in this way – a moment of despair followed by a happy moment of revelation that enables me to do something that cannot be explained, then I am left bewildered and faced with a new enterprise."[139]

His love of creation gave the artist courage again and again, and when illustrating *Florilège des Amours de Ronsard* he wrote to his friend Rouveyres: "Can one not retain a young and passionate imagination to the very last day?" and to his book *Jazz* he added "Hate is a parasite that devours all.... Yet love sustains the artist.... He who loves to fly, to run and rejoice – he is free, nothing holds him back"(F.113).

100
1951–52, printed in 1966. Aquatint, pl.390. 34.5 × 27.7 cm. 6 trial proofs; 4 artist's proofs; edition of 25, numbered and bearing the seal "HM," on BFK Rives paper. Duthuit no.828. Bibliothèque Nationale, Paris

(*left:* Rouveyre; *upper right:* Apollinaire; *lower right:* Matisse)

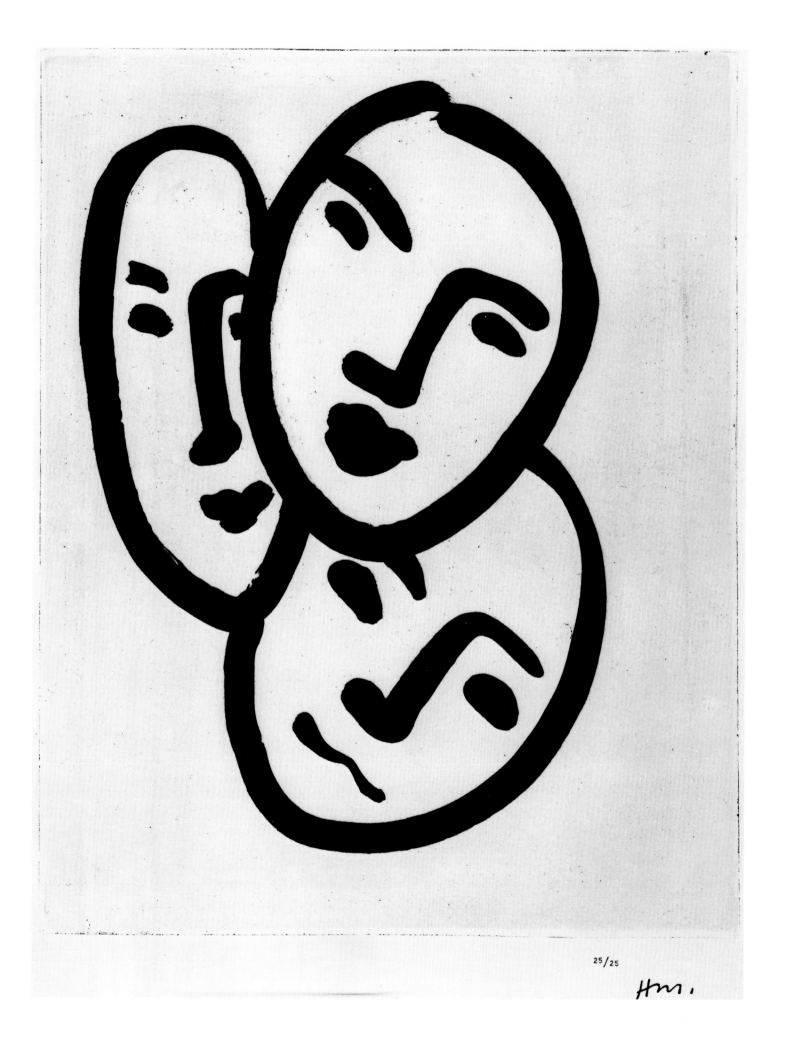

25/25

HM.

NOTES

The quotations from Matisse, for which page references are indicated in the text (F. page number), have been taken from

Flam, Jack D., ed. *Matisse on Art.* 2nd ed. Oxford and New York, 1978.

For full bibliographical information for the works mentioned below the reader is asked to consult the Select Bibliography, pp. 210–11, and the Exhibition Catalogues, p. 212.

1 Henri Matisse, *Ecrits et propos sur l'art*, edited by Dominique Fourcade, 1972, p. 162, no. 9.
2 Fourcade, ed. 1972, p. 304.
3 Fourcade, ed. 1972, p. 251.
4 Pierre Schneider, *Matisse*. 1984, p. 725.
5 *Le Point*. July 1939, p. 19.
6 *Cahiers Henri Matisse 4*. 1986–87, p. 13.
7 *Le Point*. July 1939, p. 22.
8 Illustrated in Schneider, 1984, p. 314.
9 Raymond Escholier, *Henri Matisse*. 1937, p. 43.
10 Pierre Courthion, "Henri Matisse 1942," *Formes et Couleur*. 2, 1942, unpaginated.
11 Françoise Cachin, *Paul Signac*. 1971, p. 93.
12 Paul Signac, *D'Eugène Delacroix au néo-impressionnisme*. 1921, p. 6.
13 Schneider, 1984, p. 188.
14 Schneider, 1984, p. 213.
15 Schneider, exhibition catalogue, *Matisse*. Paris, 1970, p. 68.
16 Schneider, 1984, p. 241.
17 Georges Desvallières, "Présentation de 'Notes d'un peintre,'" *La Grande Revue*. December 1908.
18 Alfred Barr, *Matisse. His Art and His Public*. 1951, p. 113.
19 Ibid.
20 *Camera Work*. no. 23, July 1908.
21 John Hallmark and Riva Castleman, exhibition catalogue, *Henri Matisse*. Fort Worth, 1986.
22 Fourcade, ed. 1972, p. 162, no. 9.
23 Danièle Giraudy, "Correspondance Henri Matisse–Charles Camoin," *Revue de l'Art*. 12, 1911, p. 12.
24 Alice Halicka, *Hier (Souvenirs)*. 1946, p. 43.
25 Giraudy, 1971, p. 15.
26 Ibid.
27 Exhibition catalogue, *Donation Louise et Michel Leiris – Collection Kahnweiler-Leiris*. Paris, 1985, p. 54.
28 Ibid.
29 *Le Point*. December 1945.
30 Fourcade, ed. 1972, p. 169.
31 Schneider, 1984, p. 122.
32 Charles Vignier and H. Inada, *Estampes japonaises exposées au Musée d'Arts décoratifs*. 6 vols., 1909–14.
33 *Le Point*. July 1939, p. 32.
34 Giraudy, 1971, p. 15.
35 Schneider, 1984, p. 322.
36 Schneider, 1984, p. 339.
37 Exhibition catalogue, *Etchings by Matisse*. New York, 1955, p. 99.
38 Jeanine Warnod, *Le Bateau-Lavoir*. 1986, p. 111.
39 Giraudy, 1971, p. 15.
40 Exhibition catalogue, *Etchings by Matisse*. New York, 1955, p. 50.
41 Fourcade, ed. 1972, p. 103, no. 59.
42 Exhibition catalogue, *Œuvres de Matisse et de Picasso*. Paris, 1918, preface.
43 Giraudy, 1971, p. 18.
44 Giraudy, 1971, p. 19.
45 Ibid.
46 *L'Art vivant*. 1920, pp. 29–30.
47 *Le Point*. December 1943, p. 4.
48 Barr, 1951, p. 185.
49 Quoted from the personal correspondance of Greta Prozor and the author, 6.19.87.
50 Barr, 1951, p. 562.
51 Giraudy, 1971, p. 21.
52 Giraudy, 1971, p. 22.
53 Exhibition catalogue, *Henri Matisse. The Early Years in Nice 1916–1930*. Washington, D.C. 1986–87, p. 27.
54 Jean Cassarini, *Matisse à Nice. 1915–45*. 1984, unpaginated.
55 Exhibition catalogue, *Henri Matisse. The Early Years in Nice 1916–1930*. 1986–87, pp. 31–32.
56 *Le Bulletin de la vie artistique*. February 1, 1925, pp. 54–55.
57 Giraudy, 1971, p. 21.
58 Fourcade, ed. 1972, p. 195.
59 Waldemar, George, *Henri Matisse. Dessins*. 1925, pp. 7–8.
60 *Le Bulletin de la vie artistique*. February 1, 1922, p. 73.
61 *L'Art vivant*. February 15, 1930, p. 156.
62 Schneider, 1984, p. 715.
63 Exhibition catalogue, *Henri Matisse. The Early Years in Nice 1916–1930*. 1986–87, p. 56.
64 Fourcade, ed. 1972, p. 168.
65 Giraudy, 1971, p. 23.
66 Fourcade, ed. 1972, p. 168, n. 17.
67 Exhibition catalogue, *Henri Matisse. The Early Years in Nice 1916–1930*. Washington, D.C., 1986–87, p. 36.
68 *Le Bulletin de la vie artistique*. May 1, 1926, p. 137.
69 Fourcade, ed. 1972, p. 165.
70 Fourcade, ed. 1972, p. 180, n. 33.
71 Fourcade, ed. 1972, p. 187.
72 Fourcade, ed. 1972, p. 162, n. 9.
73 Fourcade, ed. 1972, p. 173, n. 23.
74 Fourcade, ed. 1972, p. 162, n. 9.
75 Fourcade, ed. 1972, p. 163.
76 Fourcade, ed. 1972, p. 78.

77 H.R. Hahnloser, *En visite chez Henri Matisse*. 1970, p.11.

78 Fourcade, ed. 1972, p.141.

79 Jean Clair, "Correspondance Matisse–Bonnard," *NRF*, August 1970, pp.61–64.

80 Fourcade, ed. 1972, p.103, n.58.

81 Schneider, 1984, p.606.

82 *Time*. October 20, 1930, p.48.

83 Fourcade, ed. 1972, p.28.

84 Fourcade, ed. 1972, p.151, n.12.

85 Stéphane Mallarmé, "L'Après-midi d'un faune," *Œuvres complètes*. 1984, p.50.

86 Fourcade, ed. 1972, p.173, n.23.

87 Fourcade, ed. 1972, p.162, n.9.

88 Clair, July 1970, p.87.

89 Fourcade, ed. 1972, p.126, n.88.

90 *Cahiers Henri Matisse 1*. 1986, p.52.

91 Fourcade, ed. 1972, p.214.

92 Fourcade, ed. 1972, p.178, n.31.

93 Fourcade, ed. 1972, p.217.

94 Fourcade, ed. 1972, p.216.

95 Charles Sorlier, *Mémoires d'un homme de couleur*. 1985, p.150.

96 Lydia Delektorskaya, *Henri Matisse: l'apparente facilité. Peintures de 1935*. 1986, p.15.

97 Delektorskaya, 1986, pp.15 and 16.

98 Delektorskaya, 1986, pp.22, 25, and 26.

99 Schneider, 1984, p.602.

100 Halicka, 1946, p.165.

101 *Chroniques du jour*, April 9, 1931, pp.14–15.

102 Clair, August 1970, p.92.

103 Fourcade, ed. 1972, p.125, n.87.

104 Fourcade, ed. 1972, p.173, n.23.

105 Courthion, *Henri Matisse 1942*. unpaginated.

106 Jules Brassaï, *Conversations avec Picasso*. 1964, p.349.

107 Brassaï, 1964, p.308.

108 Courthion, *Henri Matisse 1942*. unpaginated.

109 Fourcade, ed. 1972, p.194.

110 Brassaï, 1964, p.346.

111 Giraudy, 1971, pp.31–32.

112 Giraudy, 1971, p.32.

113 Fourcade, ed. 1972, p.294.

114 Louis Aragon, *Henri Matisse. Roman*. 1971, vol.2, p.72.

115 Paul Léautaud, *Journal Littéraire XVII*. 1964, pp.10, 13, 73, and 74.

116 Paul Léautaud, *Journal Littéraire XVI*. 1964, p.363.

117 Fourcade, ed. 1972, p.165, n.13.

118 Aragon, 1971, vol.2, p.89.

119 Giraudy, 1971, p.32.

120 Fernand Mourlot, *Gravés dans ma mémoire*. 1979, p.108.

121 Mourlot, 1979, p.116.

122 Mourlot, 1979, p.105.

123 Mourlot, 1979, p.107.

124 Aragon, 1971, vol.2, p.303.

125 Fourcade, ed. 1972, p.243.

126 John Elderfield, *Matisse Drawings and Sculpture*. 1984, p.128.

127 Fourcade, ed. 1972, p.298.

128 Mourlot, 1979, p.104.

129 Fourcade, ed. 1972, pp.240–41.

130 Fourcade, ed. 1972, p.293.

131 Schneider, 1984, p.739.

132 Fourcade, ed. 1972, p.269.

133 Fourcade, ed. 1972, p.270.

134 Aragon, 1971, vol.2, p.183.

135 Ibid.

136 Schneider, 1984, p.670.

137 Brassaï, 1964, p.305.

138 Fourcade, ed. 1972, p.251.

139 Fourcade, ed. 1972, p.188.

SELECT BIBLIOGRAPHY

The titles and captions have been translated from

Duthuit, Marguerite Matisse and Claude Duthuit. *Henri Matisse, Catalogue raisonné de l'œuvre gravé.* with the collaboration of Françoise Garnaud. Preface by Jean Guichard-Meili. Paris, 1983.

The bibliography includes those titles from which a quotation has been taken, as well as the most recent monographs and exhibition catalogues.

Aragon, Louis. Introduction *Dessins: Thèmes et variations.* Paris, 1943.
—. *Henri Matisse. Roman.* 2 vols. Paris, 1971.

Barr, Alfred. *Matisse. His Art and His Public.* The Museum of Modern Art, New York, 1951.
Bergson, Henri. *L'évolution créatrice.* Paris, 1983.
Besson, Georges. *Matisse.* Paris, 1945.
Brassaï, Jules. *Conversation avec Picasso.* Paris, 1964.
Le Bulletin de la vie artistique. Paris, 1919–26.

Cachin, Françoise. *Paul Signac.* Paris, 1971.
Cahiers d'art 1–4. (1935).
Cahiers d'art 3–5. "Dessins de Matisse" (1936).
Cahiers d'art 1–4. "Dessins récents de Henri Matisse" (1939).
Cahiers d'art (1945–46): 162–96.
Cahiers Henri Matisse 1: Matisse et Tahiti, Galerie des Ponchettes. Musée Matisse, Nice, 1986.
Cahiers Henri Matisse 2: Matisse Photographies, Musée des Beaux-Arts, Jules Chéret. Musée Matisse, Nice, 1986.
Cahiers Henri Matisse 3: Matisse. L'art du livre. Musée Matisse, Nice, 1986.
Cahiers Henri Matisse 4: Matisse, Ajaccio-Toulouse, Musée d'Art Moderne. Toulouse. Musée Matisse, Nice, 1986–87.
Cassarini, Jean. *Matisse à Nice. 1916–45.* Nice, 1984.
Cassou, Jean. *Matisse.* Paris, 1947.
Chapelle du Rosaire des Dominicaines de Vence par Henri Matisse. Vence, 1951.
Clair, Jean. "Correspondance Matisse – Bonnard 1925–46", *NRF.* 211, 212, (July, August 1970).
The Cone Collection of Baltimore, Maryland – Catalogue of Paintings, Drawings, Sculpture of the Nineteenth and Twentieth Centuries. Preface by George Boas, Baltimore, 1934.
Courthion, Pierre. "Henri Matisse 1942". *Formes et Couleurs.* 2 (1942).
—. *Le Visage de Matisse.* Lausanne, 1942.

Delektorskaya, Lydia. *Henri Matisse: l'apparente facilité. Peintures de 1935–1939.* Paris, 1986.
Desvallières, Georges. "Présentation de 'Notes d'un peintre.'" *La Grande Revue* (December 1908).

Diehl, Gaston. *Henri Matisse.* 2nd ed. Paris, 1970.
Duthuit, Georges. *Les Fauves.* Geneva, 1949.

Elderfield, John. "Matisse Drawings and Sculpture." *Artforum.* 2 (September 1, 1972): 77–85.
—. *Matisse in the Collection of the Museum of Modern Art.* The Museum of Modern Art, New York, 1978.
—. *The Cut-outs of Henri Matisse.* New York, 1978.
—. *The Drawings of Henri Matisse.* London, 1984.
Escholier, Raymond. *Henri Matisse.* Paris, 1937.

Faure, Elie, Jules Romains, Charles Vildrac, and Léon Werth. *Henri Matisse.* Paris, 1923.
Fels, Florent. *Henri Matisse.* Paris, 1929.
Flam, Jack D. *Matisse, The Man and his art 1869–1918.* Ithaca and London, 1986.
Fourcade, Dominique. "Greta Prozor." *Cahiers du Musée National d'Art Moderne. Centre Georges Pompidou.* 2 (1983): 101–7.
Fourcade, Dominique and Isabelle Monod-Fontaine. *Matisse – dessins, sculpture.* Musée national d'Art moderne, Centre Georges Pompidou, Paris, 1975.
Fry, Roger. *Henri Matisse.* New York, 1935.

Giraudy, Danièle. "Correspondance Henri Matisse – Charles Camoin." *Revue de l'Art.* 12 (1971).
George, Waldemar. *Henri Matisse, Dessins.* Paris, 1925.
Gowing, Lawrence. *Henri Matisse.* New York, 1979.
Guichard-Meili, Jean. *Henri Matisse, son œuvre, son univers.* Paris, 1987.

Hahnloser, Hans R. *En visite chez Henri Matisse. (Gravures et lithographies de 1900 à 1929).* Pully, Switzerland, 1970.
Halicka, Alice. *Hier (Souvenirs).* Paris, 1946.
"Hommage à Henri Matisse." *XXᵉ siècle.* special issue. Paris, 1970.

Izerghina, A.N. *Henri Matisse: Paintings and Sculpture in Soviet Museums.* Leningrad, 1978.

Jacobus, John. *Henri Matisse.* New York, 1972.

Léautaud, Paul. *Journal littéraire XVI (July 1944–August 1946).*
—. *Journal littéraire XVII (August 1946–August 1949).*
Lieberman, William S. *Matisse, 50 Years of his Graphic Art.* New York, 1981.

Malingue, Maurice. *Matisse dessins.* Paris, 1949.
Matisse, Henri. *Écrits et propos sur l'art.* Edited by Dominique Fourcade. Paris, 1972.
McBride, Henry. *Henri Matisse.* New York, 1930.
Monod-Fontaine, Isabelle. *Œuvres de Henri Matisse.* Collections du Musée national d'Art moderne, Centre Georges Pompidou. Paris, 1979.

Monod-Fontaine, Isabelle. *The Sculpture of Henri Matisse.* London, 1984.

Moulin, Raoul-Jean. *Henri Matisse, dessins.* Paris, 1968.

Mourlot, Fernand. *Gravés dans ma mémoire (Cinquante ans de lithographie avec Picasso, Matisse, Chagall, Braque, Miró).* Paris, 1979.

Neff, John Hallmark. "Matisse and Decoration. The Shchukin Panels." *Art in America* 63 (July–August 1975): 38–45.

Le Point 21 (July 1939).

"Pour ou contre Henri Matisse." *Chroniques du Jour* 9 (April 1931).

Richardson, Brenda. *Dr. Claribel and Miss Etta, The Cone Collection.* The Baltimore Museum of Art, Baltimore, 1985.

Roger-Marx, Claude. *Dessins de Henri Matisse.* Paris, 1939.

Russell, John. *The World of Matisse, 1869–1954.* New York, 1969.

Schneider, Pierre. *Matisse.* London and New York, 1984.

Signac, Paul. *D'Eugène Delacroix au néo-impressionnisme.* Paris, 1921.

Sembat, Marcel. *Henri Matisse.* Paris, 1920.

Sorlier, Charles. *Mémoires d'un homme de couleurs.* Paris, 1985.

Verdet, André. *Prestige de Matisse.* Paris, 1952.

Vignier, Charles and H. Inada. *Estampes japonaises exposées au Musée des Arts décoratifs.* 6 vols., Paris, 1909–14.

Warnod, Jeanine. *Le Bateau-Lavoir.* Paris, 1986.

EXHIBITION CATALOGUES

New York, 1908 *An Exhibition of Drawings, Lithographs, Watercolours, and Etchings by M. Henri Matisse,* The Little Galleries of the Photo-Secession.

New York, 1915 *Henri Matisse Exhibition,* Montross Gallery.

Paris, 1918 *Œuvres de Matisse et de Picasso,* Galerie Paul Guillaume.

Paris, 1927 Exposition *Henri Matisse. Dessins et lithographies,* Galerie Bernheim-Jeune.

London, 1928 Leicester Galleries.

New York, 1932 *Poésies de Stéphane Mallarmé. Eaux-fortes originales de Henri Matisse,* Marie Harriman Gallery.

London, 1936 *Exhibition of Drawings and Lithographs by Henri Matisse,* The Leicester Galleries.

Paris, 1952 *Henri Matisse, gravures récentes,* Galerie Berggruen et Cie.

Paris, 1954 *Henri Matisse, Lithographies rares,* Galerie Berggruen et Cie.

New York, 1955 *Etchings by Matisse,* The Museum of Modern Art.

New York, 1956 *The Prints of Henri Matisse,* The Museum of Modern Art.

Geneva, 1959 *Le Livre illustré par Henri Matisse: dessins, documents,* Galerie Gérald Cramer.

Bern, 1960 *Henri Matisse. Das illustrierte Werk, Zeichnungen and Druckgraphik,* Klipstein und Kornfeld.

Chicago, Boston, and Los Angeles, 1966 Leymarie, Jean, Herbert Read, and William S. Lieberman. *Henri Matisse Retrospective,* Art Institute of Chicago; Museum of Fine Arts, Boston; University of California, Los Angeles.

Moscow, 1969 *Matisse: peintures, sculpture, œuvre graphique, lettres,* Pushkin Museum.

Paris, 1970 Guichard-Meili, Jean and Françoise Woimant. *Matisse, l'œuvre gravé,* Bibliothèque Nationale.

Paris, 1970 Schneider, Pierre. *Henri Matisse. Exposition du centenaire,* Réunion des Musées nationaux.

Paris, 1970 Schneider, Pierre. *Matisse,* Galerie Dina Vierny.

Baltimore, 1971 *Matisse as a Draughtsman,* The Baltimore Museum of Art.

Jerusalem, 1971 *Henri Matisse. Prints and Drawings from a Swiss Private Collection,* The Israel Museum.

London, 1972 Lambert, Susan. *Matisse. Lithographs,* Victoria and Albert Museum.

Marseilles, 1974 *130 dessins de Matisse,* Musée Cantini.

St. Louis, 1977 Cowart, Jack, Jack D. Flam, Dominique Fourcade, and John Hallmark Neff, *Henri Matisse – Paper Cut-outs,* The St. Louis Art Museum.

New York, 1980 Ives, Colta. *Modern Monotypes,* The Metropolitan Museum of Art.

Bielefeld, West Germany, 1981 Mähl, Hans Joachim, Ulrich Weisner, Pierre Schneider, Lorenz Dittmann, Gottfried Boehm, and Gerd Udo Feller. *Henri Matisse. Das Goldene Zeitalter,* Kunsthalle.

Paris, 1981 *Henri Matisse. Donation Jean Matisse,* Bibliothèque Nationale.

Fribourg, 1982 Hahnloser-Ingold, Margrit, Yvonne Lehnherr, and Roger Marcel Mayou. *Henri Matisse. Gravures et lithographies,* Musée d'art et d'histoire.

Zurich, 1982 Baumann, Felix, Pierre Schneider, Klaus Schrenk, Reinhold Hohl, Margrit Hahnloser-Ingold, and Franz Meyer. *Henri Matisse,* Kunsthaus.

Fort Worth, 1984 Mezzatesta, Michael P. *Henri Matisse, Sculptor/Painter,* Kimbell Art Museum.

Paris, 1984 Fourcade, Dominique. *Henri Matisse, Œuvres gravées,* Galerie Maeght Lelong.

Paris, 1985 *Donation Louise et Michel Leiris – Collection Kahnweiler-Leiris,* Musée national d'Art moderne, Centre Georges Pompidou.

Fort Worth, 1986 Neff, John Hallmark and Riva Castleman. *Henri Matisse,* Kimbell Art Museum.

Washington, D.C., 1986–87 Cowart, Jack, Dominique Fourcade, and Margrit Hahnloser-Ingold. *Henri Matisse. The Early Years in Nice 1916–1930,* The National Gallery of Art.

Venice, 1987 Schneider, Pierre. *Henri Matisse e l'Italia,* Ala Napoleonica e Museo Correr.

WORKS ILLUSTRATED BY HENRI MATISSE

(From *Cahiers Henri Matisse 3: Matisse. L'art du livre.* Musée Matisse, Nice, 1986.)

Stéphane Mallarmé. *Poésies.* 29 original etchings. Lausanne, Albert Skira et Cie. 1932.
Edition of 145, signed and numbered. 30 copies on Japan paper; 5 numbered 1 to 5, each featuring a series on Japan paper with comments in black, a series on China paper with comments in black and original drawings by the artist; 25 copies numbered from 6 to 30, each featuring a series on Japan paper with comments in black; 95 copies numbered from 31 to 125 on Arches wove paper; and 20 copies not for sale numbered in Roman numerals from I to XX, reserved for the artist and his collaborators.

James Joyce. *Ulysses.* New York, The Limited Editions Club, 1935.
6 inset etchings and 20 reproductions of studies on colored paper. 150 series of 6 signed etchings were also printed by R. Lacourière. Edition of 1,500 signed and numbered.

Henri de Montherlant. *Pasiphaé. Chant de Minos (Les Crétois).* Paris, Martin Fabiani, 1944.
147 linocuts: 18 insets in black, 26 borders in black, 13 borders in red, 84 initials in red, and 6 tailpieces.
Edition of 30 on old Japan paper with series of 12 engraved plates with the frontispiece printed on China paper, numbered from 1 to 30; 200 copies not for sale, Arches wove paper numbered from 31 to 230; 20 copies not for sale, on Arches wove paper marked from I to XX. 250 copies signed by the artist.

Visages. Quatorze lithographies de Henri Matisse accompagnées de poésies par Pierre Reverdy. Paris, Les Editions du Chêne, 1946.
14 full-page lithographs printed in red chalk; 17 linocuts in black, 3 on the cover and 14 tailpieces; 14 initials in violet.
Edition of 250: 30 on Montval wove paper numbered from 1 to 30; 200 on Lana wove paper numbered from 31 to 230; 20 not for sale, on Lana wove paper marked from I to XX.

Marianna Alcaforado. *Lettres Portugaises.* Paris, Tériade, 1946.
15 full-page lithographs in maroon, 55 lithographed ornaments in violet (2 on cover, 5 full-page, and 6 tailpieces) and 35 lithographed initials in violet.
Edition of 250 on Arches wove paper, numbered from 1 to 250, the first 80 copies including a series of 12 plates of studies, and 20 copies not for sale numbered from I to XX.

Charles Baudelaire. *Les Fleurs du mal.* Paris, La Bibliothèque Française, 1947.
An original etching on cut China paper; 33 photo lithographed inset plates; 38 ornaments, 2 on the cover, 10 full-page and 22 initials engraved in wood. Edition of 320 on Rives paper: 300 copies numbered from 1 to 300 and 20 copies for collaborators not for sale, lettered A–T, including an etching on China paper.

Vingt-trois lithographies de Henri Matisse pour illustrer "Les Fleurs du mal." presented by Louis Aragon, Paris, 1946.
Lithographs printed in black.

Edition of 5 copies, not offered for sale: I for Henri Matisse, II for Elsa Triolet and Aragon, III for F. Morlot; IV for Lydia Delektorskaya, V for the Bibliothèque littéraire Jacques Doucet. Drawing in blue and red colored pencils on title page.

André Rouveyre. *Repli.* Paris, Editions du Bélier, 1947.
12 lithographed inset plates; 6 in black on white paper, and 6 in black on gray paper; 6 linocuts: 2 borders in black, 2 tailpieces in black, 2 initials in red.
Edition of 370: 35 copies on Montval paper, accompanied by a series of lithographs printed on China paper, numbered from 1 to 25 and from I to X; 315 on Arches wove paper, numbered from 26 to 250 and from XI to C; 20 copies on Arches. The lithographs were printed on Ile-de-France and Lana rag paper.

Henri Matisse. *Jazz.* Paris, Tériade, 1947.
20 color plates, 15 double page, and 12 ornaments in black.
Edition of 270. 250 copies on Arches wove paper, numbered from 1 to 250; 20 not for sale, numbered from I to XX.
100 albums were also printed with the plates from the book exclusively.

Henri Matisse. *Florilège des Amours de Ronsard.* Paris, Albert Skira, 1948.
128 lithographs (2 on the cover, 1 on frontispiece, 21 inset plates, 104 in text) printed in red chalk, except for the illustration on the title page.
Edition of 320 on tinted Arches wove paper, numbered as follows: 20 copies numbered from 1 to 20; 12 original lithographs, "rejected plate" on Imperial Japan paper, 20 of each monogrammed by the artist; the proofs of this series are variations on the illustration for the poem *Marie qui voudroit votre nom retourner*; 30 copies numbered from 21 to 50, with 8 original lithographs on Imperial Japan paper, 50 of each monogrammed by the artist; the proofs of this series are variations on the illustration for the poem *Marie qui voudroit votre nom retourner*; 250 copies numbered from 51 to 300; 20 copies not for sale, numbered in Roman numerals from I to X.

Charles d'Orléans. *Poèmes.* Paris, Tériade, 1950.
100 lithographs (portraits, ornaments, fleurs-de-lys) in several colors.
Edition of 1,200 on Arches wove paper, numbered from 1 to 1,200; 30 copies not for sale, numbered from I to XXX.

André Rouveyre. *Apollinaire.* Paris, Raison d'Etre, 1952.
1 aquatint as frontispiece, 7 lithographs in black on cream background, 6 as inset plates and 1 tailpiece; 3 red linocut initials.
Edition of 30 on large Arches wove paper, numbered from 1 to 30; 300 on Arches wove paper, numbered from 31 to 330; 20 copies for collaborators and not for sale, numbered from I to XX.

Echos, Poèmes inédits de Jacques Prévert. André Verdet. Nazim Hikmet. Paris, Fernand Mourlot, 1952.
6 lithographs on cream background, one printed in sepia for the frontispiece and 5 in black; 11 linocut initials, 9 blue and red tailpieces.
Edition of 15 copies, not for sale, on Arches wove paper.

Georges Duthuit. *Une Fête en Cimmérie*. Paris, Tériade, 1963.
31 lithographs in black: one on the cover, 16 inset plates, and 14 in series inside jacket, numbered on reverse.
Edition of 120 on Rives paper, numbered from 1 to 120; 10 copies for collaborators, numbered from I to X.

John Antoine Nau. *Poésies antillaises*. Paris, Fernand Mourlot, 1972.
28 lithographs printed on brown paper – 1 frontispiece and 27 inset plates; 27 initials and numerous ornaments printed in blue.
Edition of 250 on Arches wove paper, 50 numbered from 1 to 50 and including a series of 12 original lithographs in addition; 200 copies numbered from 51 to 250; 25 copies not for sale.

ALBUMS

Henri Matisse, *Fifty Drawings*. Preface by Charles Vildrac. Album published by the artist, Paris, 1920.
Signed etching on the frontispiece on China paper. 50 full-page reproductions of drawings.
Edition of 1,000 on Van Gelder wove paper, numbered from 1 to 1,000; 3 copies with scratched plates, numbered from I to III.

Henri Matisse. *Dessins. Thèmes et variations*. Preface by Louis Aragon: "Matisse in France." Paris, Martin Fabiani, 1943.
3 lithographs as ornaments; 158 reproductions of drawings.
Edition of 950, all numbered: 10 copies on Imperial Japan paper, numbered from 1 to 10; 20 copies on Arches wove paper, numbered from 11 to 30; 920 copies on linen wove paper, numbered from 31 to 950.

Henri Matisse. *Portraits*. Preface by Henri Matisse, Monte Carlo, André Sauret, 1954.
An original lithograph as frontispiece. Cover from a composition by the artist produced specially for this work.
Edition of 2,850 including 500 copies in English, all numbered.

BOOKS

Louis Thomas. *André Rouveyre*. Paris, Dorbon-Aîné, 1912.
Portrait of André Rouveyre as frontispiece. Edition of 500.

Cézanne. Paris, Bernheim-Jeune, 1914.
Texts by Octave Mirbeau, Théodore Duret, Léon Werth, and Frantz Jourdain.
1 lithograph by Henri Matisse, plate V of 100 copies on Japan paper.
Edition of 600.

Pierre Reverdy. *Les Jockeys camouflés et Période hors-texte*. Paris, Paul Birault, 1918.
5 previously unpublished drawings by Henri Matisse. Edition of 105.

Tableaux de Paris. Previously unpublished pieces by Paul Valéry, Roger Allard, Francis Carco, Colette, Jean Cocteau, etc. Original lithographs and engravings on copper by Bonnard, Céria, Daragnès, etc. Paris, Emile-Paul Frères, 1927.
One etching, *Le Pont Saint-Michel*, by Henri Matisse.
Edition of 25 on Imperial Japan paper featuring a series of etchings on Arches wove paper, numbered from 1 to 25; 200 copies on Rives paper, numbered from 26 to 225.

Tristan Tzara. *Midis gagnés. Poèmes*. Paris, Edition Denoël, 1939.
6 drawings by Henri Matisse. One drypoint numbered and signed as frontispiece to first edition. 6 reproductions of drawings.
Edition of 28 on Van Gelder wove paper, featuring as a frontispiece an original drypoint by Henri Matisse; 25 numbered from 1 to 25; 1,150 on wove paper, 1,000 numbered from 26 to 1,025.

Henry de Montherlant. *Sur les femmes*. Paris, Sagittaire, 1942.
Frontispiece by Henri Matisse (portrait of Montherlant).
Edition of 1,430.

Elsa Triolet. *Le Mythe de la Baronne Mélanie*. Neuchâtel and Paris, Ides et Calendes, 1945. 2 drawings (cover and frontispiece) by Henri Matisse. Edition of 5,182.

André Gide. *Jeunesse*. Neuchâtel, Ides et Calendes, 1945.
Cover designed by Henri Matisse. Edition of 327.

Alternance. Previously unpublished pieces by F. Mauriac, J. Giraudoux, Léon Paul Fargue, and Max Jacob. Illustrated by various artists (Laboureur, Villon, Cocteau, Matisse, etc.), 16 etchings. Paris, Le Gerbier, 1946.
One etching by Henri Matisse, *Boy's Mask*, 1945.
Edition of 340.

Tristan Tzara. *Le Signe de vie*. Paris, Bordas, 1946.
Frontispiece (lithograph) by Henri Matisse (portrait of Claude Duthuit). Reproduction of 6 drawings.
Edition of 540.

André Rouveyre. *Choix de pages de Paul Léautaud*. Paris, Editions du Bélier, 1946.
A lithograph (portrait of Paul Léautaud) by Henri Matisse as frontispiece to the first edition of 50.
Edition of 50, on rag paper, numbered from 1 to 45 and from I to V; 350 copies on laid paper, numbered from 46 to 380 and from VI to XX.

Franz Viller (pseudonym of Thomassin). *Vie et Mort de Richard Winslow*. Paris, Editions du Bélier, 1947.

Frontispiece by Henri Matisse (portrait of Thomassin), lithograph on cut China paper.

René Char. *Le Poème pulvérisé.* Paris, Edition de la Revue Fontaine, 1947.
Frontispiece by Henri Matisse, linocut (woman's face) for the first 65 copies.

Jacques Kober. *Le Vent des épines.* Paris, Pierre à Feu, published by Maeght, 1947.
Edition of 300 on Auvergne wove paper. Each copy is illustrated by Pierre Bonnard, Georges Braque, and Henri Matisse.

Jean Giraudoux. *Visitations.* Neuchâtel, Ides et Calendes, 1947.
Cover designed by Henri Matisse.

Tristan Tzara. *Midis gagnés: Poèmes,* Paris, Les Editions Denoël, 1948.
A lithograph by Henri Matisse on cut China paper as frontispiece to the first 15 copies. 8 reproductions of drawings.
Edition of 1,000 on Alpha paper. 950 numbered from A1 to A950; 50 not for sale and numbered from AI to AL.

Jules Romains. *Pierres levées.* Paris, Flammarion, 1948.
An original lithograph by Henri Matisse as frontispiece.
Edition of 340 on Lana wove paper.

Poésie de Mots inconnus. Paris, Le Degré 41, 1949. Book conceived by Iliazd.
Poems by Albert-Birot, Arp, Artaud, Audiberti, Ball, etc. Decorated by Arp, Braque, Brayen, Chagall, etc.
A lithograph by Henri Matisse printed in blue illustrates a poem by Rouke Akin-semoyin.
Edition of 150 on Ile-de-France paper.

René Leriche. *Chirurgie, discipline de la connaissance.* Nice, La Diane Française, 1949.
A lithograph on laid China paper by Henri Matisse as frontispiece (portrait of author). Edition of 300 on Rives paper, numbered from 1 to 300.

Albert Skira. *20 ans d'activité.* Paris and Geneva, Albert Skira, 1949.
Cover and frontispiece (portrait of the publisher).

Georges Duthuit. *Les Fauves.* Geneva, Editions des Trois Collines, 1949.
Cover by Henri Matisse with five drawings of flowers in red and blue (for the first copies). Edition of 86.

Colette. *La Vagabonde.* Paris, André Sauret, 1951.
Original lithograph as frontispiece (portrait of Colette) for the first 300 copies.

Chapelle du Rosaire des Dominicaines de Vence par Henri Matisse. Vence, 1951.
Cover by Henri Matisse from a paper cutout (yellow and blue).

Chapelle du Rosaire des Dominicaines de Vence par Henri Matisse. Offprint from *France Illustration.* Christmas 1951.
Cover by Henri Matisse from a paper cutout (yellow and blue).
Edition of 1,500, numbered from 1 to 1,500.

Henri Cartier-Bresson. *Images à la Sauvette.* Paris, Verve, 1952.
Cover by Henri Matisse in paper cutout (black, blue, and green).

Jacques Howlett. *Un temps pour rien.* Paris, Plon, 1953.

Jean-Pierre Monnier. *L'Amour Difficile.* Paris, Plon, 1953.

Alfred Narcisse. *L'Ombre de la morte.* Paris, Plon, 1954.

Jacques Sternberg. *Délit.* Paris, Plon, 1954.

Paul Demarne. *Pure peine perdue.* Paris, Editions de Minuit, 1955.
Reproduction of lithograph *(Portrait of the Author).*

LIST OF PLATES